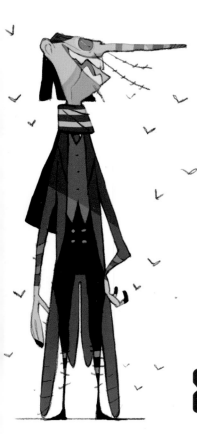
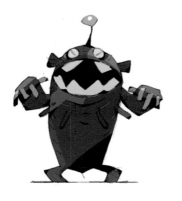
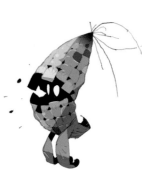

Fantasy Characters & Creatures

AN ARTIST'S SOURCEBOOK

Satoshi Matsuura

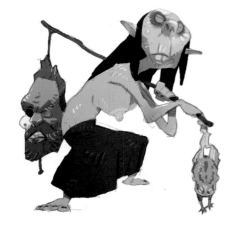
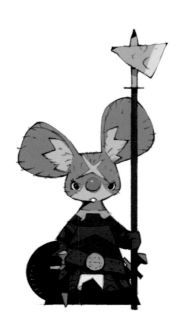
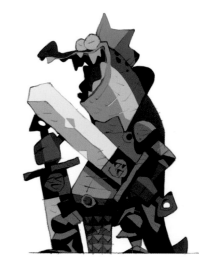
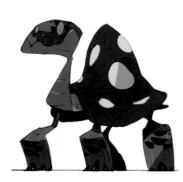

TUTTLE Publishing

Tokyo | Rutland, Vermont | Singapore

Contents

70 Rabbit Ranger
Wolf Samurai

71 Small Bat
Ape Soldier
War Elephant
Cat Bandit
Wild Hunter
Rat Soldier
Orc Ranger
Beast Man
Spaniel Knight

72 Black Dog
Werechipmunk
Dwarf King

73 Squid Cap
Barbaroi
Harpy
Elf
Eye Hunter
Frontier Warrior

74 Dragonewt
Vampire

75 Battle King
Medusa Knight
Mr. Kentauros
Ogre Lady
Gorgon
Woodcutter Giant
Bison Mage
Assassin Gnome
Dark Elf

76 Half-ogre
Sphinx Lady
Dwarf
Dark High Elf
Hunchback
Medusa

77 Cat Woman
Dragonewt Explorer
Uncle Spider
Moth Fairy
Elephant Soldier
Swamp Giant

Human Warriors

78 Dragon Tamer
Gushnasaph
Le Coq Chevaliers

79 Swedish Knight
Note Knight
Valhalla Warrior
Saxon Knight
Veteran Warrior
Plague Knight

80 Dragon Slayer
El Batoidea

81 Mexican Skeleton
Amazon Warrior
Castle Soldier
Ashigaru
Scottish Warrior
Roman Soldier
Monk
Female Warrior
Scared Knight

82 Imperial Guard
Wise Man
Kung Fu Boy
Female Knight
Cheers Knight
Blue Knight

83 Sir Dragon
Explorer
Unicorn Man
Old Knight
King
Defeated Knight

84 Giant Slayer
Knight Maghreb

85 Knight Arlon
Blacksmith
Horse Head Knight
Sumo Wrestler
Fearsome Knight
Skilled Knight
Tomahawk Viking
White Knight
Thunder Joe

86 Snail Knight
Berserker
Knight Asim
Blue-haired Warrior
Dragoon
Germanic Knight

87 Knight Voltaire
Butler
Knight Gotthard
Mononofu
Dragoon Guard
Chinese Warlord

88 Mercenary Clegane
Bowl-cut Knight
Knight Engelbert
Nordic Warrior
Sir Galahad
Conical-helmeted
 Knight

89 Bishop Knight
Footsoldier
Paladin
Girl Warrior
Sage of the Dead
 Leaf
Cleric Knight

90 Orange Knight
Eagle Knight

91 Ghost Gentleman
Bobbed Knight
Topknot Samurai
Headhunter
Amazonian Queen
Ramen Man
Heron Rider
Boy Knight
Minister

Rogues, Assassins and Mercenaries

92 Knight Idris
Witch
Necromancer

93 King Slayer
Cyclops Knight
Executor
Bone Shaman
Baron Konstanty
Sebek Priest
Golyat
Black Claw
Archer

94 Barbarian
Bad King
Swamp Witch
Pirate Captain
Hook Man
Atlantean Convict

95 Swamp Warrior
Big Man
Redhood Acolyte
Wolf Ranger
Heresy Priest
Spriggan

96 Dark Witch
General Bramall

97 Baron Penguin
Catfish Warrior
Jack the Ripper
Torch Knight
Nomadic Warrior
Beetle Gladiator
Robber Knight
Viking
Wizard Donegal

98 Plague Soldier
Demon Knight
Erik the Red
Cerberus and Keeper
Sir Liudolf
Supreme Leader

99 Dog Trainer
Dark Alchemist
Mongol Warrior
Imperial Soldier
Anubis Warrior
Scar Man

Why I Wrote This Book

I'm not an illustrator; I'm primarily a character designer. I'm not particularly good at producing illustrations, nor can I draw effortlessly, but what I value most is when someone looks at my work and thinks, "Wow, that's great!" This book is not about "how to draw," but rather "how to think."

This book summarizes my thought process when I'm designing characters and creatures. I'm not relating anything esoteric here—I believe that anyone can do it. In Part 1, "My Character Catalog," I feature more than 600 characters and creatures from the world of fantasy that I've drawn as my personal work. I felt that a broad range of colorful examples would illustrate my process more succinctly than a dry, unwieldy how-to manual ever could.

Here, I've included my original work, from monsters, anthropomorphic creatures, humans, demons and the undead, to magical creatures and off-the-wall organisms. I've drawn from my imagination as well as taking cues from natural history, mythology and literature. You may find some design inspiration just by casually flipping through these pages.

In Part 2, "My Character Design Process," I've outline my creative process and illustrated how my designs evolve as I synthesize ideas and make design decisions. I've written in simple terms about the original character's inspiration, and how I come up with dynamic silhouettes, interesting character highlights and special features. I think you'll find my thoughts on interesting silhouettes and ways to avoid monotonous forms to be helpful in your own creative process.

I hope reading this book will give you plenty of tips and inspiration for your own character design endeavors!

—Satoshi Matsuura

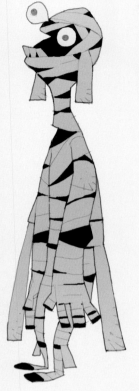
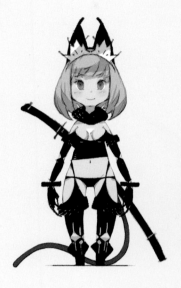
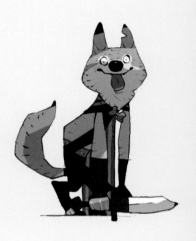

Part 1
My Character Catalog

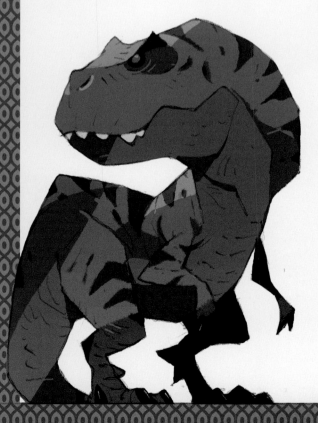

Dragons

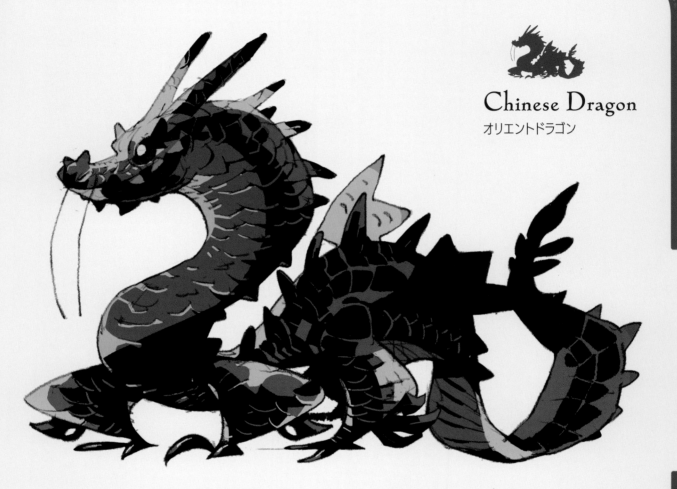

Chinese Dragon
オリエントドラゴン

Dragons are enchanting beasts, aren't they? They're creatures that we've grown familiar with since childhood through games, comics, movies and the like. I've drawn countless dragons over the course of my life. There's a standard design, but it's fun to create your own mutations. Dragons can be a blend of reptiles like snakes, crocodiles and lizards, or even amphibians and birds, just by adding limbs, wings or a unique tail. I want to draw designs that have never been seen before using my imagination, and I'm also interested in seeing the different interpretations of dragons that others have drawn.

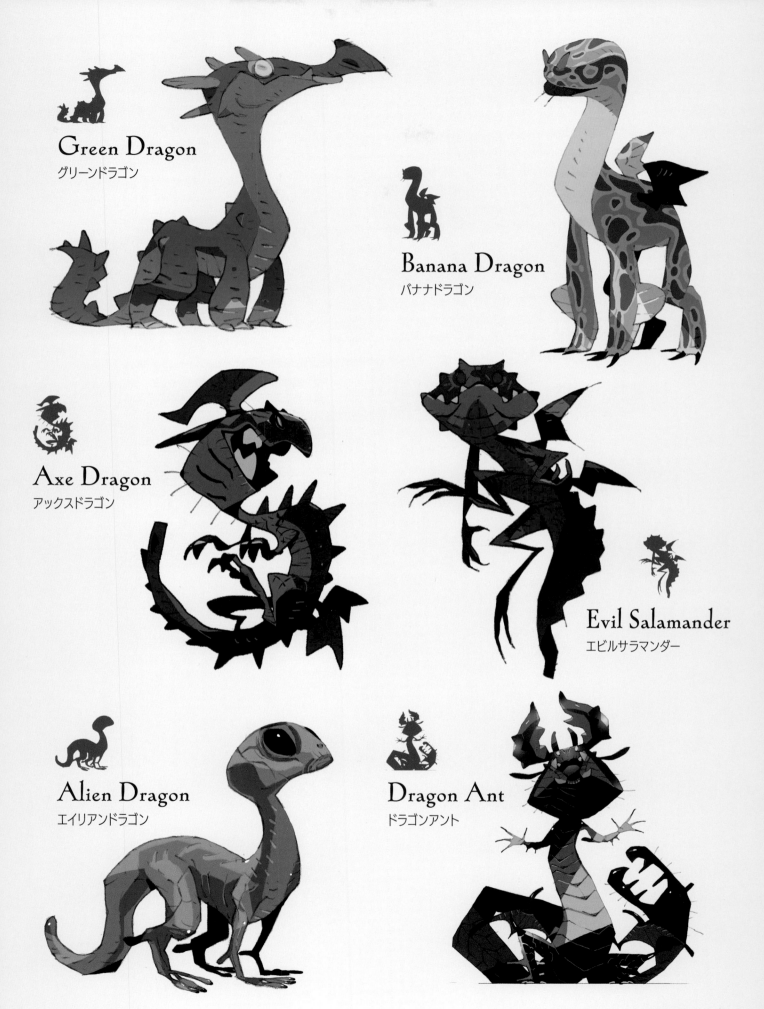

Green Dragon
グリーンドラゴン

Banana Dragon
バナナドラゴン

Axe Dragon
アックスドラゴン

Evil Salamander
エビルサラマンダー

Alien Dragon
エイリアンドラゴン

Dragon Ant
ドラゴンアント

By incorporating a lot of spiky shapes, you can evoke a venomous, spiny impression.

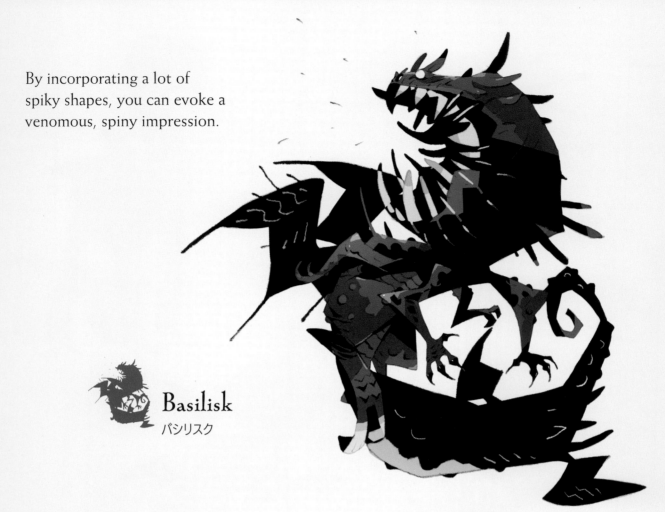

Basilisk
バシリスク

Lesser Dragon
レッサードラゴン

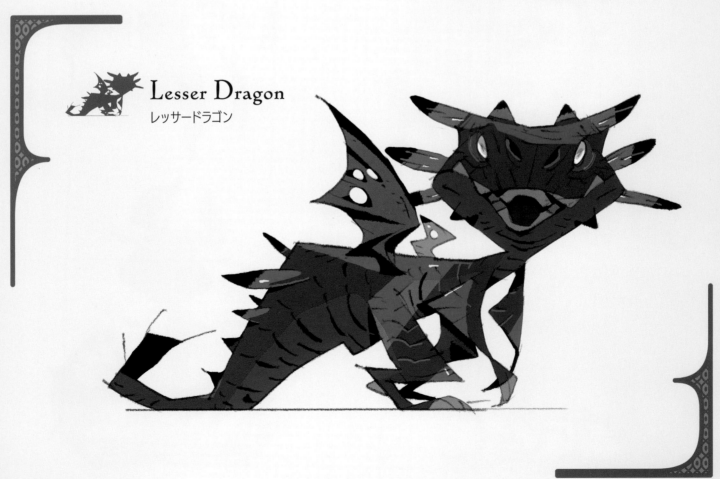

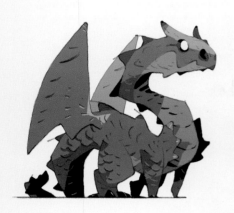

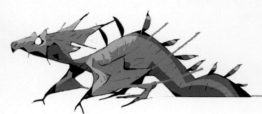

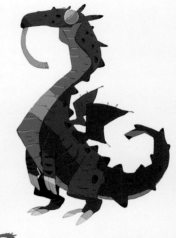

Desert Dragon
デザートドラゴン

Bat Dragon
フロートドラゴン

Anteater Dragon
アントイータードラゴン

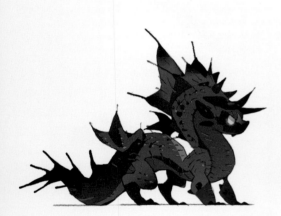

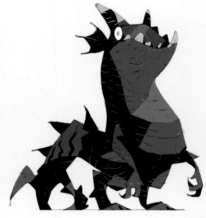

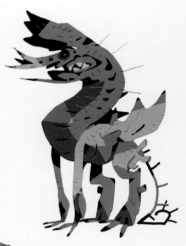

Behemoth
ベヒーモス

Blue Dragon
ブルードラゴン

Carrion Dragon
キャリオンドラゴン

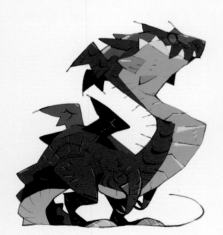

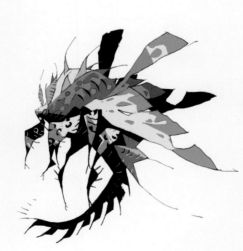

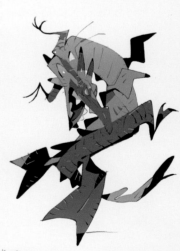

Lind Drake
リンドドレイク

Dragon Moth
ドラゴンモス

Lesser Wyvern
レッサーワイバーン

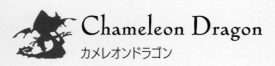

Chameleon Dragon
カメレオンドラゴン

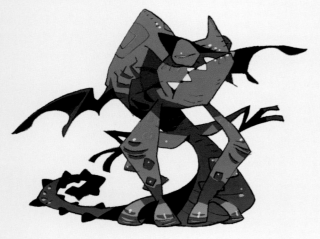

Wyvern
ワイバーン

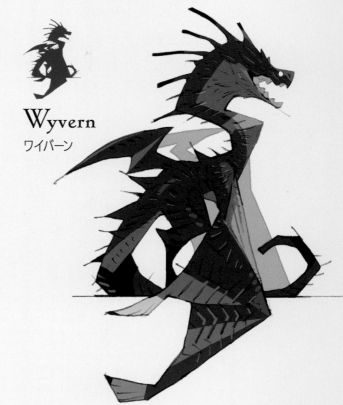

Evil Dragon
イビルドラゴン

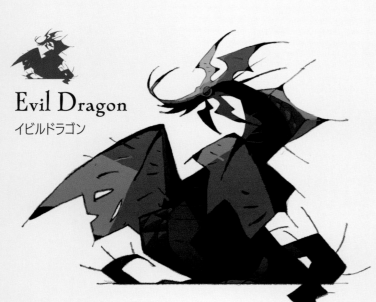

Flatfish Dragon
フラットフィッシュドラゴン

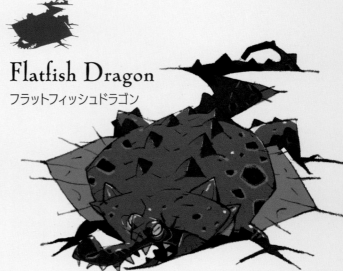

Hippo Dragon
ヒッポドラゴン

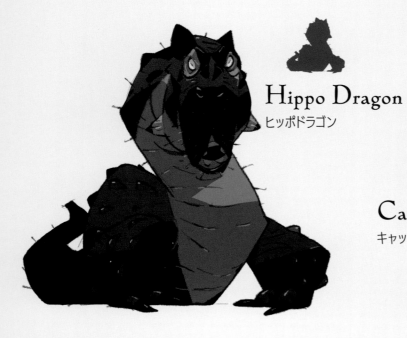

Catfish Dragon
キャットフィッシュドラゴン

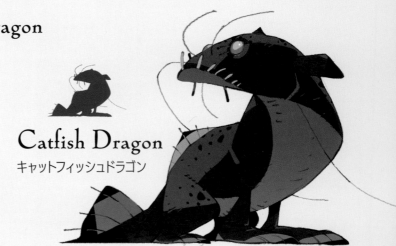

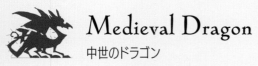

Medieval Dragon
中世のドラゴン

Rock Dragon
ロックドラゴン

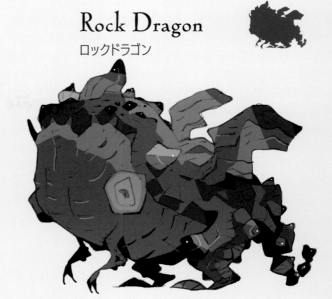

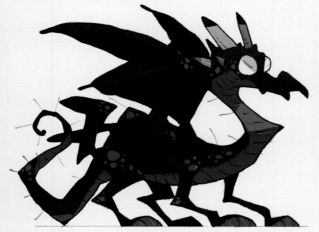

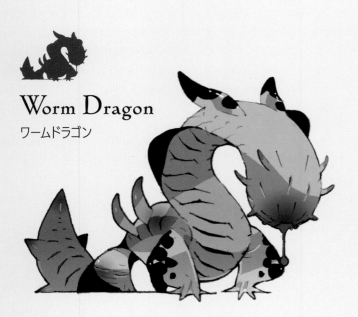

Worm Dragon
ワームドラゴン

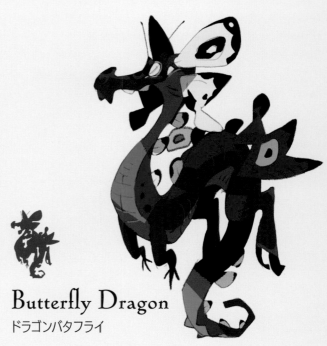

Butterfly Dragon
ドラゴンバタフライ

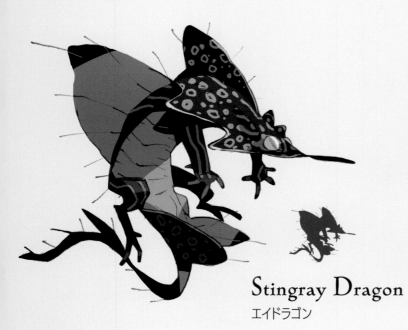

Stingray Dragon
エイドラゴン

Dragon Eel
ドラゴンイール

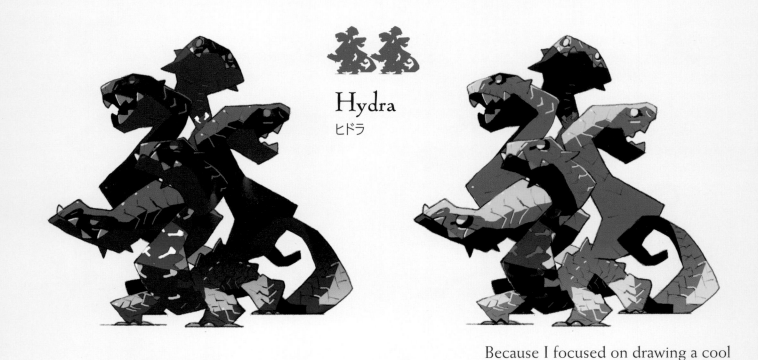

Hydra

ヒドラ

Because I focused on drawing a cool silhouette, the anatomical structure around the neck is not completely fleshed out, but I think it's fine as long as the drawing looks good!

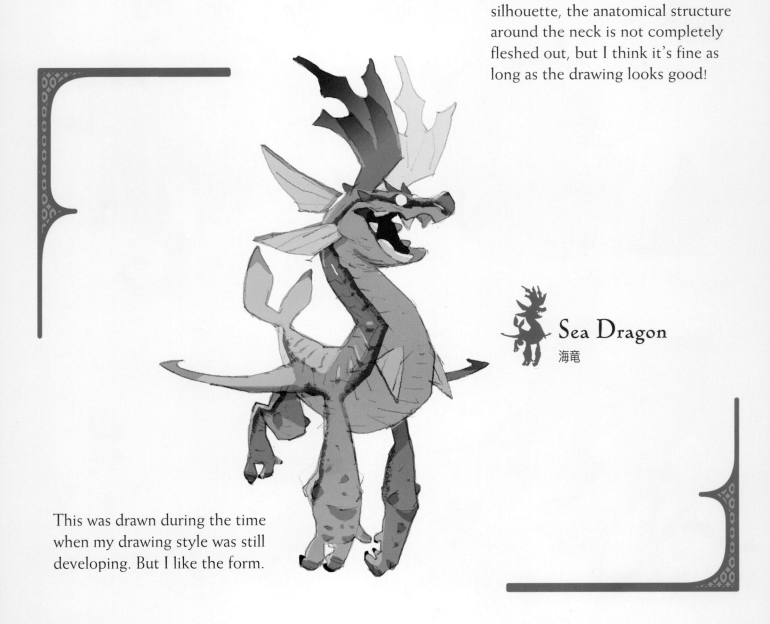

Sea Dragon

海竜

This was drawn during the time when my drawing style was still developing. But I like the form.

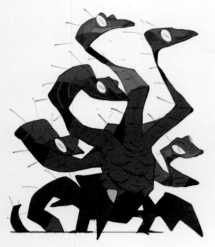

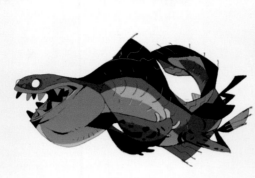

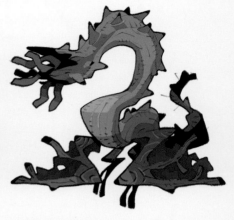

King Hydra
キングヒドラ

River Devil
リバーデビル

Dead-tree Dragon
デッドツリードラゴン

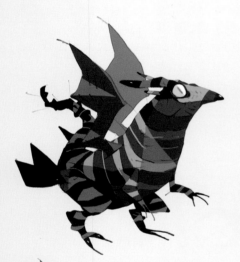

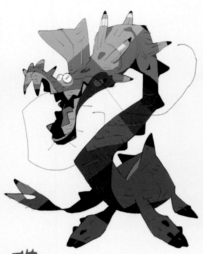

Striped Dragon
ストライプドラゴン

Lake Dragon
シードラゴン

Sludge Dragon
スレッジドラゴン

Dragon Boar
ドラゴンボア

Dragon Caterpillar
ドラゴンキャタピラー

Forest Dragon
フォレストドラゴン

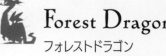

Fungus Dragon
ファンガスドラゴン

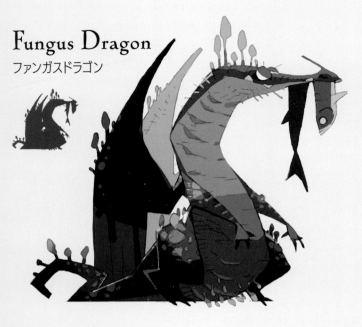

Linnorm
リンノルム

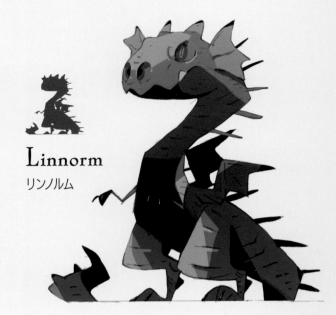

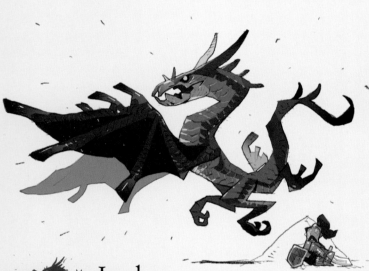

Lindorm
レンオアム

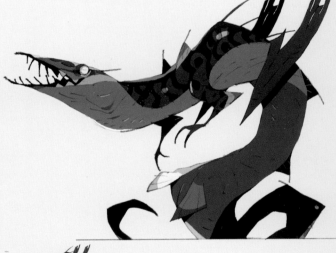

Serpent Dragon
サーペントドラゴン

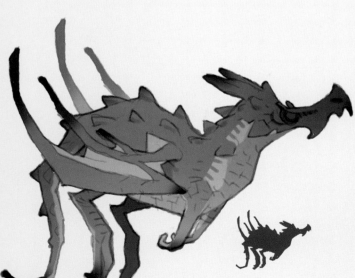

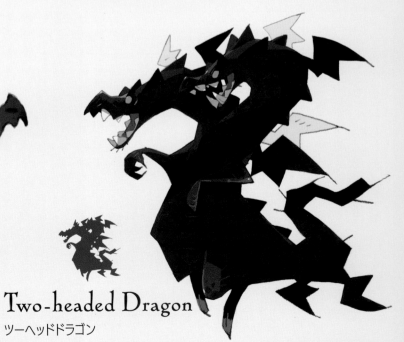

Spring Dragon
スプリングドラゴン

Two-headed Dragon
ツーヘッドドラゴン

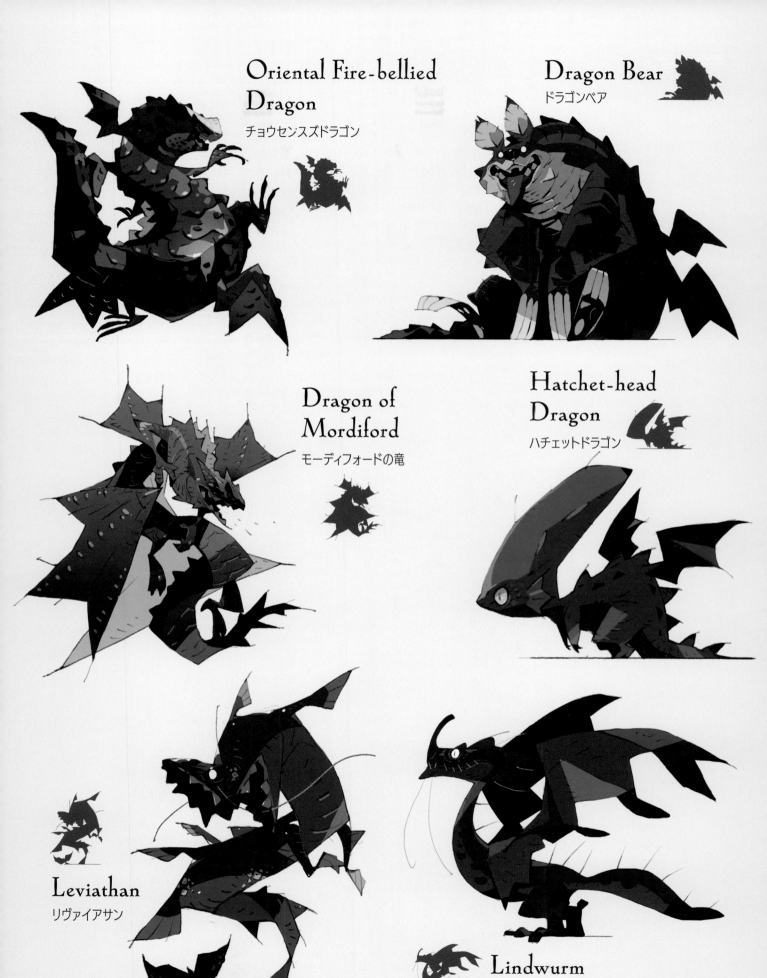

Oriental Fire-bellied Dragon
チョウセンスズドラゴン

Dragon Bear
ドラゴンベア

Dragon of Mordiford
モーディフォードの竜

Hatchet-head Dragon
ハチェットドラゴン

Leviathan
リヴァイアサン

Lindwurm
リンドブルム

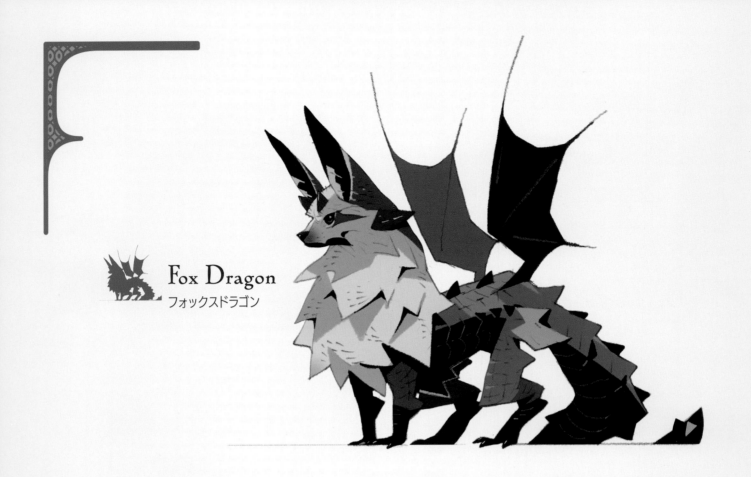

Fox Dragon
フォックスドラゴン

The markings on the cap
resemble eyes, but the actual eye
is the small black dot on the side.

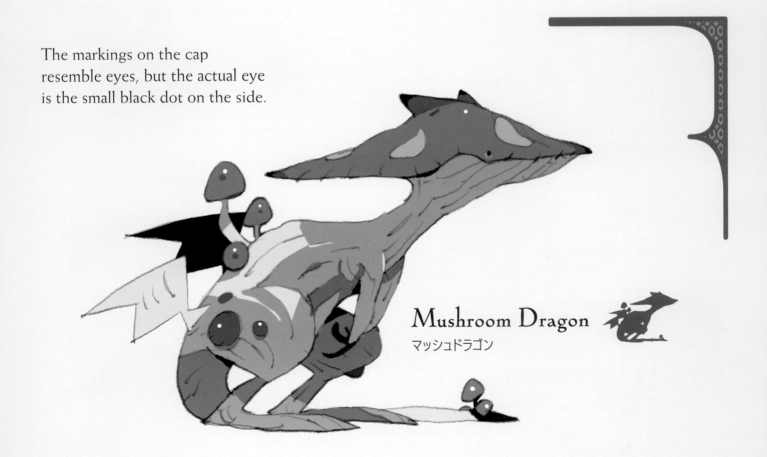

Mushroom Dragon
マッシュドラゴン

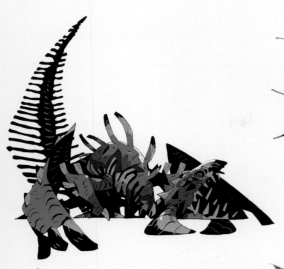

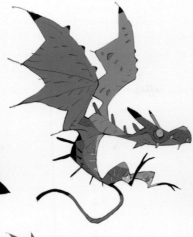

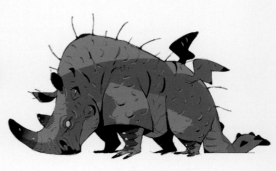

Dragon Zombie
ドラゴンゾンビ

Little Wyvern
リトルワイバーン

Rhino Dragon
ライノドラゴン

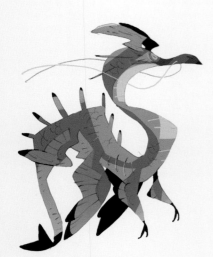

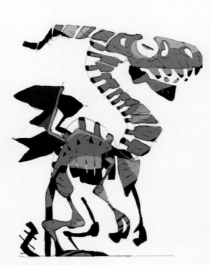

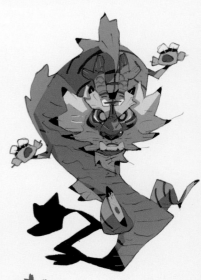

Wind Dragon
ウインドドラゴン

Bone Dragon
ボーンドラゴン

Tiger Dragon
タイガードラゴン

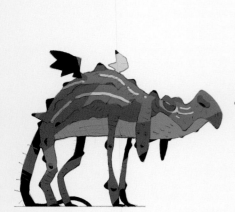

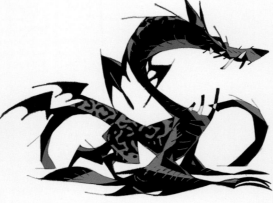

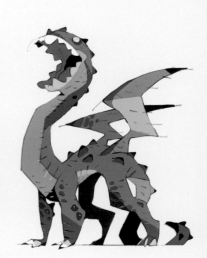

Pink Dragon
ピンクドラゴン

Black Mage Dragon
ブラックメイジドラゴン

Venomous Dragon
ポイズンドラゴン

Dinosaurs

Spinosaurus
スピノサウルス

I designed these in my own way without deviating too much from
the actual dinosaurs that existed. I'm not a dinosaur expert, so I don't have any
preconceived notions of what a dinosaur should look like. Many ancient
creatures have interesting shapes, so I want to learn more about them.
As a starting point, I'll make sure the names and the drawings agree!

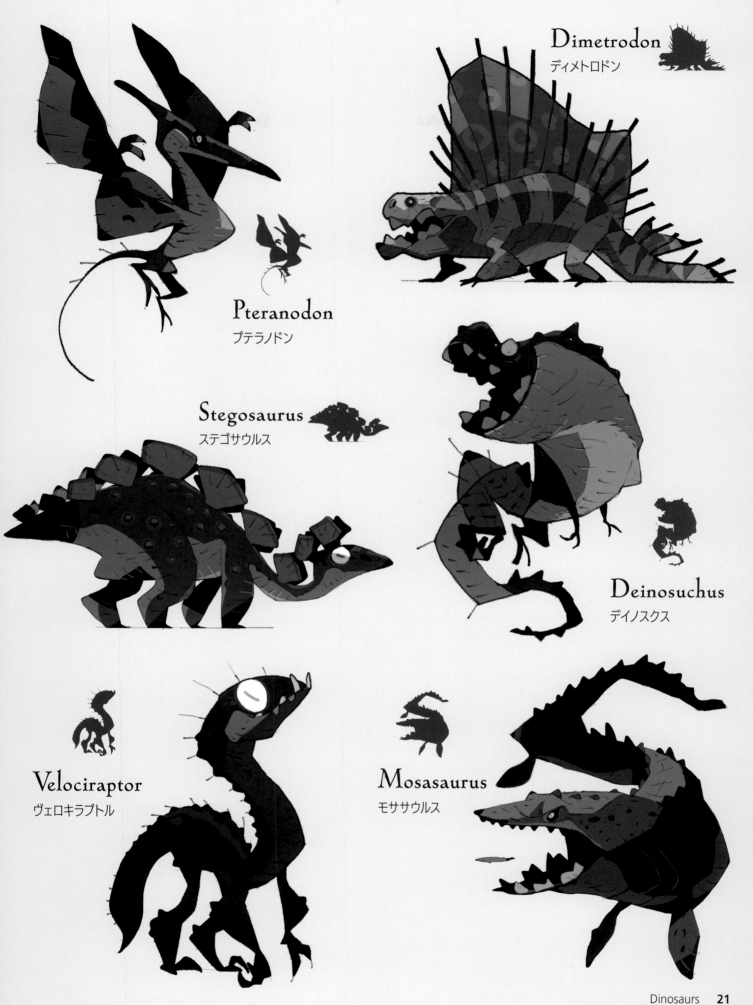

Pteranodon
プテラノドン

Dimetrodon
ディメトロドン

Stegosaurus
ステゴサウルス

Deinosuchus
デイノスクス

Velociraptor
ヴェロキラプトル

Mosasaurus
モササウルス

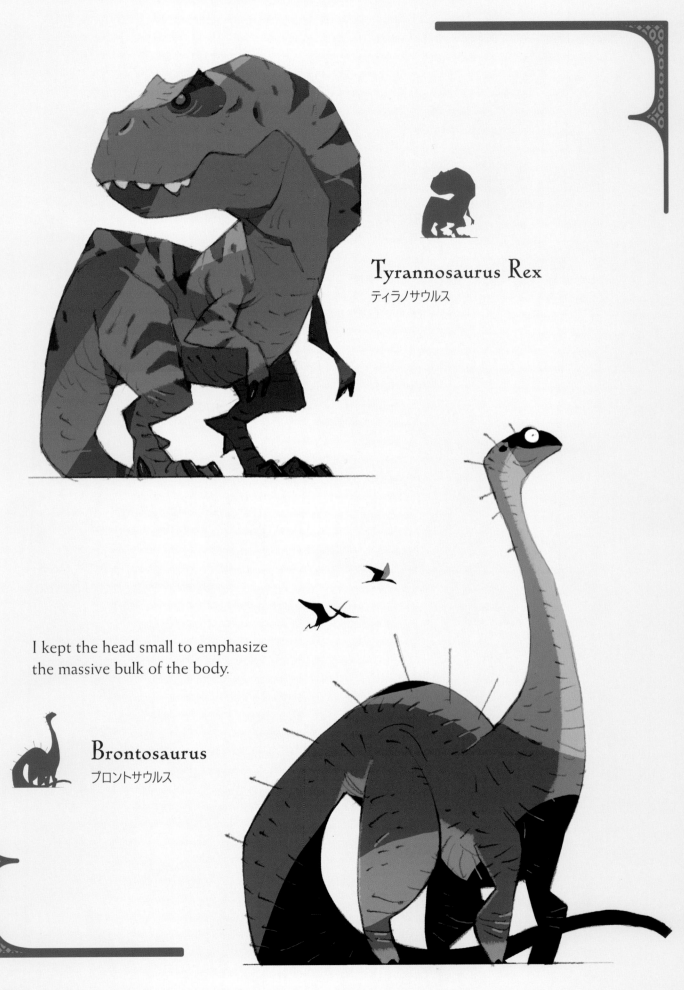

Tyrannosaurus Rex
ティラノサウルス

I kept the head small to emphasize
the massive bulk of the body.

Brontosaurus
ブロントサウルス

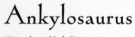

Nothosaurus
ノトサウルス

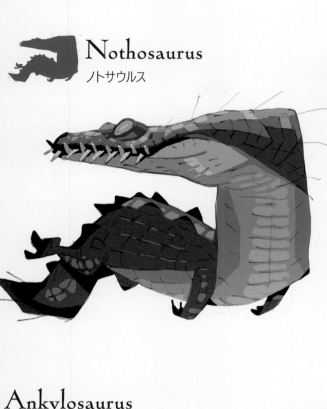

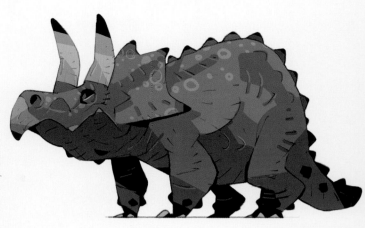

Triceratops
トリケラトプス

Ankylosaurus
アンキロサウルス

Prognathodon
プログナトドン

Ammonite
アンモナイト

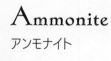

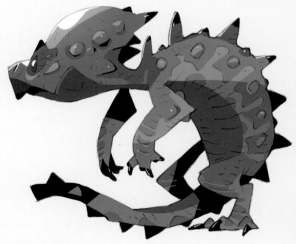

Pachycephalosaurus
パキケファロサウルス

Monsters

Almost 20 years have passed since I began working in the gaming industry, and I've been designing monsters all this time, but I never get bored of it. I like the aspect of it being an uninhibited contest of ideas, like, "What would happen if I turned this material into a monster?" I aim to create simple and lovable designs.

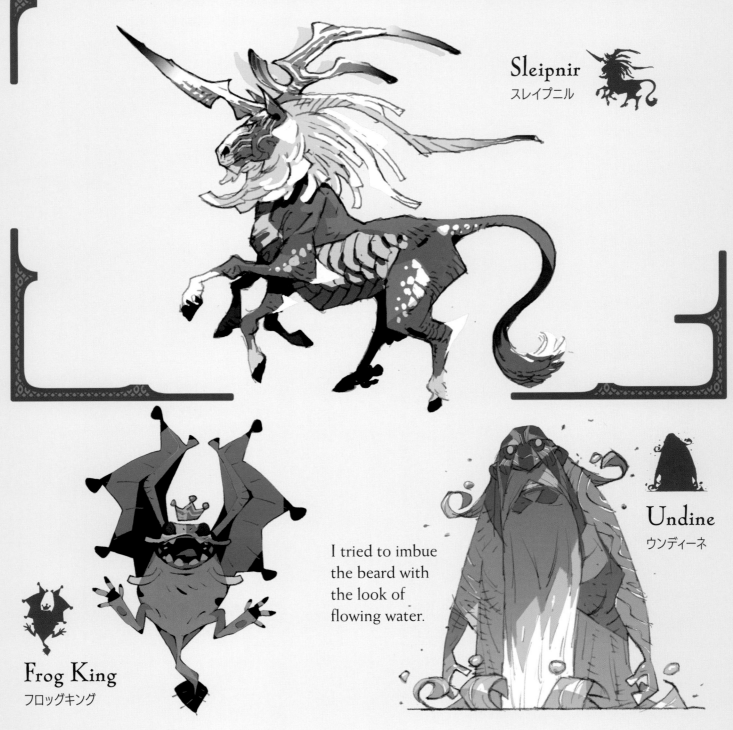

Sleipnir
スレイプニル

I tried to imbue the beard with the look of flowing water.

Undine
ウンディーネ

Frog King
フロッグキング

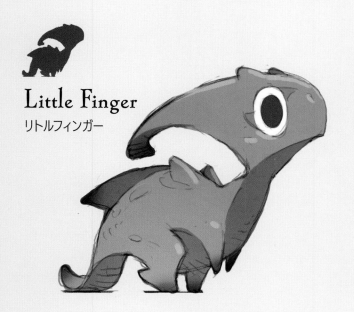

Little Finger
リトルフィンガー

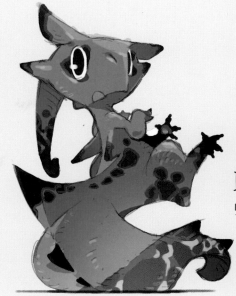

Ring Finger
リングフィンガー

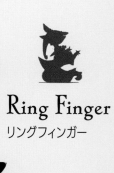

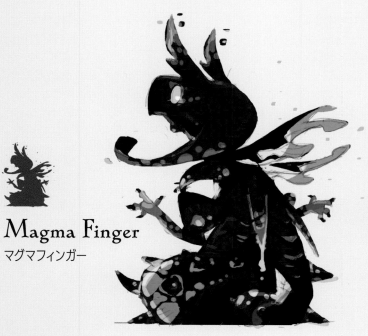

Magma Finger
マグマフィンガー

Skull Eater
スカルイーター

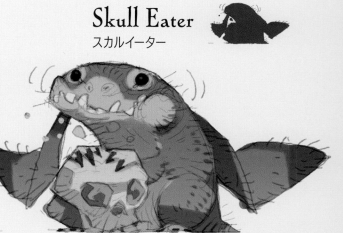

Rooster Toad
オンドリガエル

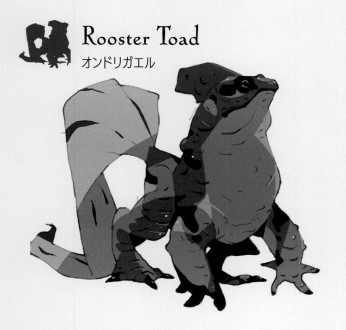

Kelpie
ケルピー

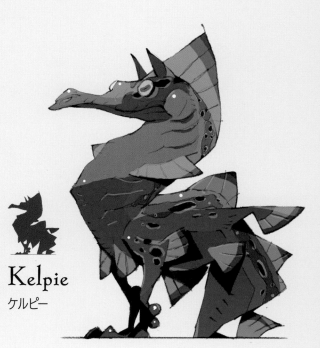

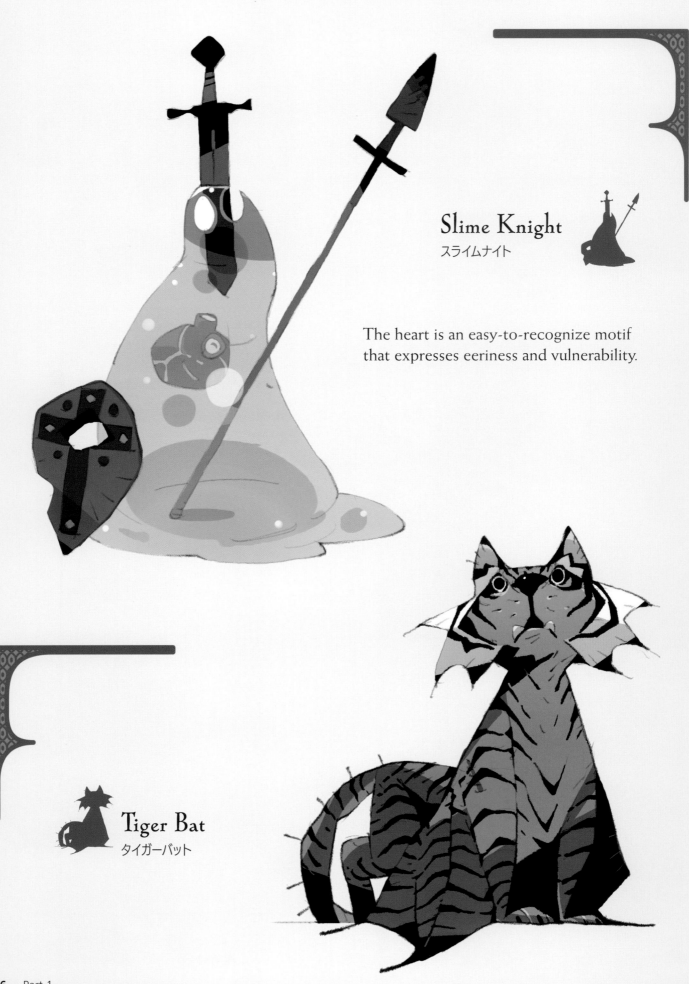

Slime Knight
スライムナイト

The heart is an easy-to-recognize motif that expresses eeriness and vulnerability.

Tiger Bat
タイガーバット

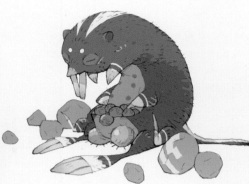

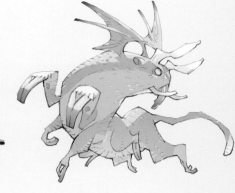

Potato Mole No. 1
ジャガイモール 1

Potato Mole No. 2
ジャガイモール 2

Potato Mole No. 3
ジャガイモール 3（キタアカリ種）

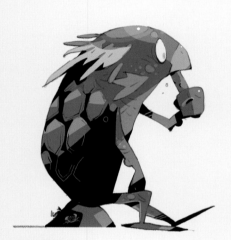

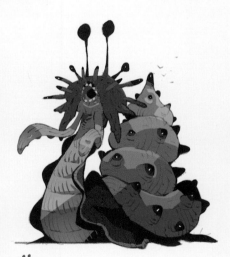

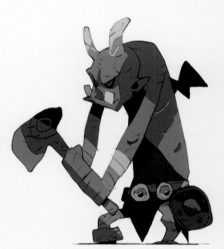

Kappa
カッパ

Lou Carcolh
ルー・カーコル

Hob Goblin
ホブゴブリン

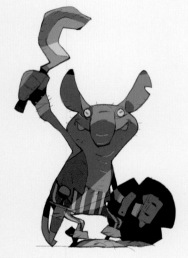

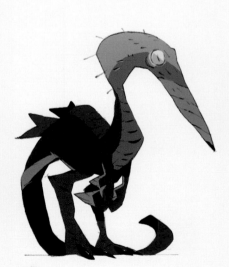

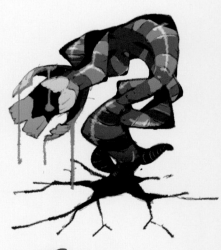

Elephant-nose Goblin
ハナナガゴブリン

Unicorn Turkey
イッカクターキー

Wormroot
ワームルート

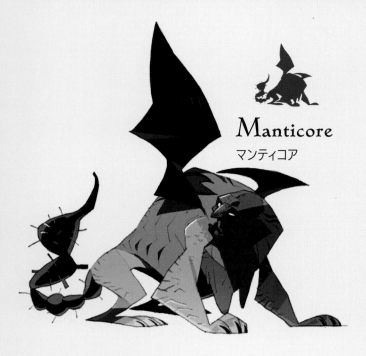

Manticore
マンティコア

Spider Tortoise
タカアシガメ

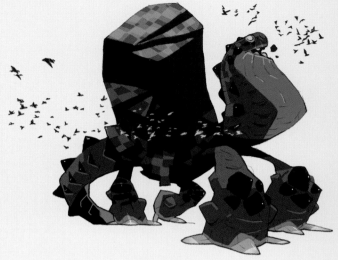

Hyena Bear
ハイエナベア

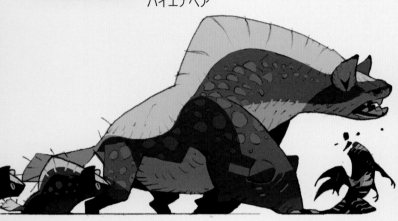

Bird Sauros
バードザウルス

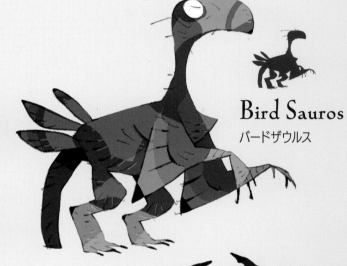

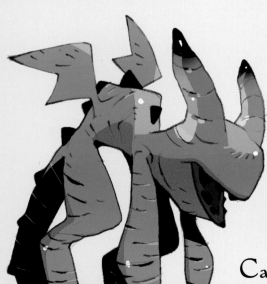

Cave Predator
ケイブプレデター

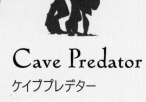

Crab Serpent
クラブサーペント

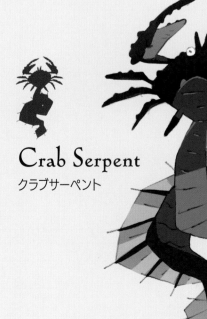

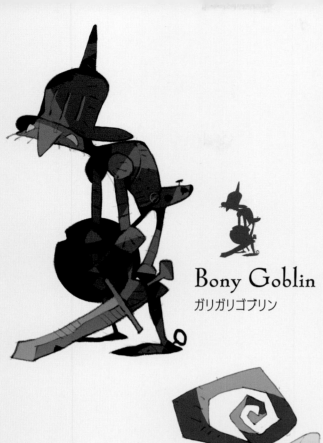

Bony Goblin
ガリガリゴブリン

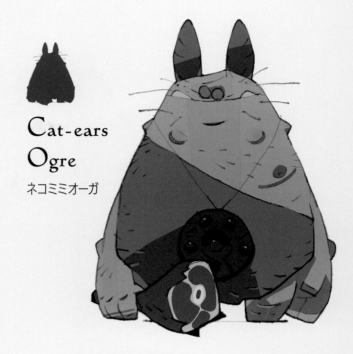

Cat-ears Ogre
ネコミミオーガ

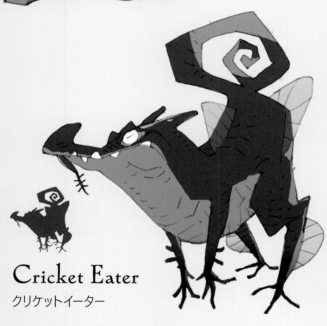

Cricket Eater
クリケットイーター

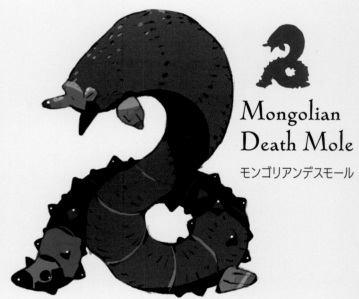

Mongolian Death Mole
モンゴリアンデスモール

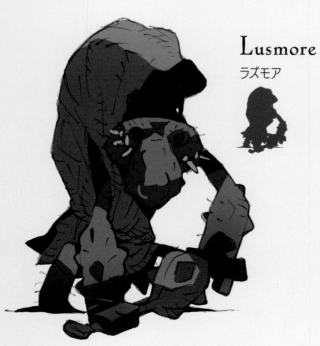

Lusmore
ラズモア

Catoblepas
カトプレパス

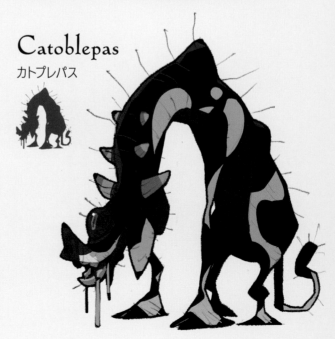

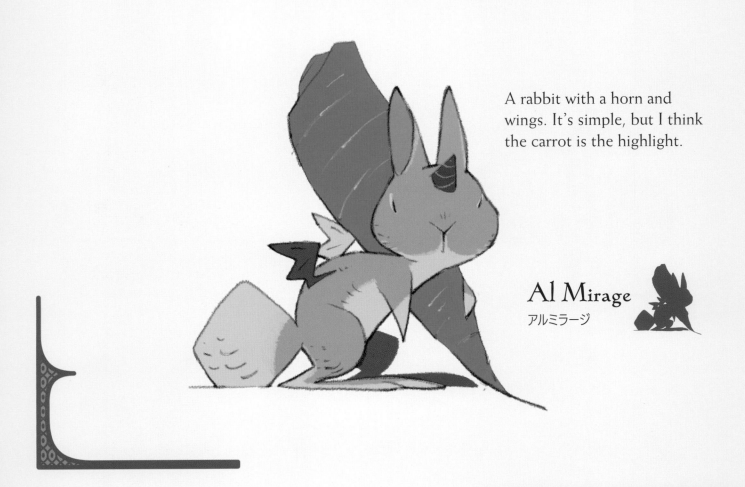

A rabbit with a horn and wings. It's simple, but I think the carrot is the highlight.

Al Mirage
アルミラージ

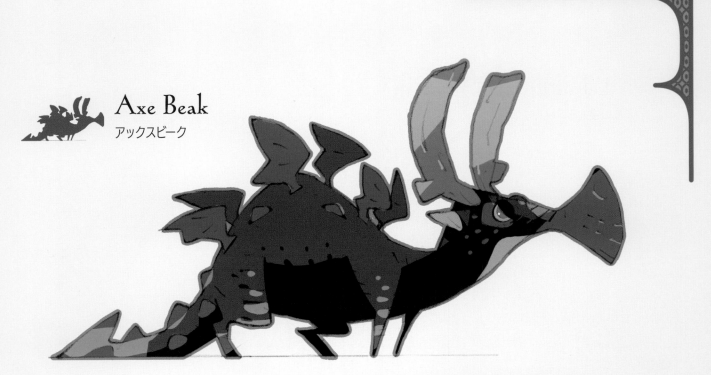

Axe Beak
アックスビーク

A monster with an axe-like beak. The corners are symmetrically elongated. The body is accented with a pattern.

Grizzly
グリズリー

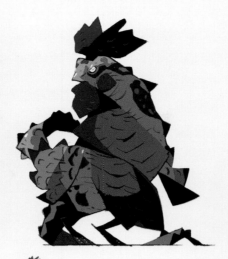

Cockatrice
コカトリス

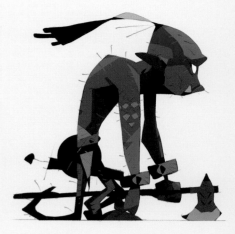

Red Goblin
レッドゴブリン

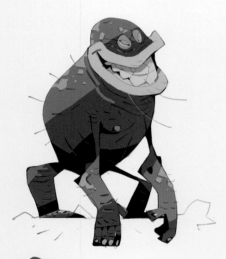

 ### Lakebed Dweller
湖底の棲人

Two-headed Giant
双頭の巨人

Jaguar Serpent
ジャガーサーペント

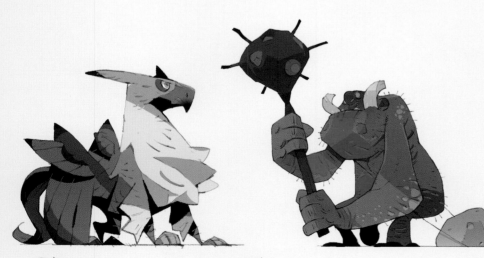

 ### Hippogriff
ヒッポグリフ

 ### Mace Troll
メイストロル

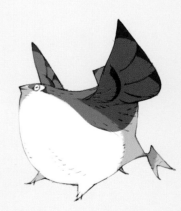

Petit Griffon
プチグリフォン

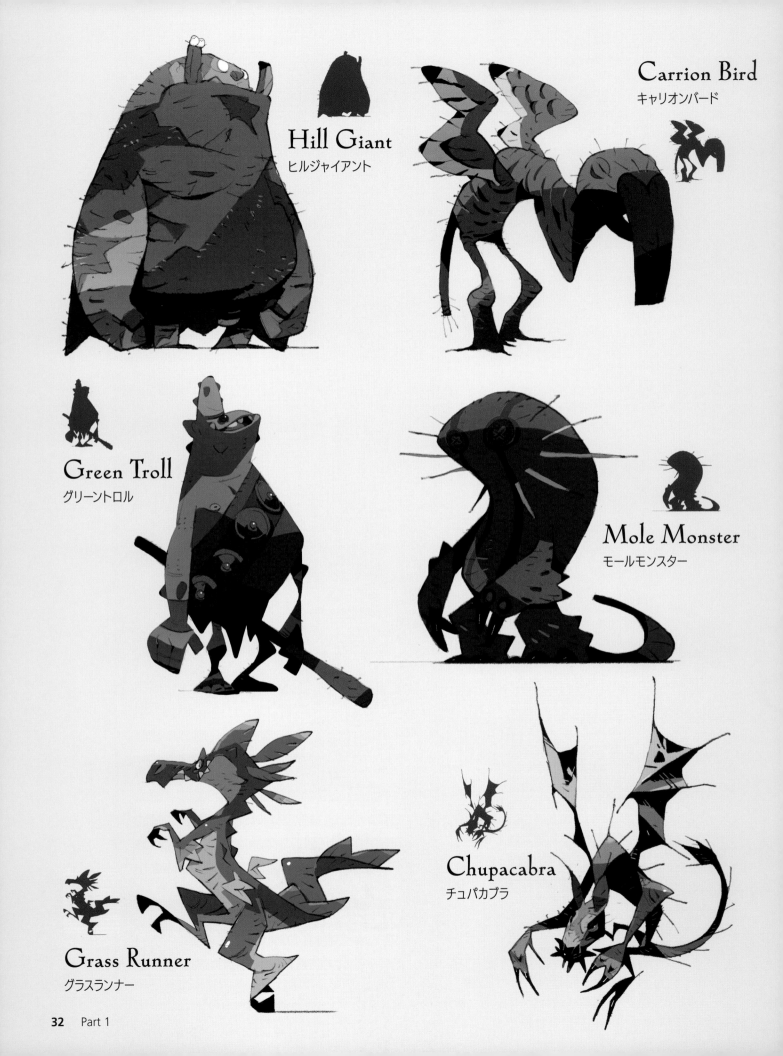

Hill Giant
ヒルジャイアント

Carrion Bird
キャリオンバード

Green Troll
グリーントロル

Mole Monster
モールモンスター

Grass Runner
グラスランナー

Chupacabra
チュパカブラ

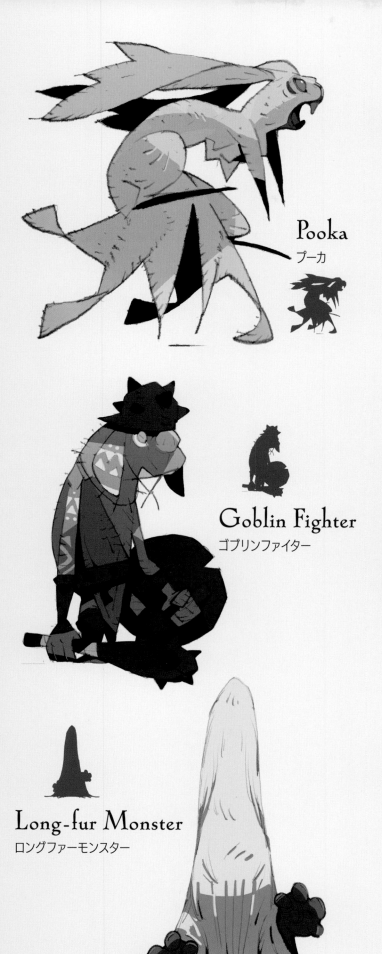

Pooka
プーカ

Blue Scissors
ブルーシザース

Goblin Fighter
ゴブリンファイター

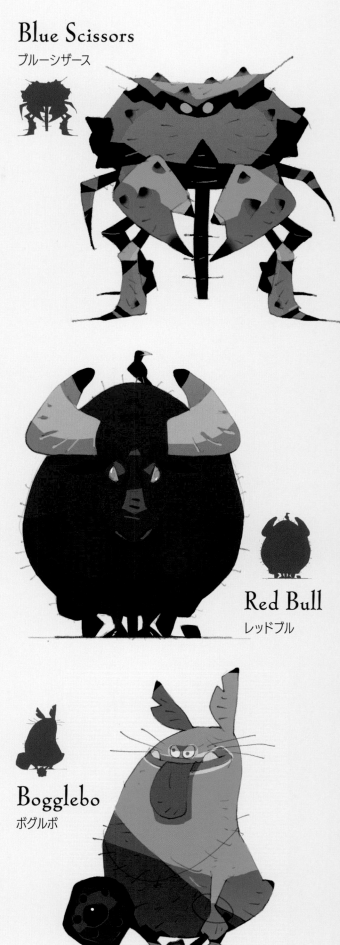

Red Bull
レッドブル

Long-fur Monster
ロングファーモンスター

Bogglebo
ボグルボ

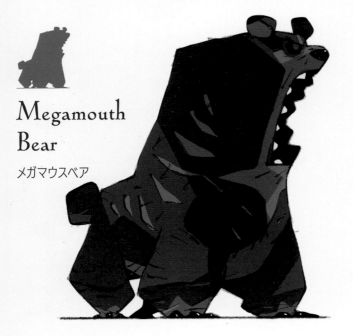

Megamouth
Bear

メガマウスベア

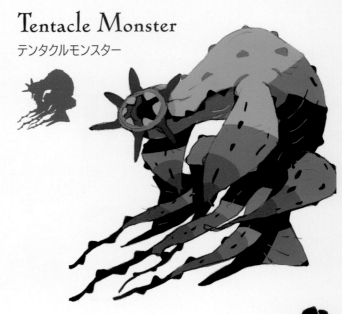

Tentacle Monster

テンタクルモンスター

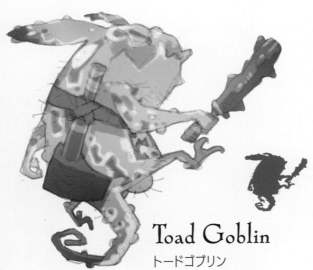

Toad Goblin

トードゴブリン

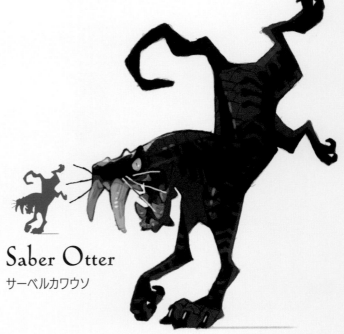

Saber Otter

サーベルカワウソ

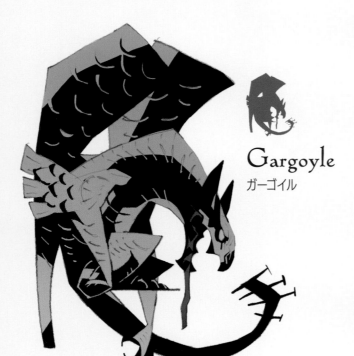

Gargoyle

ガーゴイル

Troll

トロル

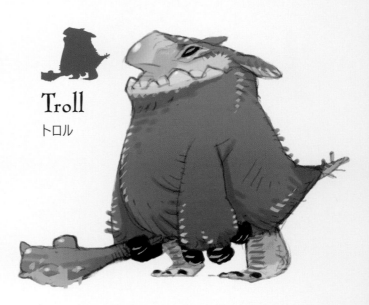

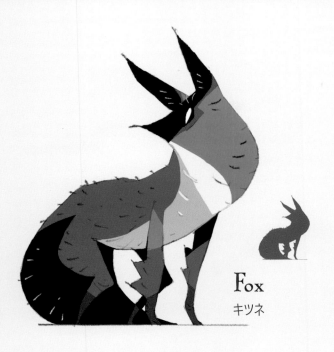

Fox
キツネ

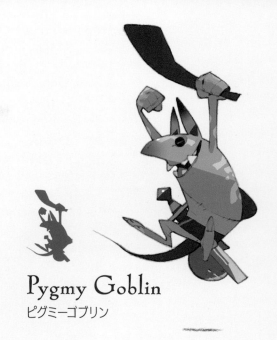

Pygmy Goblin
ピグミーゴブリン

Dark Goblin
ダークゴブリン

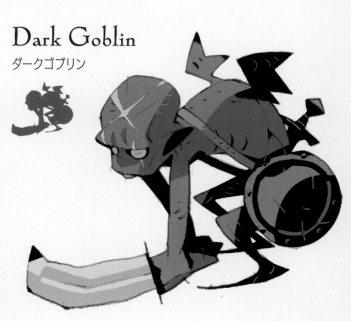

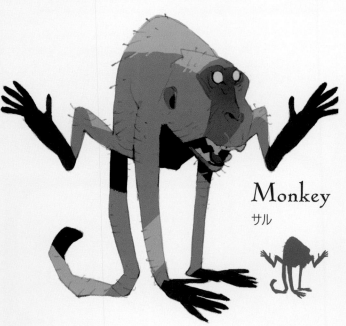

Monkey
サル

Axe-head Lizard
アックスヘッドリザード

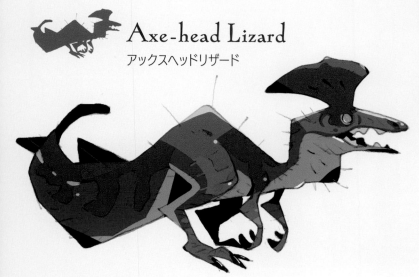

Cobra Lizard
コブラリザード

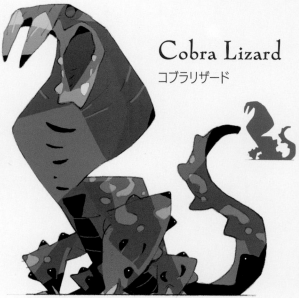

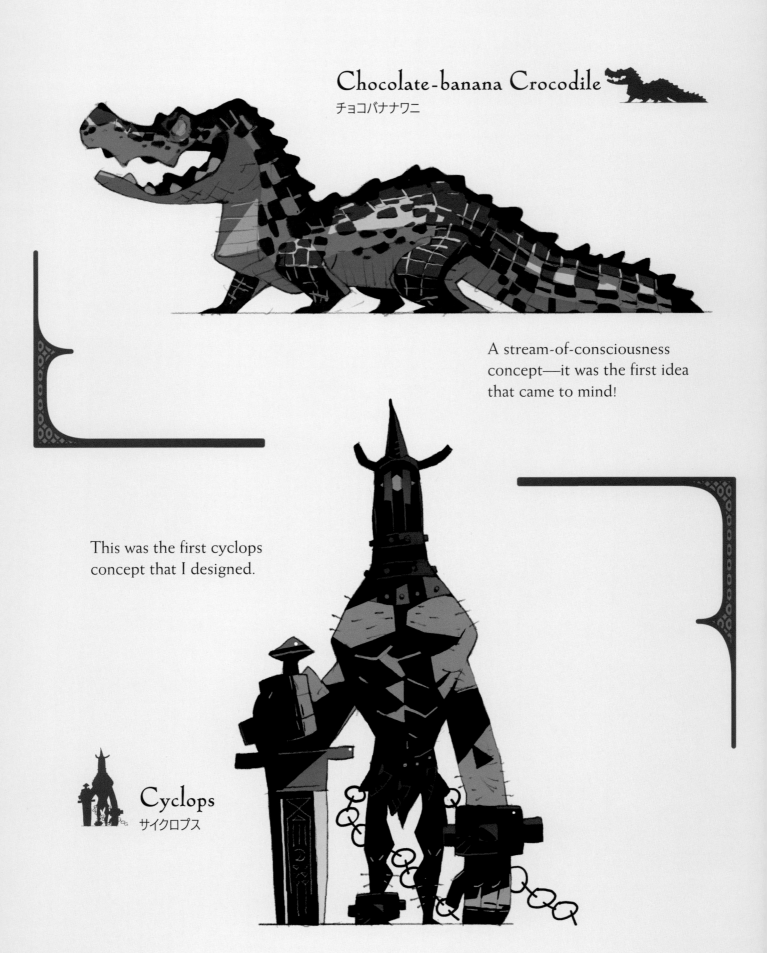

Chocolate-banana Crocodile
チョコバナナワニ

A stream-of-consciousness concept—it was the first idea that came to mind!

This was the first cyclops concept that I designed.

Cyclops
サイクロプス

Mandrill Beast
マンドリルビースト

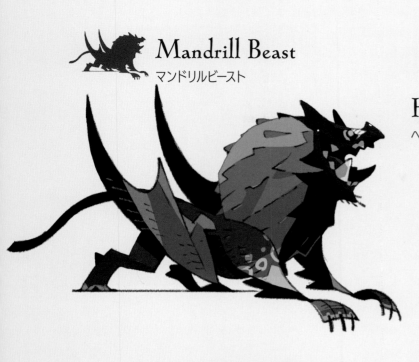

Hercules Crab
ヘラクレスオオツノガニ

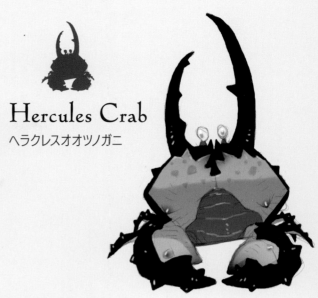

Bunny Beast
バニービースト

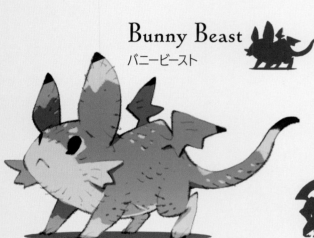

Sphinx
スフィンクス

Half Goblin
ハーフゴブリン

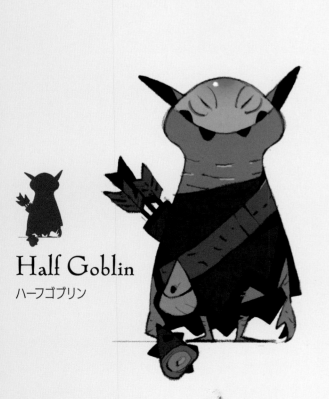

Monopedal Giant
隻足の巨人

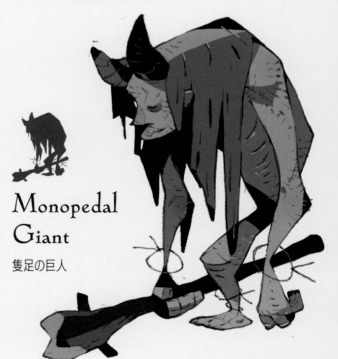

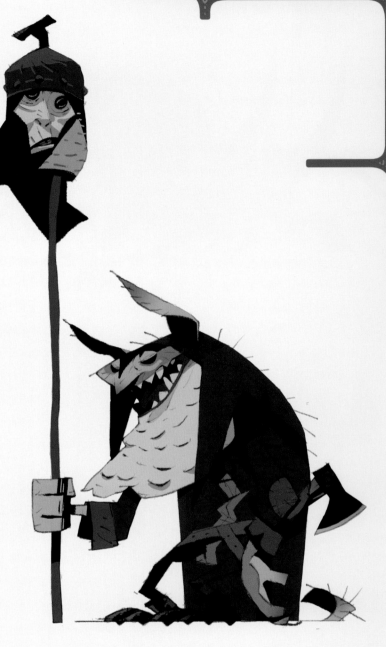

Red Cap
レッドキャップ

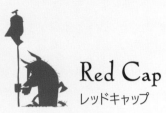

There are many folklore imps to be drawn, so I thought I'd try my hand at it.

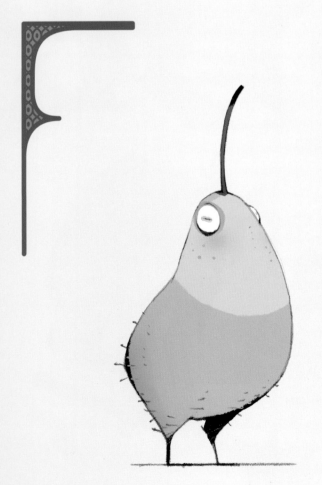

Pear Bird
ヨウナシバード

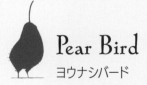

A pear-shaped bird. The kiwi-like elongated beak resembles a fruit stem.

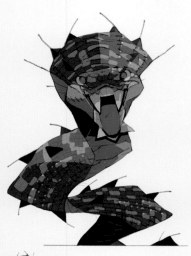

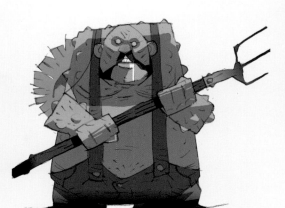

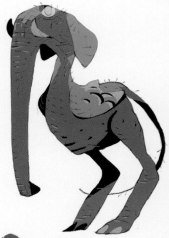

Serpent
サーペント

Farm Troll
農場トロル

Elerich
エレリッチ

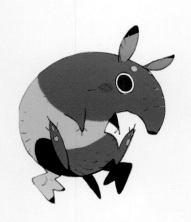

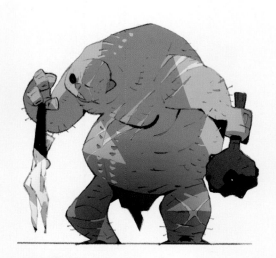

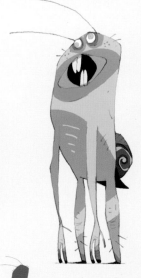

Tapir Fairy
テイパーフェアリー

Fat Troll
太っちょトロル

Snail Alien
スネイルエイリアン

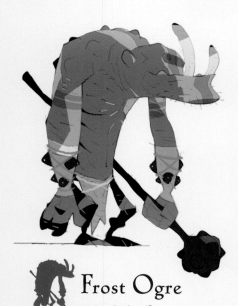

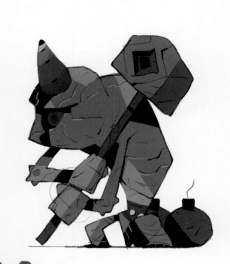

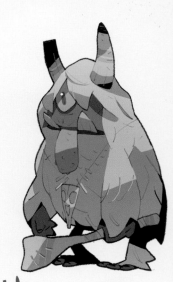

Frost Ogre
フロストオーガ

Apprentice Cyclops
見習いサイクロプス

Snow Ogre
スノーオーガ

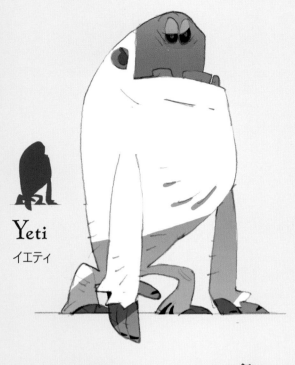

Yeti
イエティ

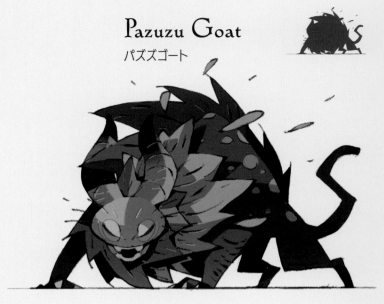

Pazuzu Goat
パズズゴート

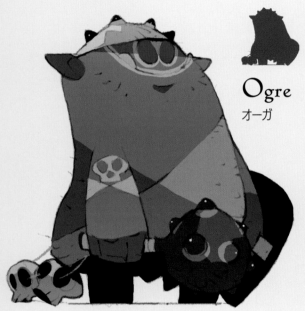

Ogre
オーガ

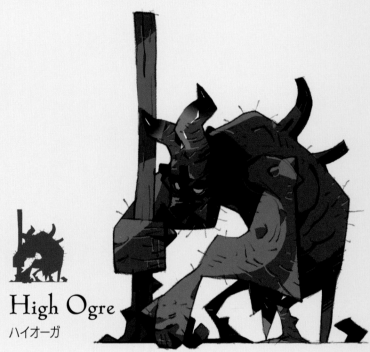

High Ogre
ハイオーガ

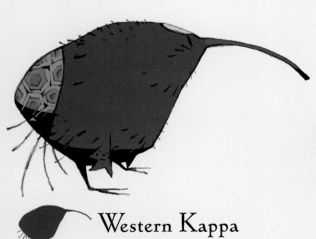

Western Kappa
セイヨウカッパ

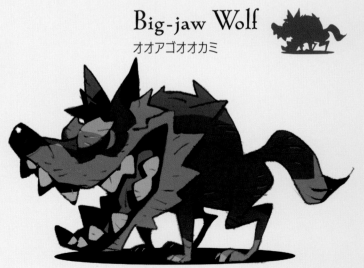

Big-jaw Wolf
オオアゴオオカミ

Monocular Orc
1つ目オーク

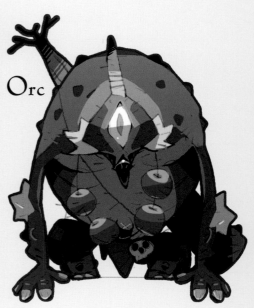

Ashura Ape
アシュラエイプ

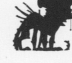

Hellhound
ヘルハウンド

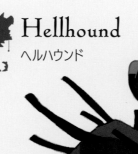

Mud Man
マッドマン

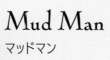

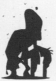

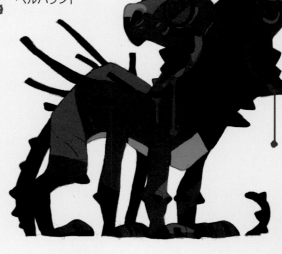

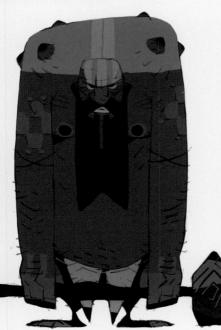

Giant
ジャイアント

Baby Salamander
ベビーサラマンダー

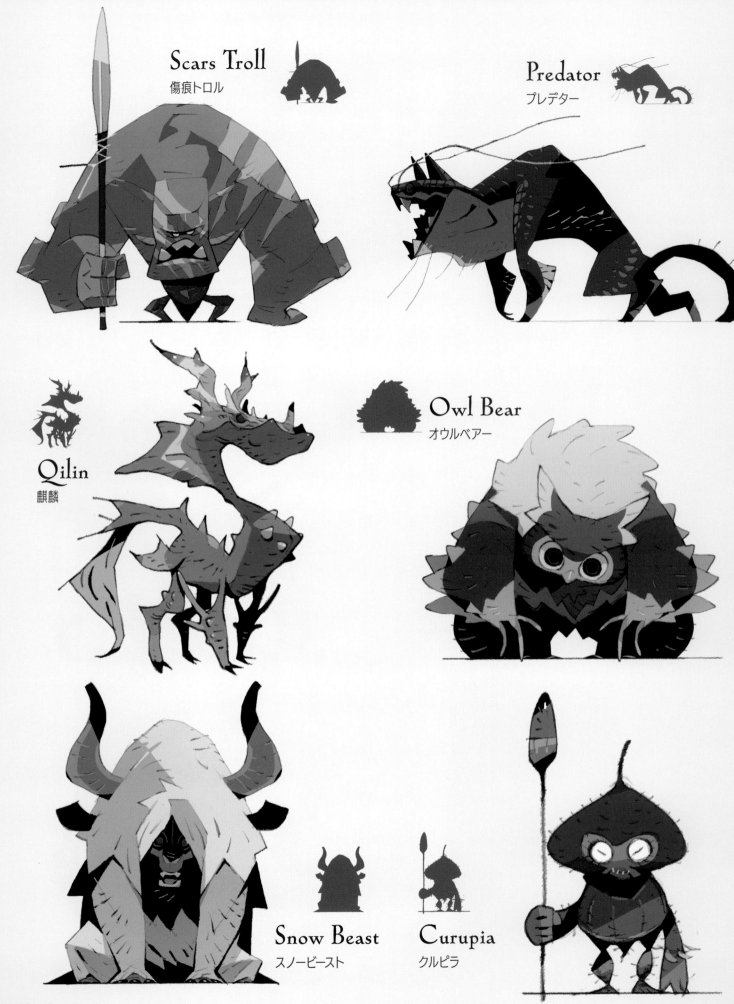

Scars Troll
傷痕トロル

Predator
プレデター

Qilin
麒麟

Owl Bear
オウルベアー

Snow Beast
スノービースト

Curupia
クルピラ

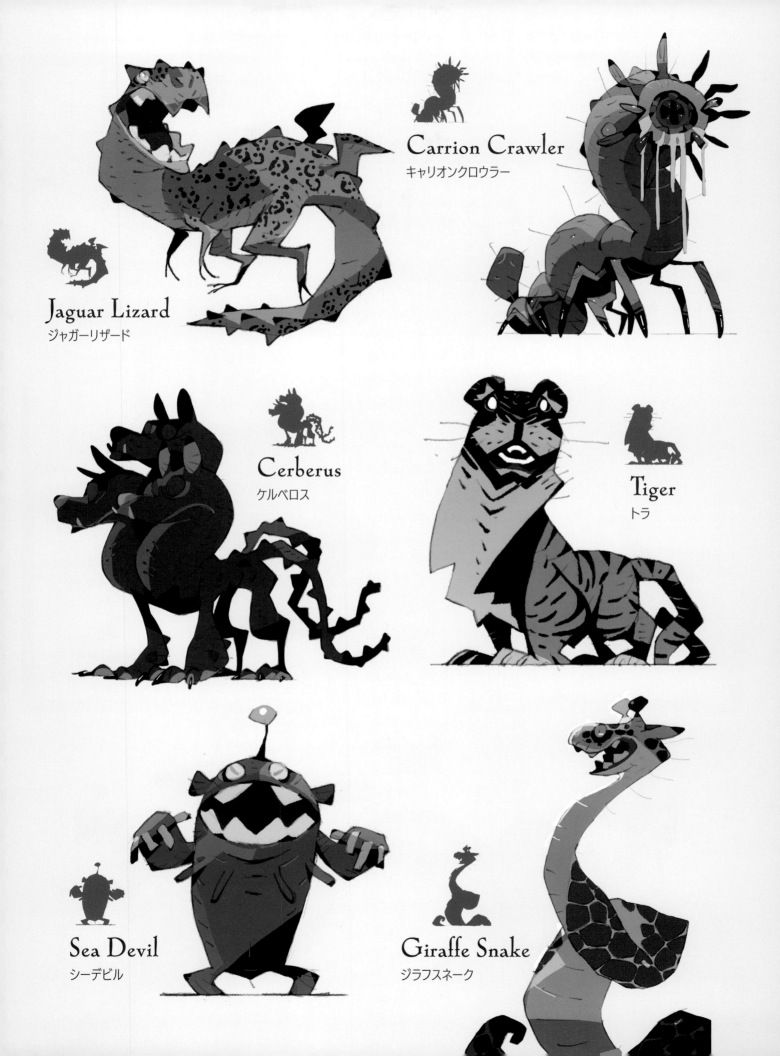

Jaguar Lizard
ジャガーリザード

Carrion Crawler
キャリオンクロウラー

Cerberus
ケルベロス

Tiger
トラ

Sea Devil
シーデビル

Giraffe Snake
ジラフスネーク

Anthropomorphic Reptiles

The following sections focus on the anthropomorphism of creatures such as reptiles, amphibians, fish, birds and insects. You can design freely and boldly in this category, trying out concepts in a contest of ideas.

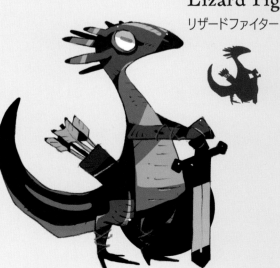

Lizard Man
リザードマン

Saurus Soldier
サウルスソルジャー

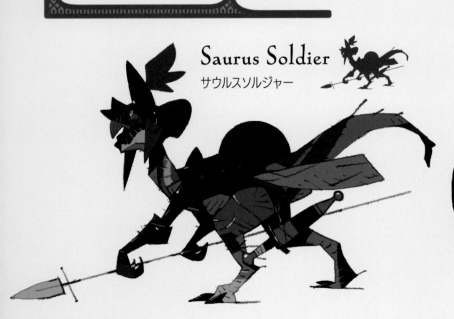

Lizard Fighter
リザードファイター

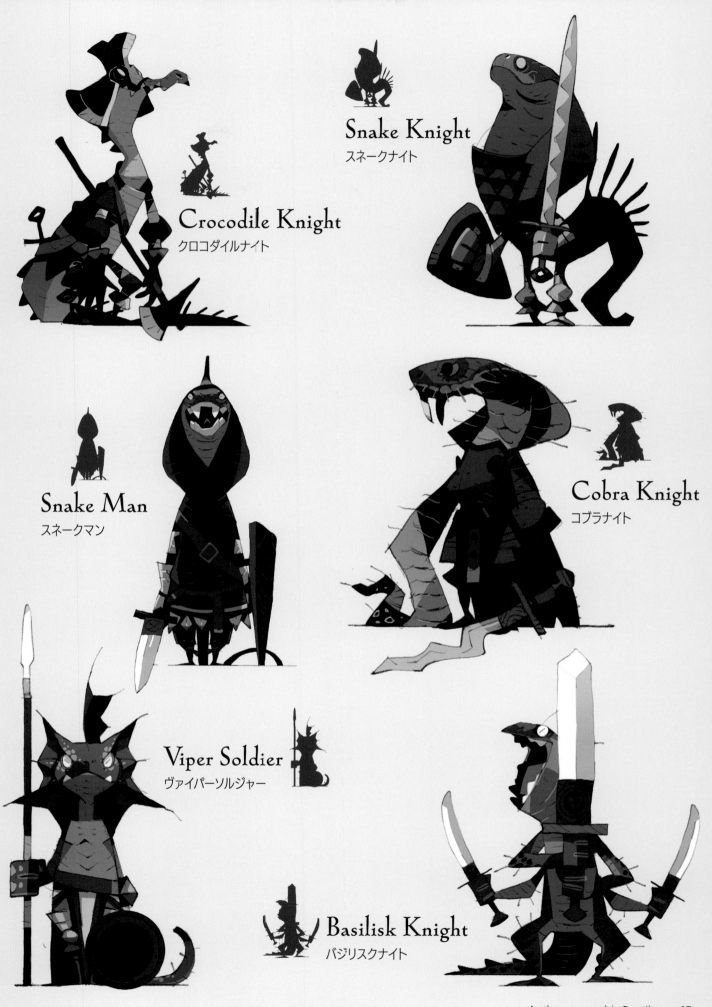

Crocodile Knight
クロコダイルナイト

Snake Knight
スネークナイト

Snake Man
スネークマン

Cobra Knight
コブラナイト

Viper Soldier
ヴァイパーソルジャー

Basilisk Knight
バジリスクナイト

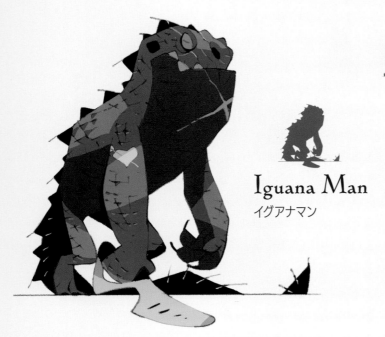

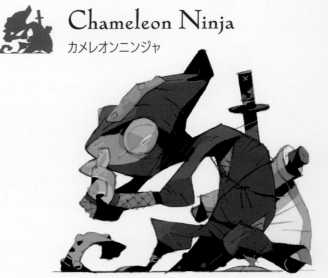

Chameleon Ninja
カメレオンニンジャ

Iguana Man
イグアナマン

Frilled Lizard Man
エリマキトカゲマン

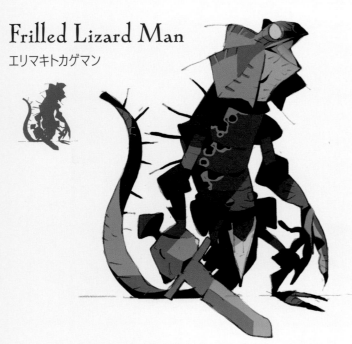

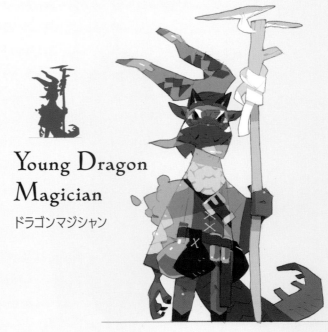

Young Dragon Magician
ドラゴンマジシャン

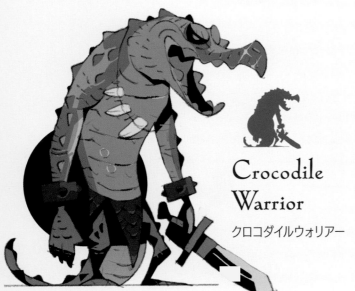

Crocodile Warrior
クロコダイルウォリアー

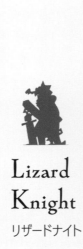

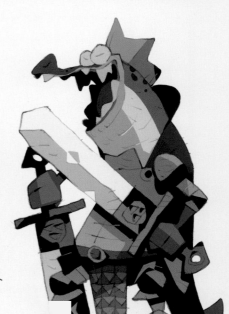

Lizard Knight
リザードナイト

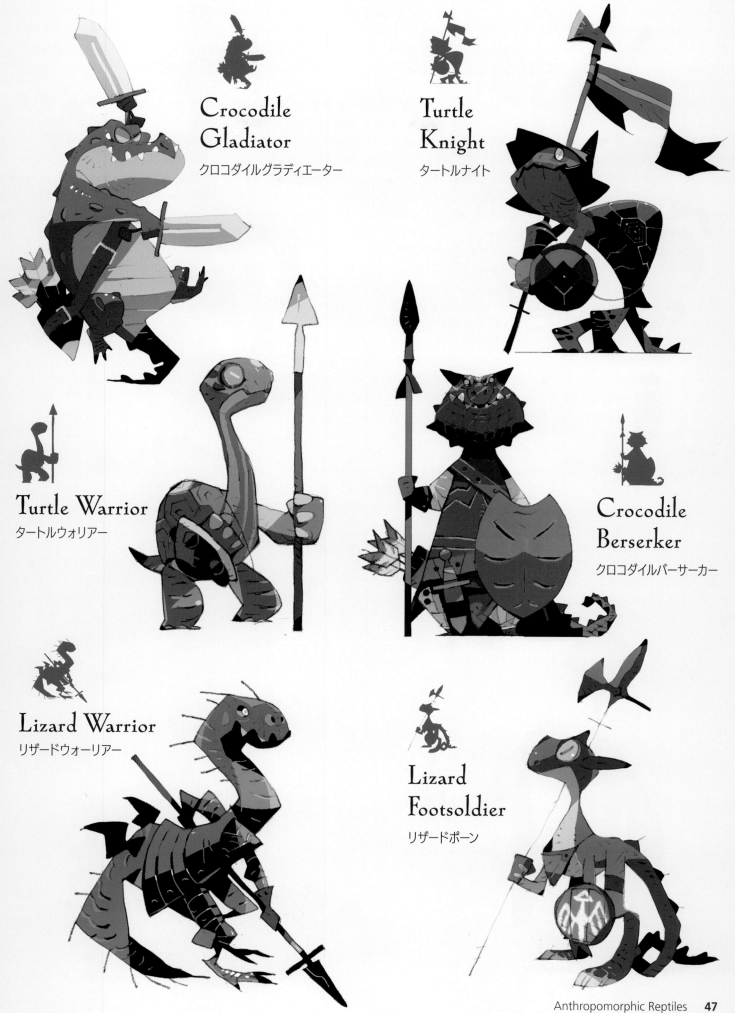

Crocodile Gladiator
クロコダイルグラディエーター

Turtle Knight
タートルナイト

Turtle Warrior
タートルウォリアー

Crocodile Berserker
クロコダイルバーサーカー

Lizard Warrior
リザードウォーリアー

Lizard Footsoldier
リザードポーン

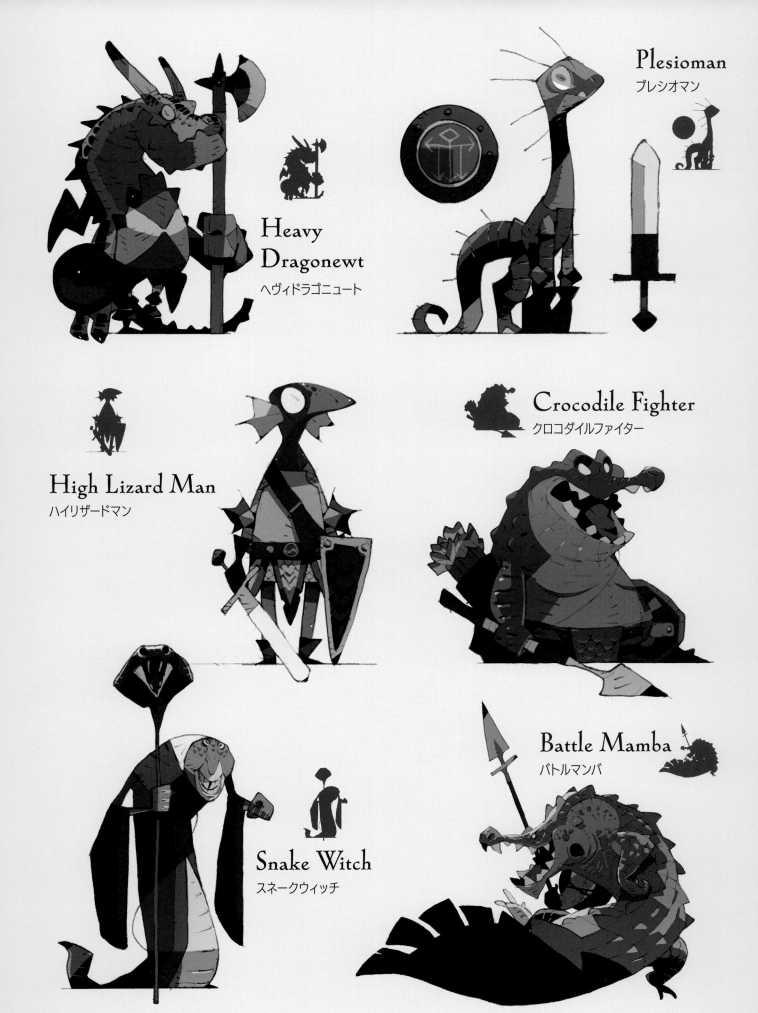

Heavy Dragonewt
ヘヴィドラゴニュート

Plesioman
プレシオマン

High Lizard Man
ハイリザードマン

Crocodile Fighter
クロコダイルファイター

Snake Witch
スネークウィッチ

Battle Mamba
バトルマンバ

Anthropomorphic Sea Creatures

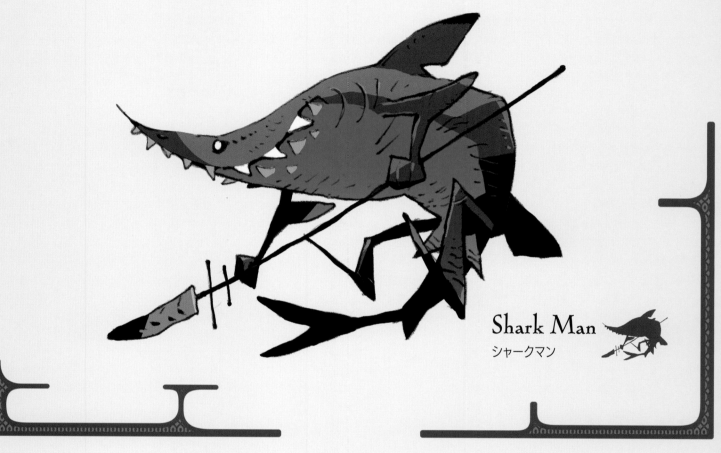

Shark Man
シャークマン

Because octopuses are intelligent, they exhibit a lot of character. To differentiate them, emphasize the accouterments.

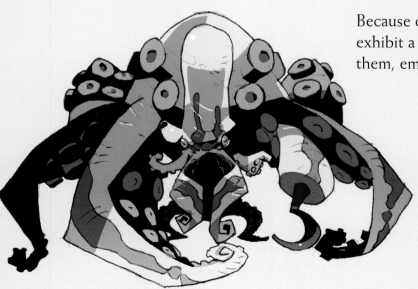

Octopus Man
オクトパスマン

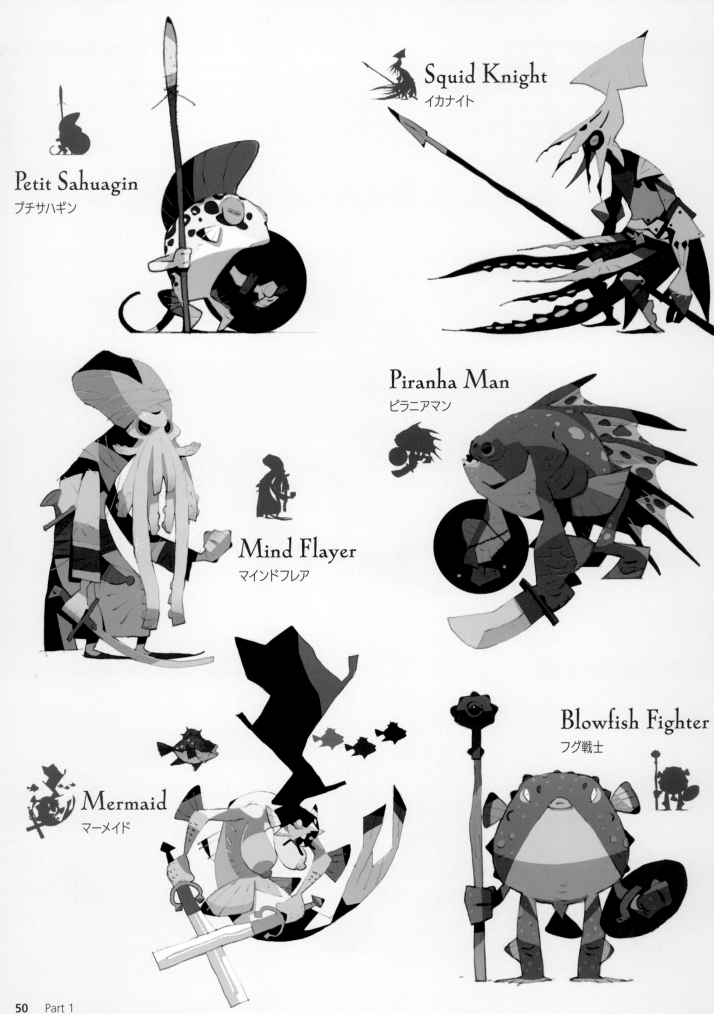

Petit Sahuagin
プチサハギン

Squid Knight
イカナイト

Mind Flayer
マインドフレア

Piranha Man
ピラニアマン

Mermaid
マーメイド

Blowfish Fighter
フグ戦士

Goblin Shark Man
ゴブリンシャークマン

Napoleon Fish Man
ナポレオンフィッシュマン

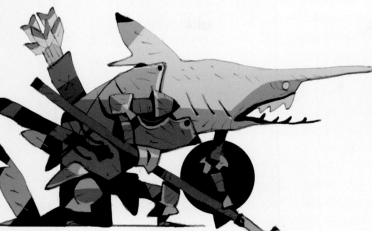

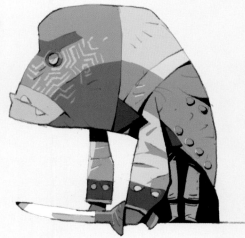

Octopus Alien
タコ型エイリアン

Island Guardian
島の守護者

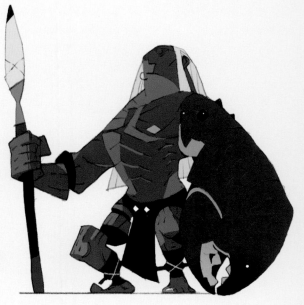

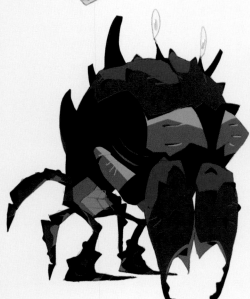

Werecrab
ワークラブ

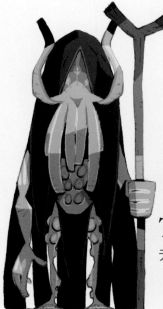

Tentacled Wizard
テンタクルスウィザード

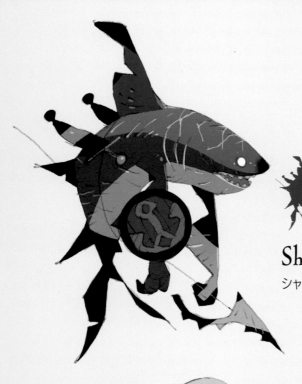

Sahuagin
(Thread-sail Filefish)
カワハギサハギン

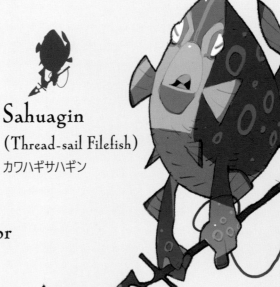

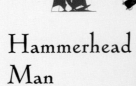

Shark Warrior
シャークウォリアー

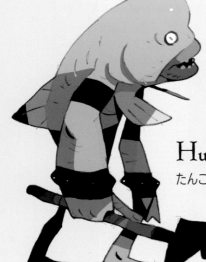

Humphead Sahuagin
たんこぶサハギン

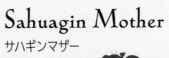

Octopus Warrior
タコ戦士

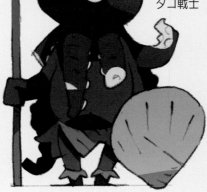

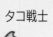

Sahuagin Mother
サハギンマザー

Hammerhead Man
ハンマーヘッドマン

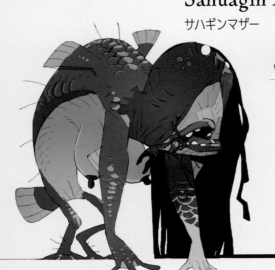

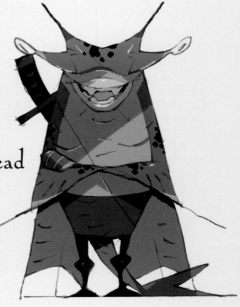

Shark Knight
シャークナイト

Colored Carp Warrior
錦鯉戦士

Squid Mage
スクイッドメイジ

Lobster Man
ロブスターマン

Sahuagin Knight
サハギンナイト

Goby Soldier
ハゼ兵士

Anthropomorphic Insects

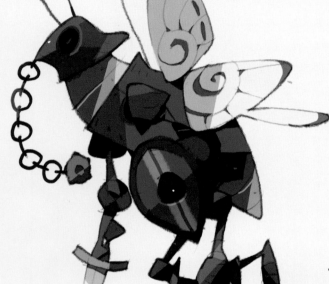

Butterfly Knight
バタフライナイト

This butterfly's proboscis is shaped like a flail, which is appropriate for this armored character.

Sickle Master
カマ使い

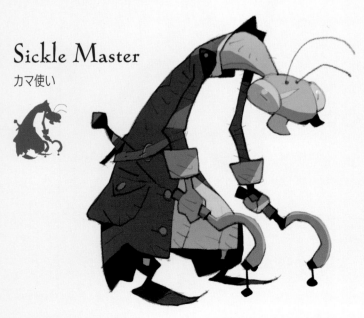

Beetle Knight
ビートルナイト

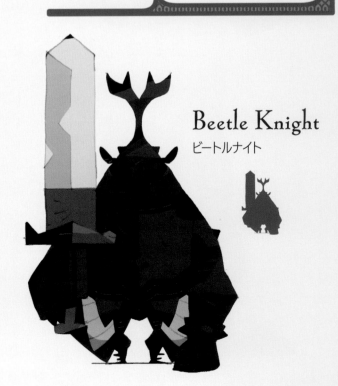

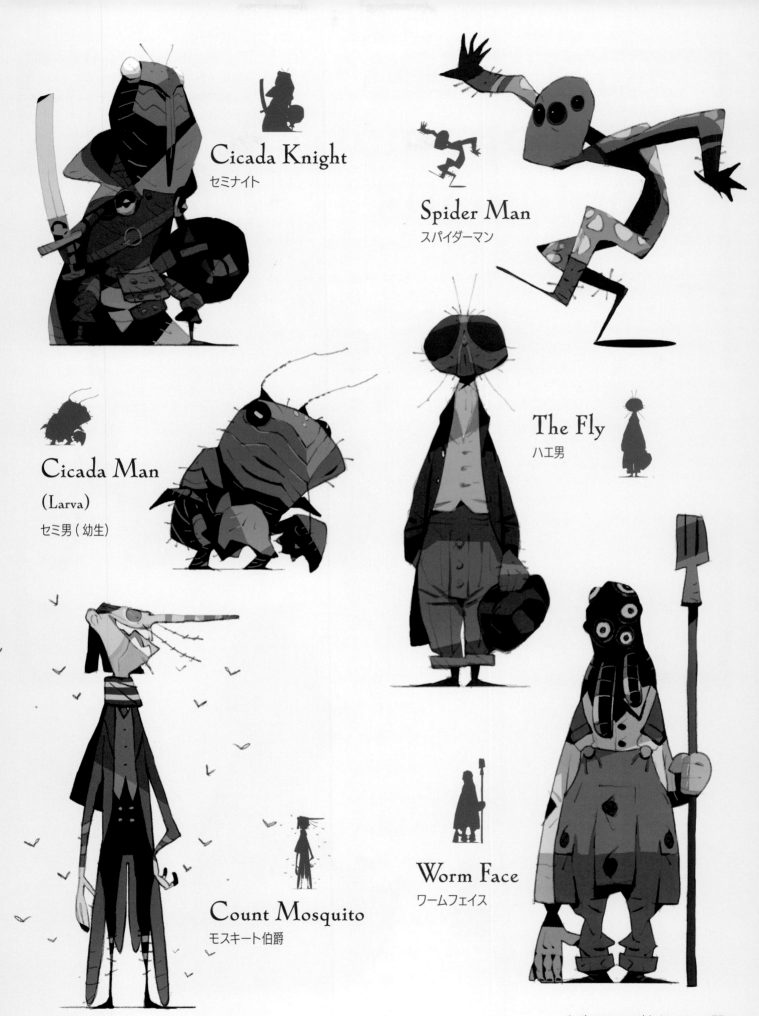

Cicada Knight
セミナイト

Spider Man
スパイダーマン

Cicada Man
(Larva)
セミ男（幼生）

The Fly
ハエ男

Count Mosquito
モスキート伯爵

Worm Face
ワームフェイス

Anthropomorphic Amphibians

Frog Witch
フロッグウィッチ

Rings and talismans give this character the look of someone able to channel forces from the spirit world.

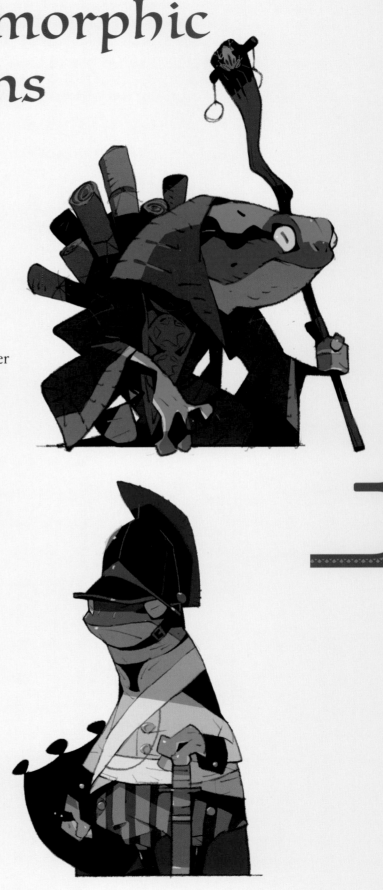

The look of a frog can be blended with just about any character, making them a good motif with strong individuality.

Toad Centurion
トード アーミー

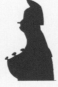

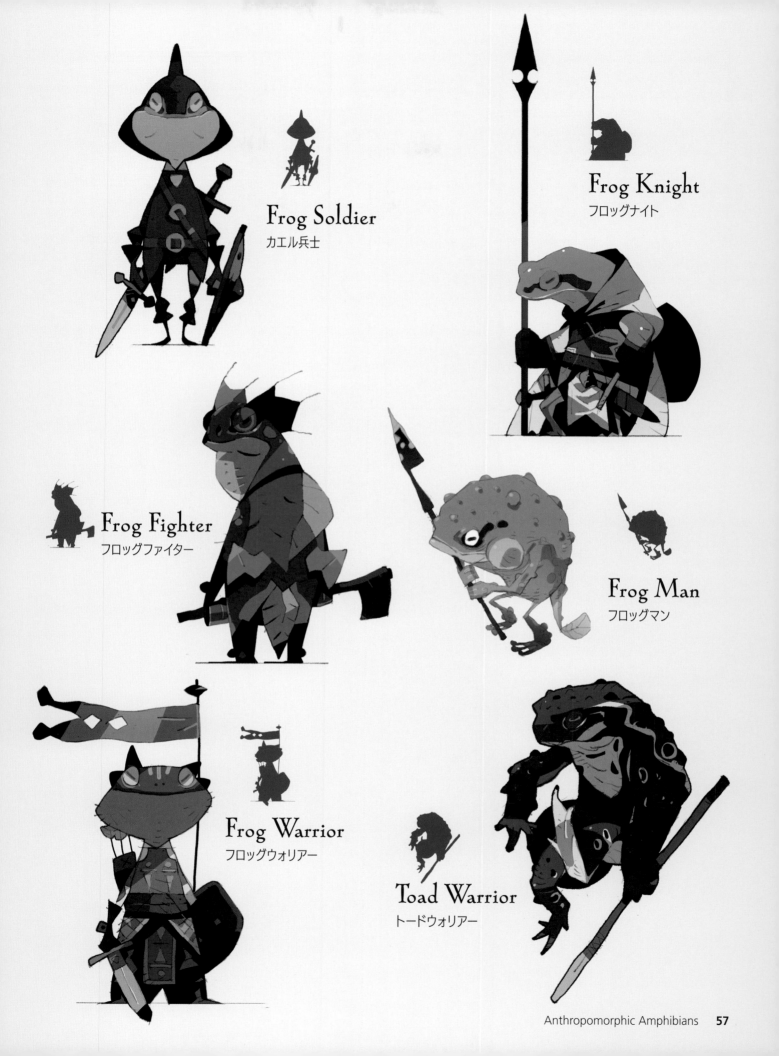

Frog Soldier
カエル兵士

Frog Knight
フロッグナイト

Frog Fighter
フロッグファイター

Frog Man
フロッグマン

Frog Warrior
フロッグウォリアー

Toad Warrior
トードウォリアー

Anthropomorphic Birds

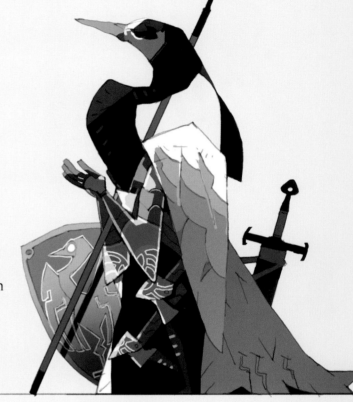

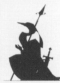 ## Heron Knight
サギの騎士

I combined the graceful image of a heron with the stately bearing of a knight.

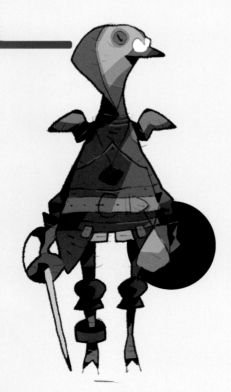

 ## Pigeon Knight
ピジョンナイト

The dove, a symbol of peace. I regret not making it white.

Penguin Knight
ペンギンナイト

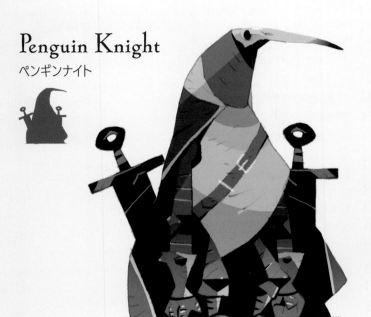

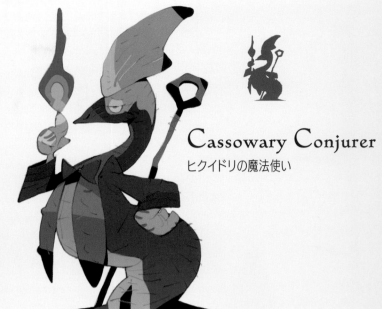

Cassowary Conjurer
ヒクイドリの魔法使い

Duckmole Mage
ダックモールメイジ

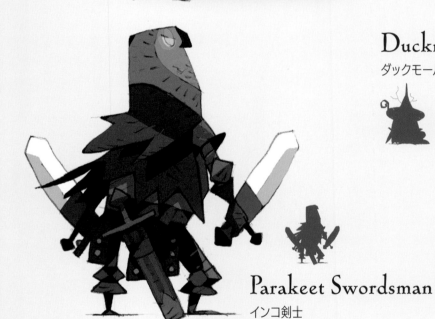

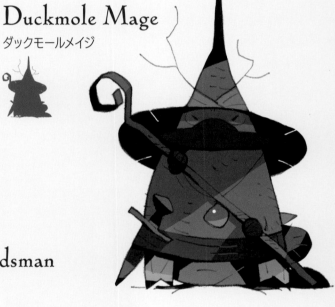

Parakeet Swordsman
インコ剣士

Chicken Burglar
泥棒チキン

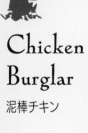

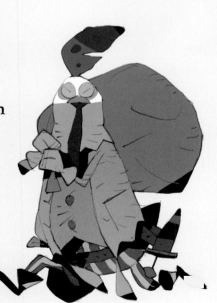

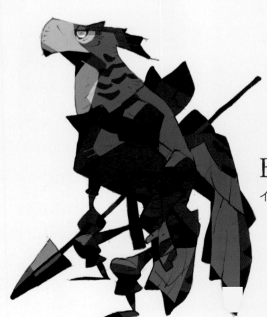

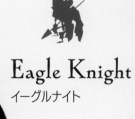

Eagle Knight
イーグルナイト

Beast Warriors

Polar Bear Warrior
ホッキョクグマの戦士

I like the simple silhouette of this polar bear warrior. I hope to one day anthropomorphize all the bears of the world.

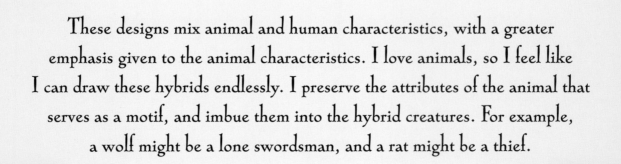

These designs mix animal and human characteristics, with a greater emphasis given to the animal characteristics. I love animals, so I feel like I can draw these hybrids endlessly. I preserve the attributes of the animal that serves as a motif, and imbue them into the hybrid creatures. For example, a wolf might be a lone swordsman, and a rat might be a thief.

Cat Fairy
ネコ妖精

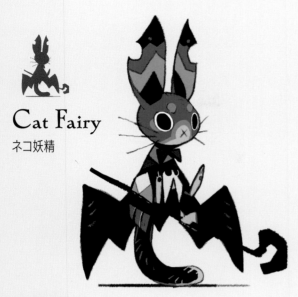

Oak Witch
オークウィッチ

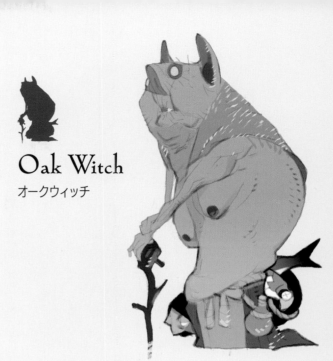

Forest Orc
フォレストオーク

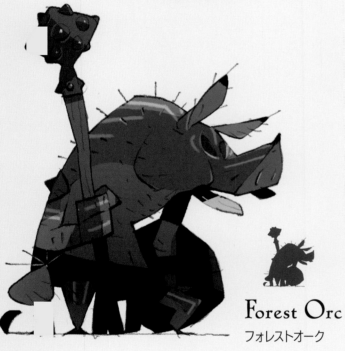

Sea Sentinel
海の衛兵

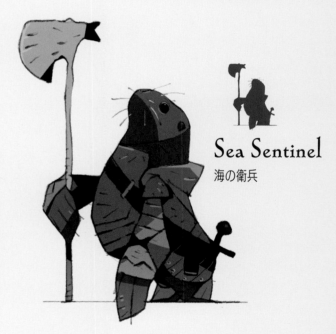

Rodent Bandit
盗賊ウサギ

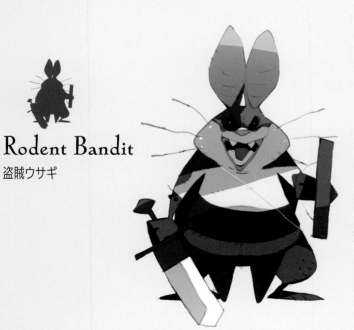

Werebear
ウェアベアー

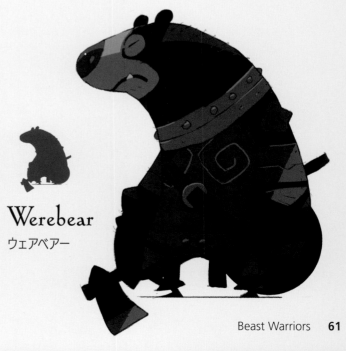

Tiger Man
タイガーマン

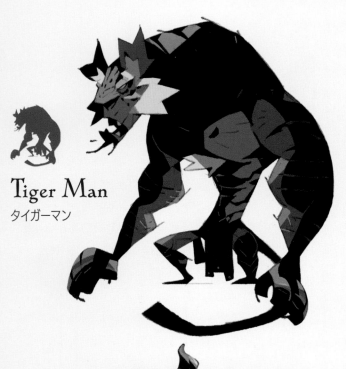

Kobold
コボルド

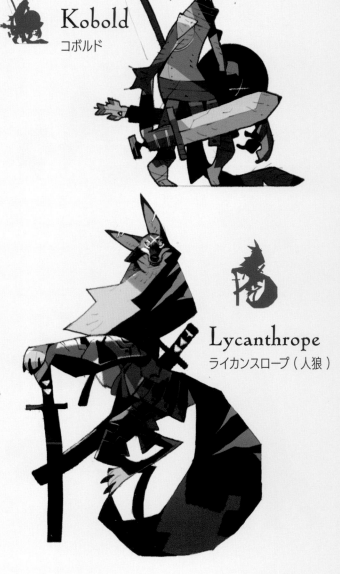

Half Minotaur
ハーフミノタウロス

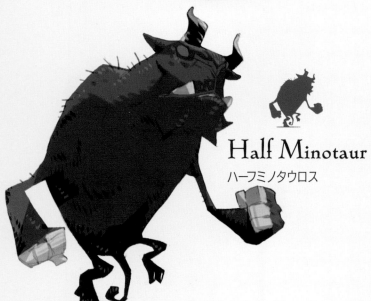

Lycanthrope
ライカンスロープ（人狼）

Orc Leader
オークリーダー

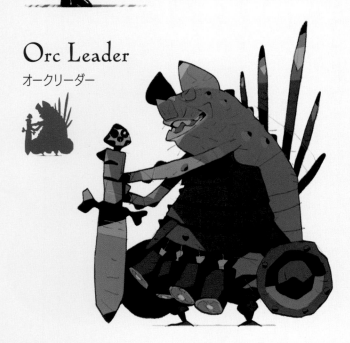

Orc Wizard
オークウィザード

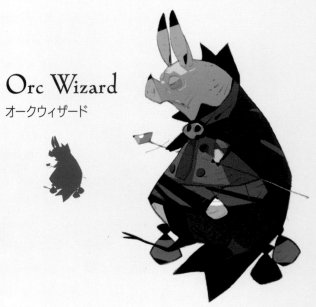

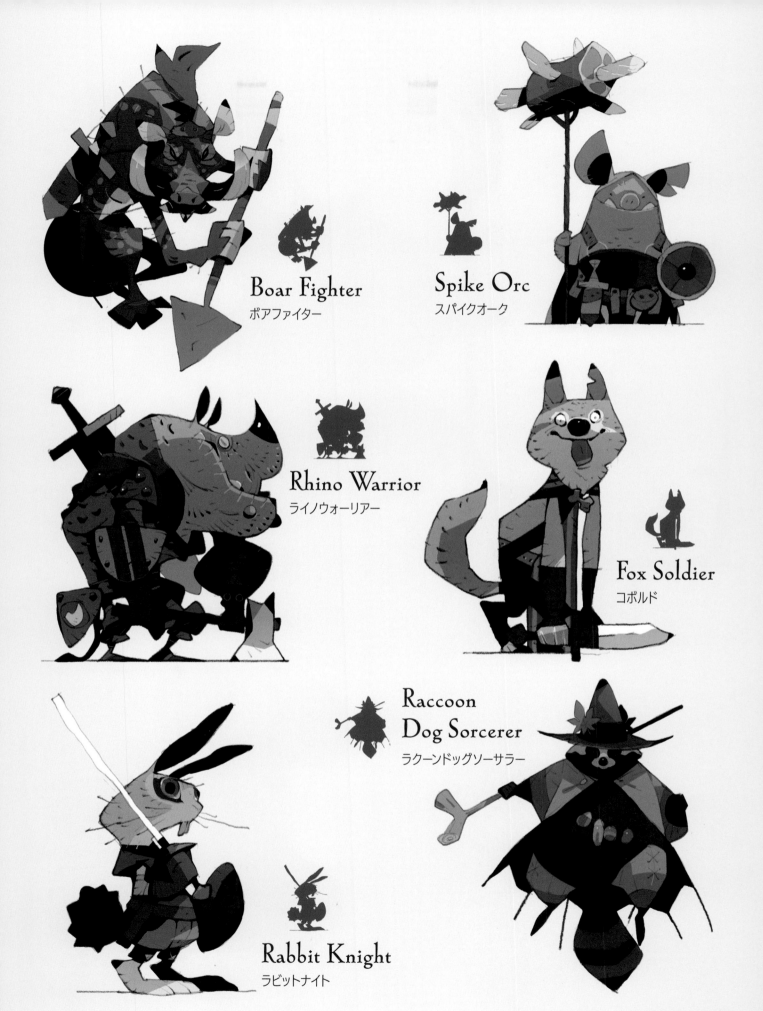

Boar Fighter
ボアファイター

Spike Orc
スパイクオーク

Rhino Warrior
ライノウォーリアー

Fox Soldier
コボルド

Raccoon
Dog Sorcerer
ラクーンドッグソーサラー

Rabbit Knight
ラビットナイト

High Orc

ハイオーク

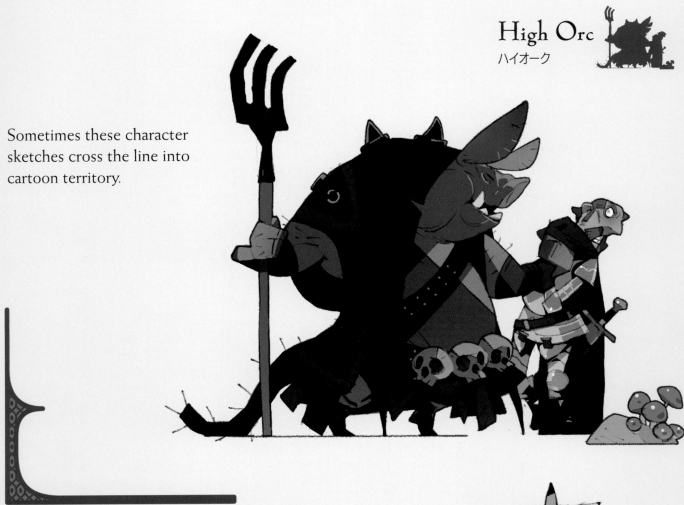

Sometimes these character sketches cross the line into cartoon territory.

 ## Mouse Knight

マウスナイト

The halberd is tipped with a skewered wedge of cheese. The scars on the mouse give it character.

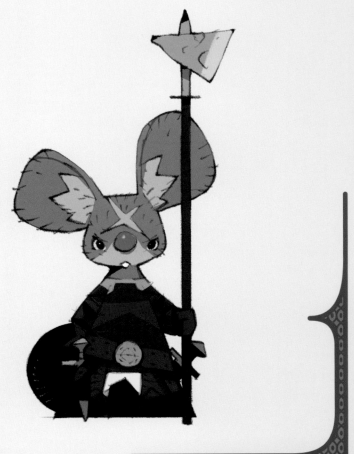

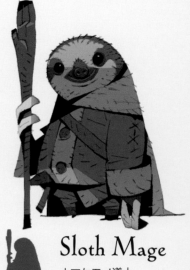

Naked Mole Rat Man
デバネズミ男

Loupgarou
ルー・ガルー

Sloth Mage
ナマケモノ導士

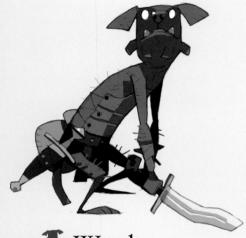

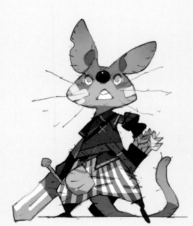

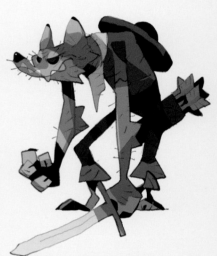

Weredog
ウェアドッグ

Small Knight
小さい騎士

Wolf Soldier
オオカミ兵士

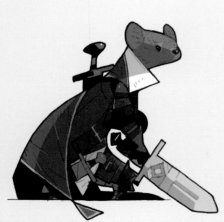

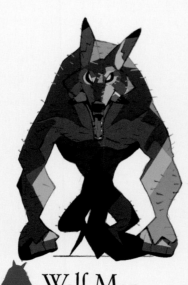

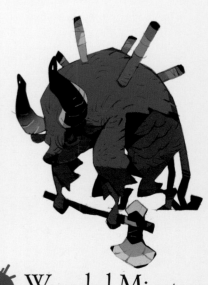

Weasel Knight
イタチナイト

Wolf Man
オオカミ男

Wounded Minotaur
傷付いたミノタウロス

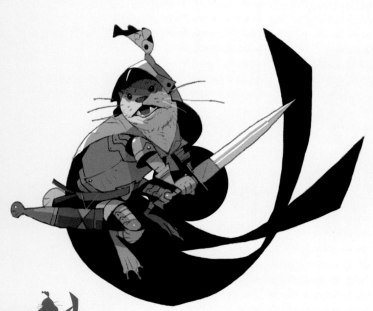

Otter Knight
カワウソナイト

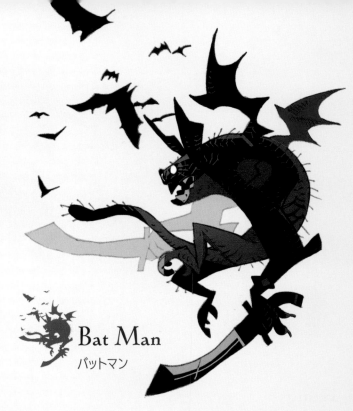

Bat Man
バットマン

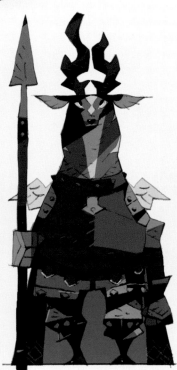

Deer Knight
シカナイト

Petite Minotaur
プチミノタウロス

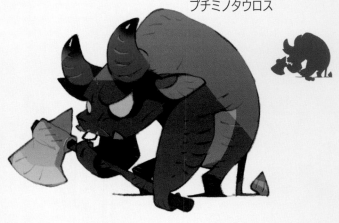

Beaserker
ビーサーカー

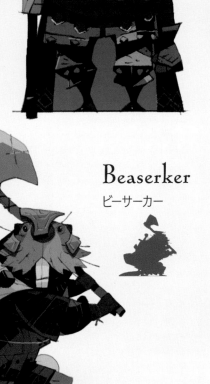

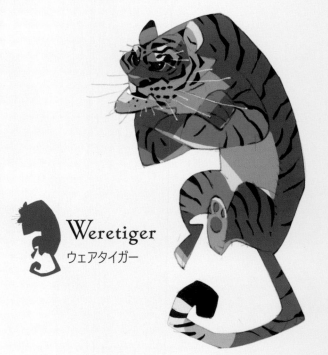

Weretiger
ウェアタイガー

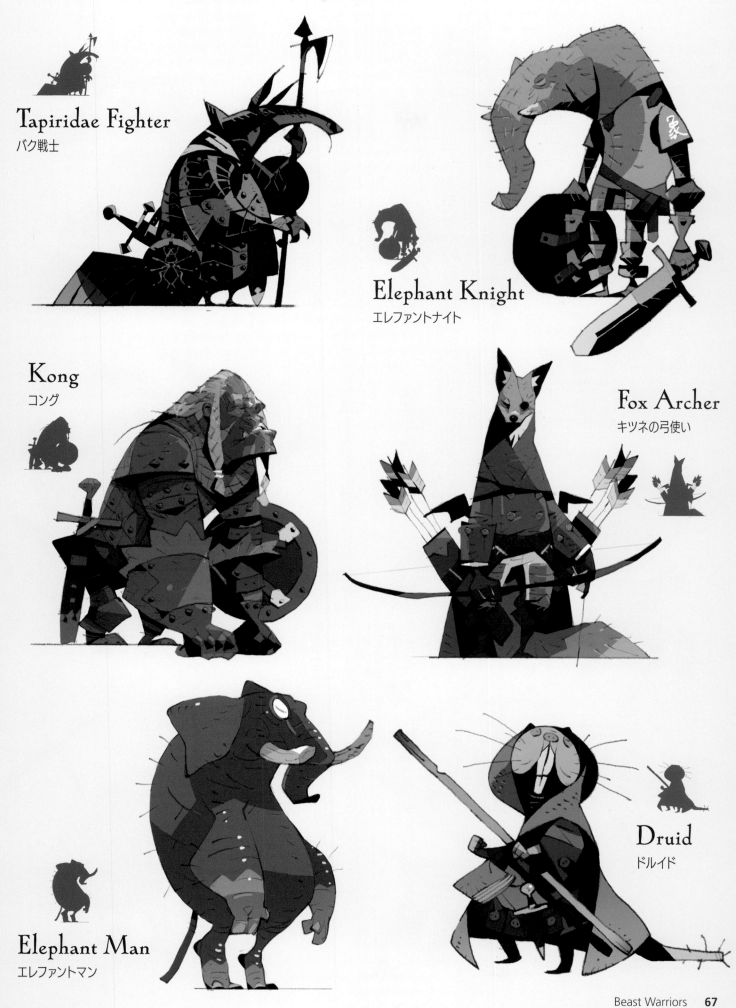

Tapiridae Fighter
バク戦士

Elephant Knight
エレファントナイト

Kong
コング

Fox Archer
キツネの弓使い

Elephant Man
エレファントマン

Druid
ドルイド

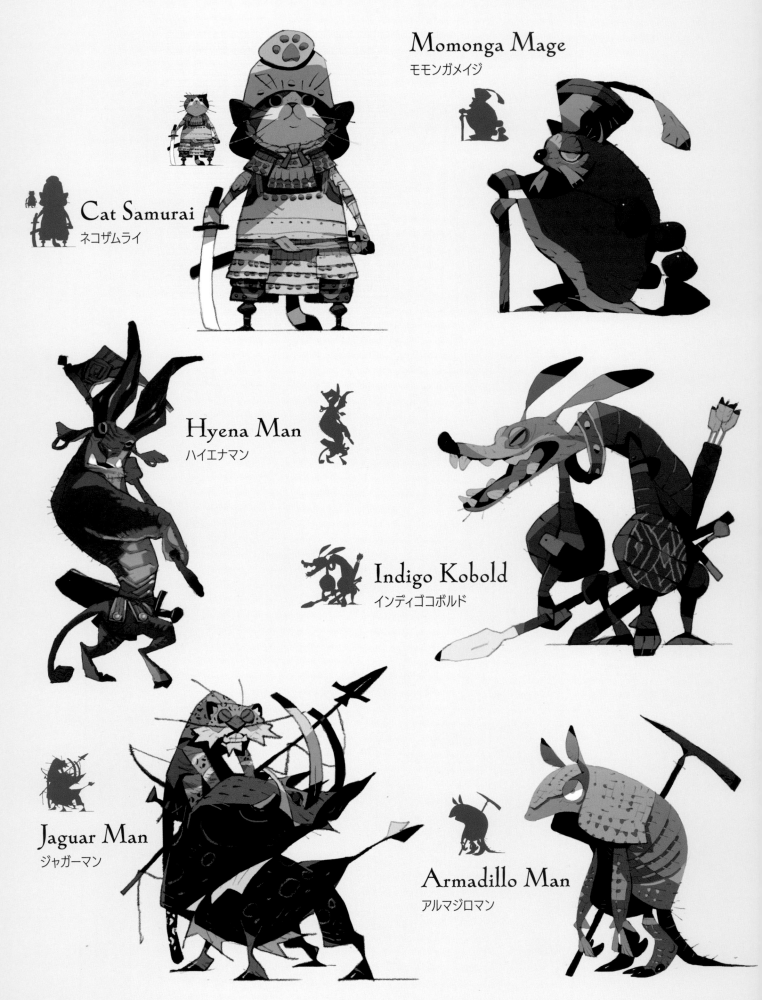

Momonga Mage
モモンガメイジ

Cat Samurai
ネコザムライ

Hyena Man
ハイエナマン

Indigo Kobold
インディゴコボルド

Jaguar Man
ジャガーマン

Armadillo Man
アルマジロマン

Bear King
クマの王

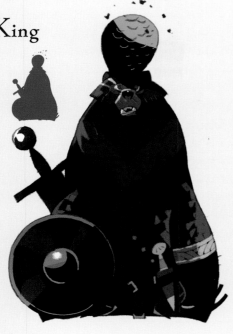

Lycanthrope and Zombification
狼男とゾンビ狼男

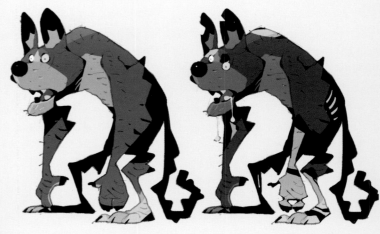

Orc Cook
オーク料理長

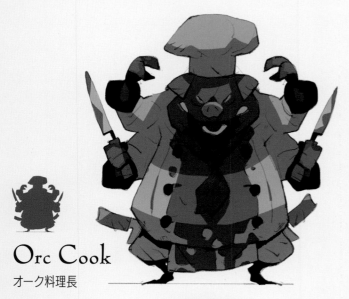

Rat Knight
ラットナイト

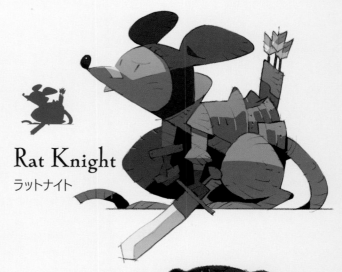

Werelion
ワーライオン

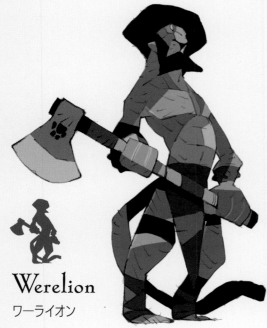

Sun Bear Warrior
サンベアウォーリアー

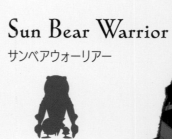
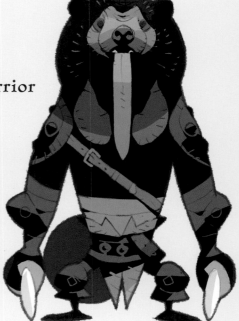

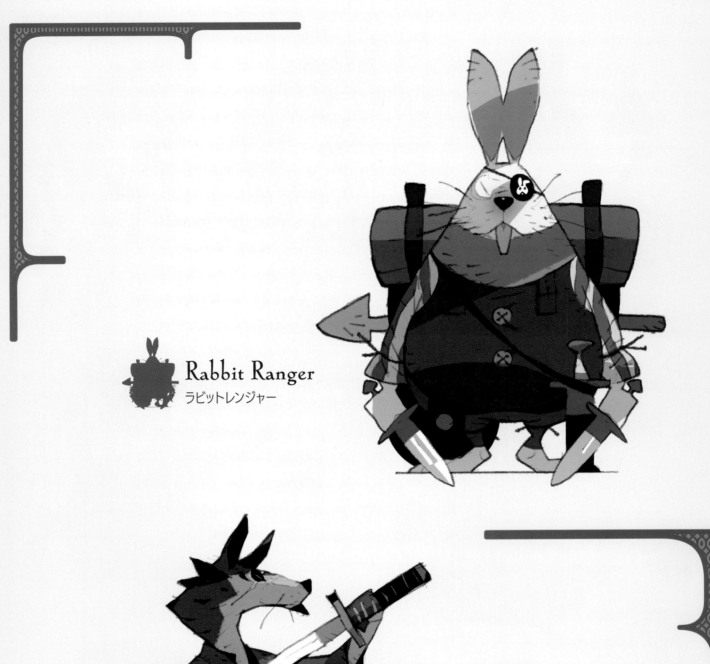

Rabbit Ranger
ラビットレンジャー

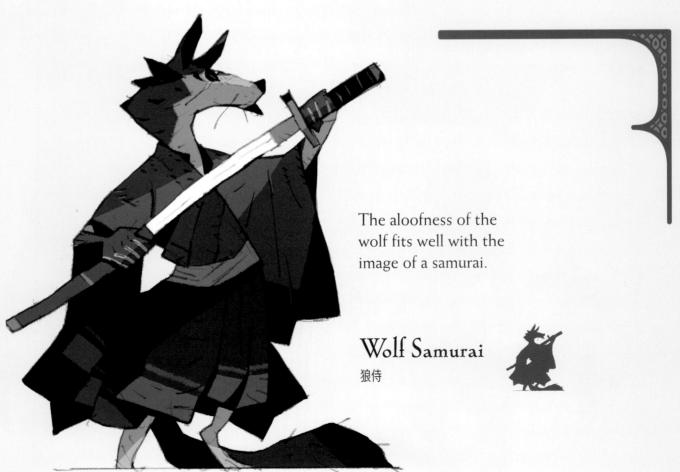

The aloofness of the wolf fits well with the image of a samurai.

Wolf Samurai
狼侍

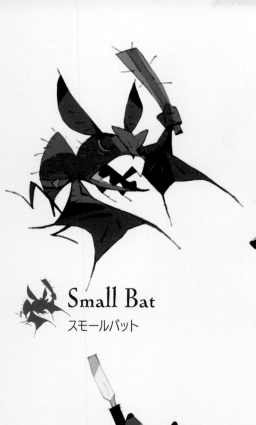

Small Bat
スモールバット

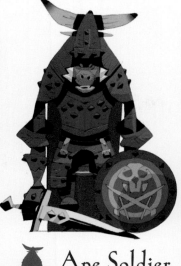

Ape Soldier
猿人の兵士

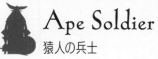

War Elephant
ウォーエレファント

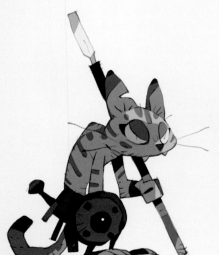

Cat Bandit
盗賊ネコ

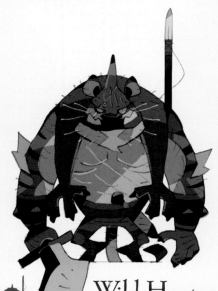

Wild Hunter
ワイルドハンター

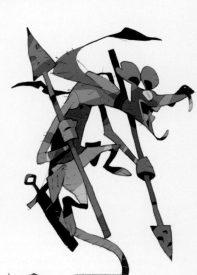

Rat Soldier
ラットソルジャー

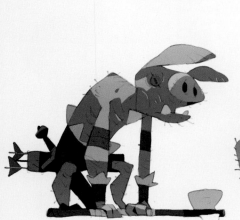

Orc Ranger
オークレンジャー

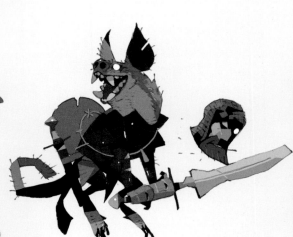

Beast Man
獣人

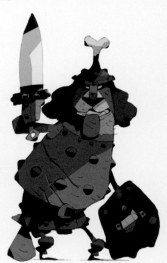

Spaniel Knight
スパニエルナイト

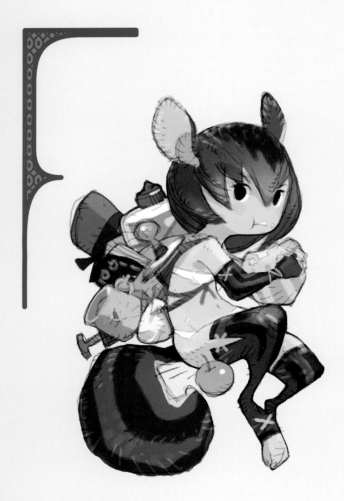

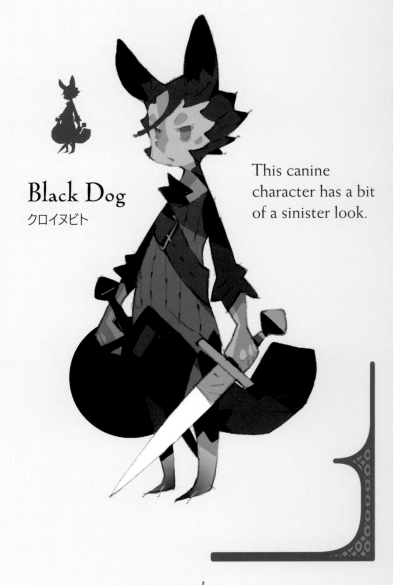

Black Dog
クロイヌビト

This canine character has a bit of a sinister look.

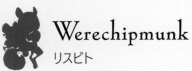

Werechipmunk
リスビト

Chipmunks like to steal and hide food, so I think it fits well with the image of a thief.

Dwarf King
ドワーフキング

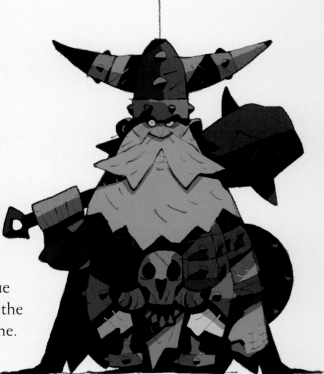

This design is a bit monochromatic, but by adding blue as an accent color, the color scheme pops. By making the cool shade transparent, it blends well with the skin tone.

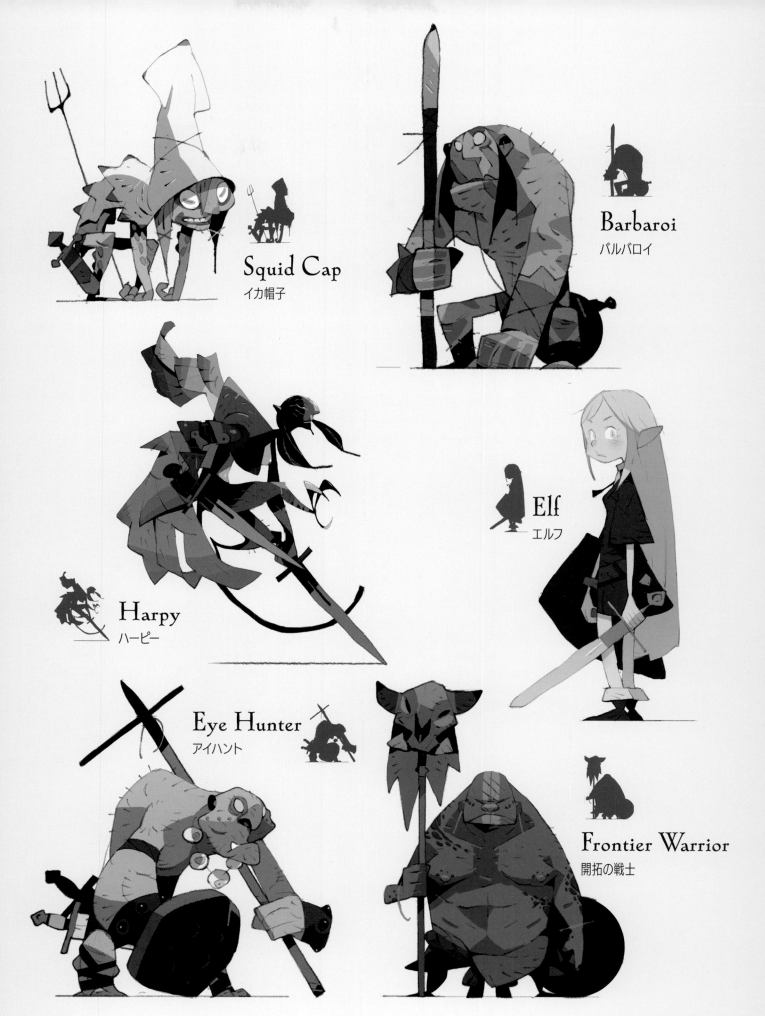

Squid Cap
イカ帽子

Barbaroi
バルバロイ

Harpy
ハーピー

Elf
エルフ

Eye Hunter
アイハント

Frontier Warrior
開拓の戦士

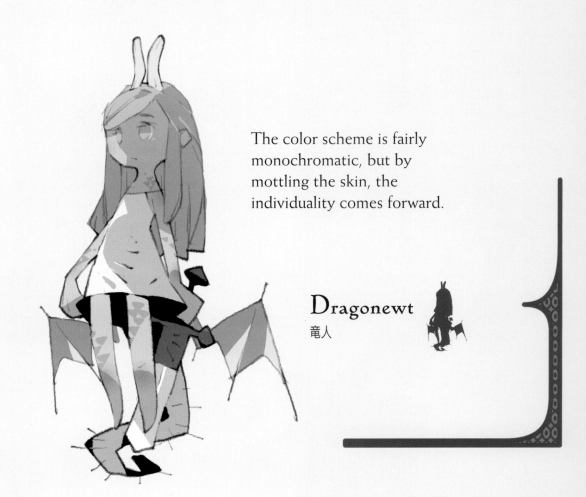

The color scheme is fairly monochromatic, but by mottling the skin, the individuality comes forward.

Dragonewt
竜人

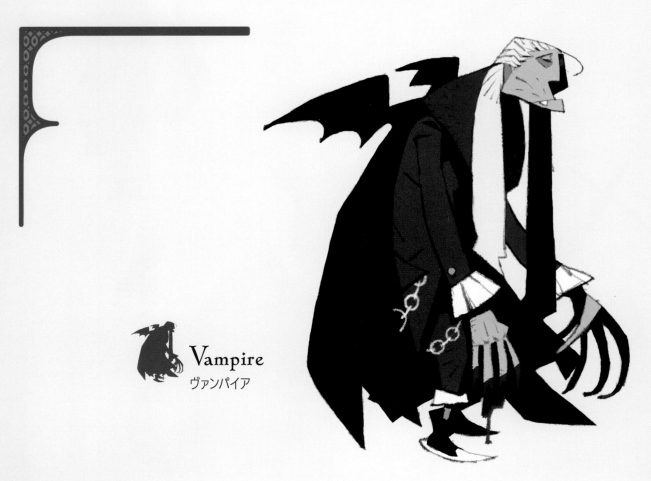

Vampire
ヴァンパイア

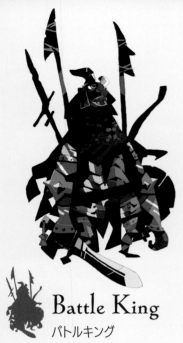

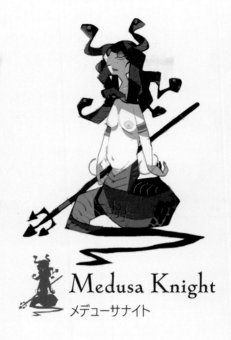

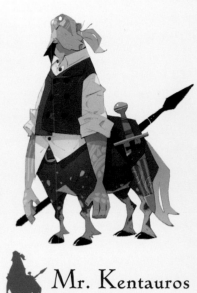

Battle King
バトルキング

Medusa Knight
メデューサナイト

Mr. Kentauros
Mr. ケンタウロス

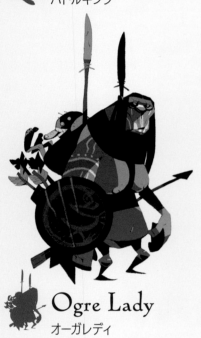

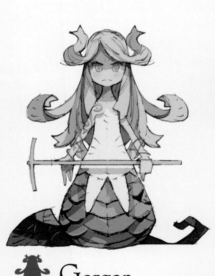

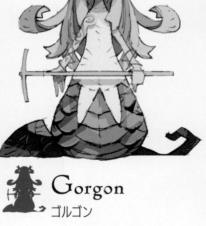

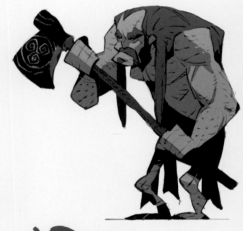

Ogre Lady
オーガレディ

Gorgon
ゴルゴン

Woodcutter Giant
木こりの巨人

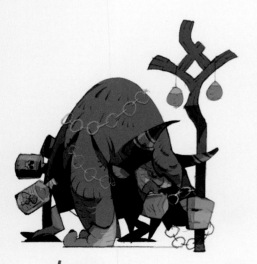

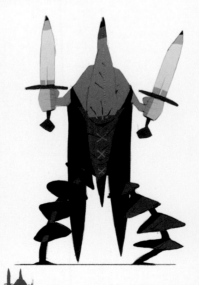

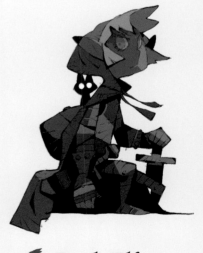

Bison Mage
バイソンメイジ

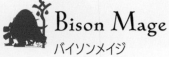

Assassin Gnome
アサシンホビット

Dark Elf
ダークエルフ

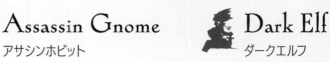

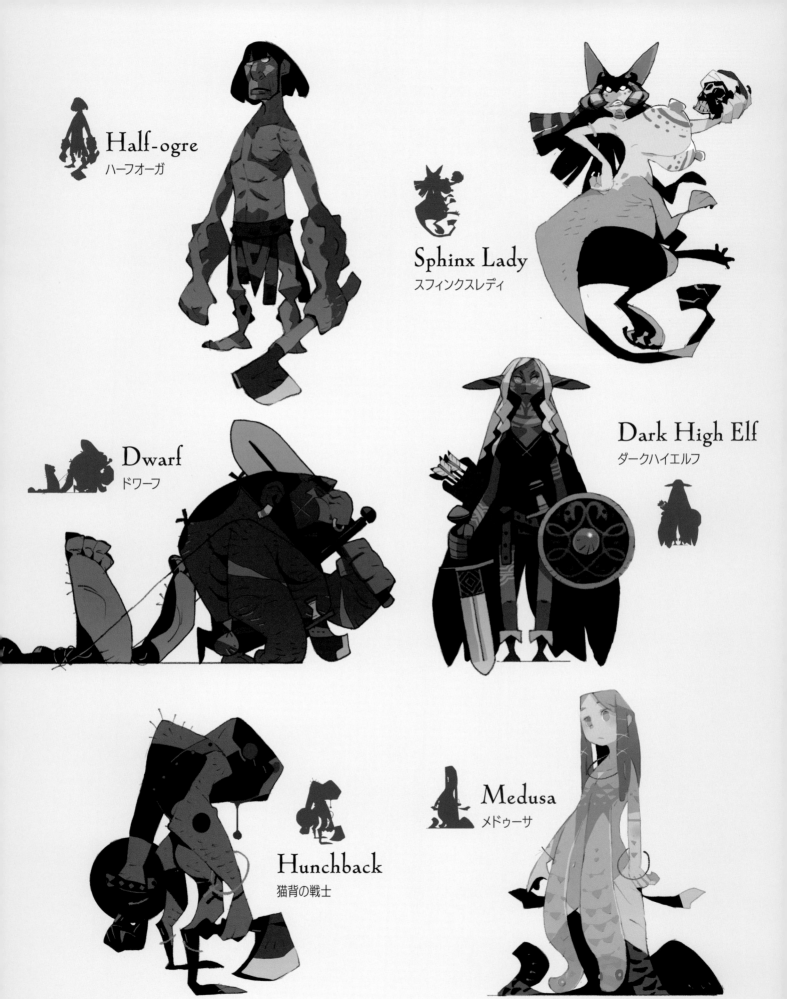

Half-ogre
ハーフオーガ

Sphinx Lady
スフィンクスレディ

Dwarf
ドワーフ

Dark High Elf
ダークハイエルフ

Hunchback
猫背の戦士

Medusa
メドゥーサ

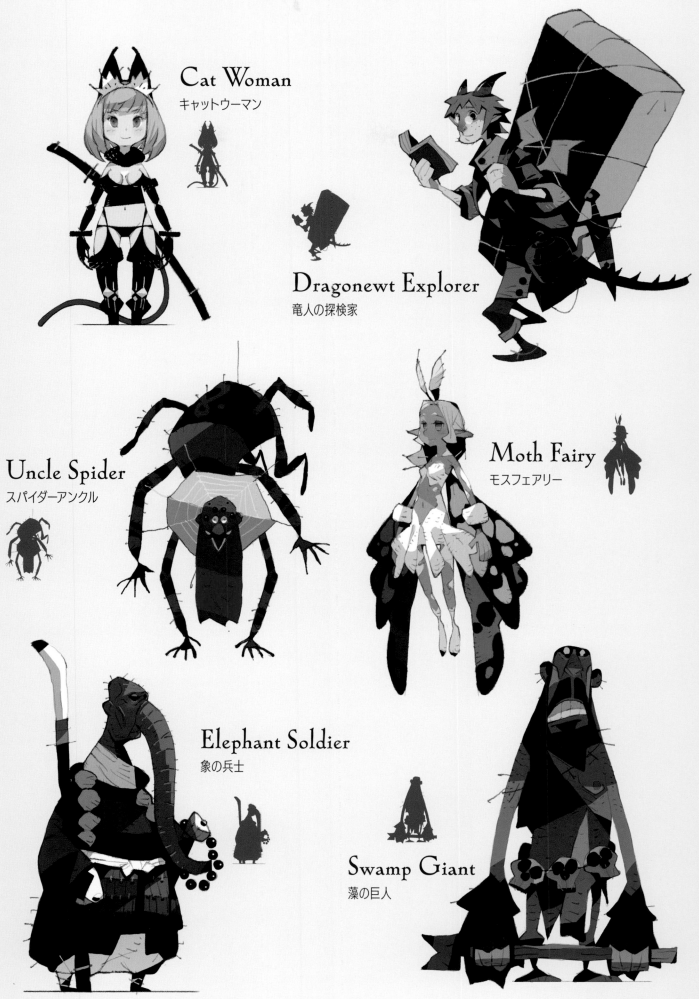

Cat Woman
キャットウーマン

Dragonewt Explorer
竜人の探検家

Uncle Spider
スパイダーアンクル

Moth Fairy
モスフェアリー

Elephant Soldier
象の兵士

Swamp Giant
藻の巨人

Human Warriors

I draw a lot of warriors! I love armor and swords. The reason there are fewer females is because I still can't draw them freely in my own imagination, and I want to overcome that. I have to draw more!

Dragon Tamer
ドラゴンテイマー

Gushnasaph
グシュナサフ
（東方の三博士より）

Le Coq Chevaliers
雄鶏の騎士

I thought it would be fun to draw a French knight with a rooster motif.

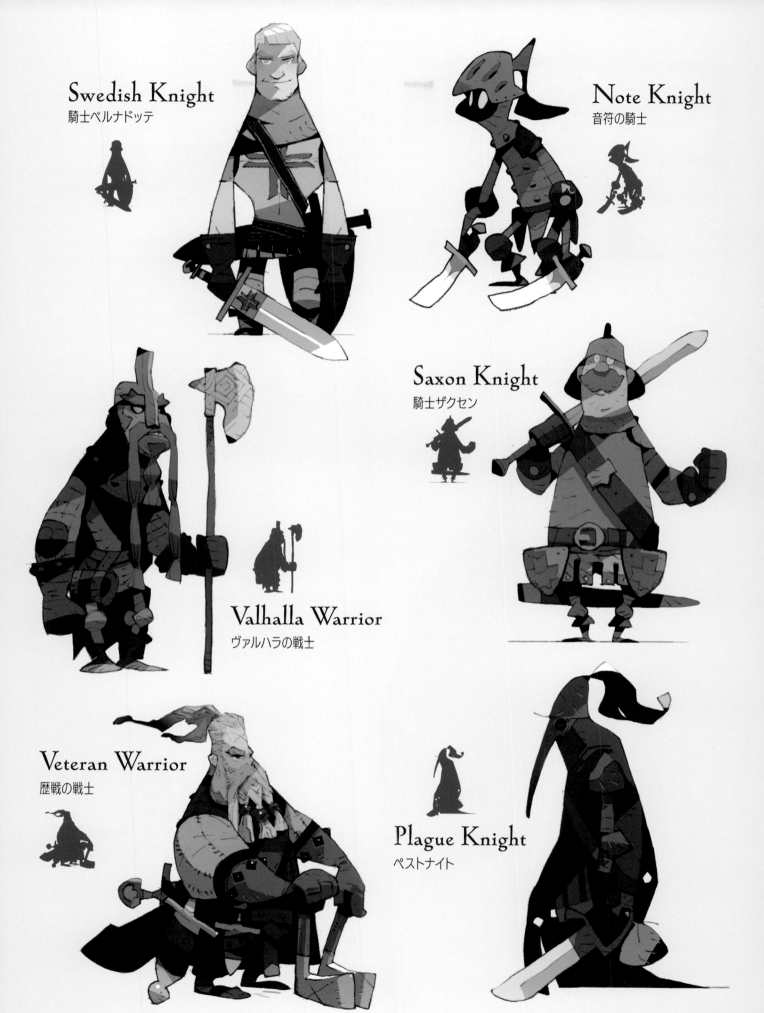

Swedish Knight
騎士ベルナドッテ

Note Knight
音符の騎士

Saxon Knight
騎士ザクセン

Valhalla Warrior
ヴァルハラの戦士

Veteran Warrior
歴戦の戦士

Plague Knight
ペストナイト

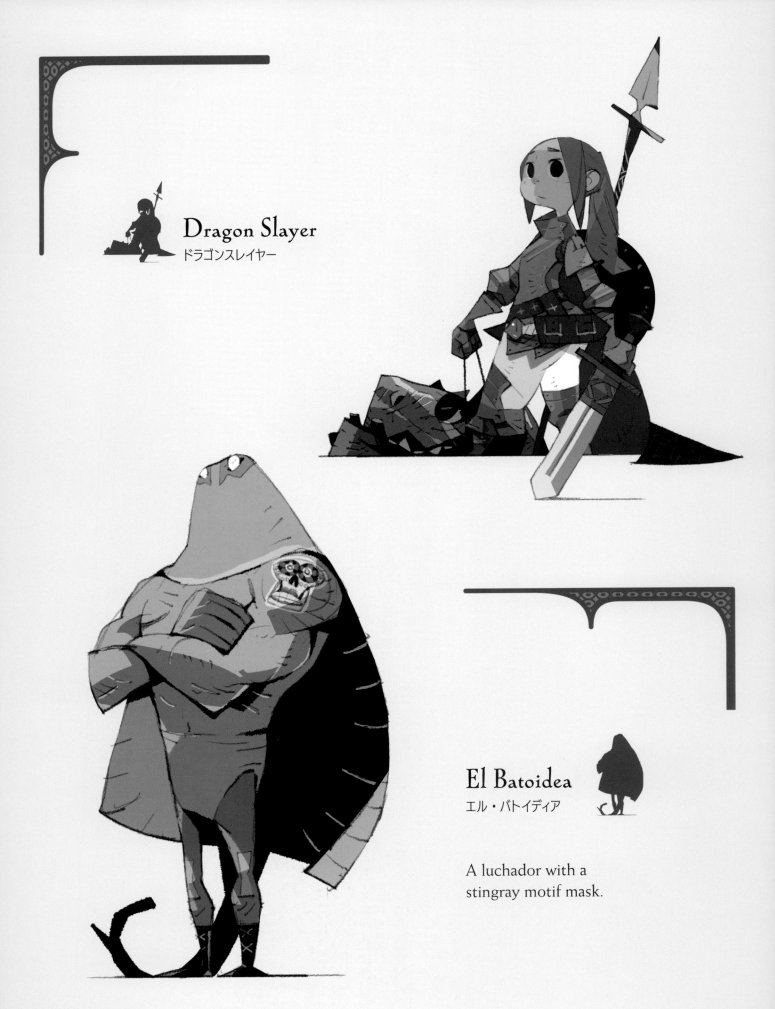

Dragon Slayer
ドラゴンスレイヤー

El Batoidea
エル・バトイディア

A luchador with a
stingray motif mask.

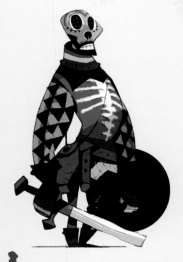

Mexican Skeleton
メキシカンスケルトン

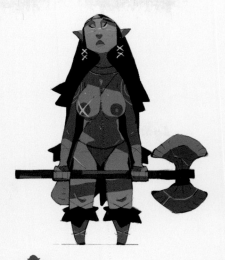

Amazon Warrior
アマゾネス

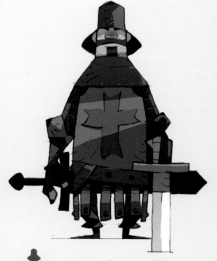

Castle Soldier
城兵

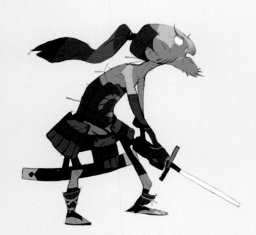

Ashigaru
足軽

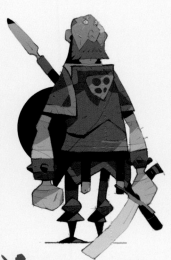

Scottish Warrior
戦士ダンバートン

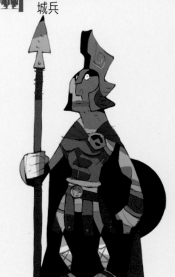

Roman Soldier
ローマ兵

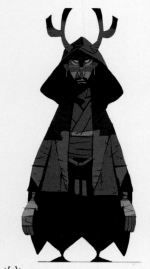

Monk
モンク

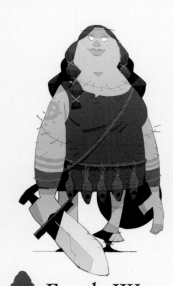

Female Warrior
女戦士

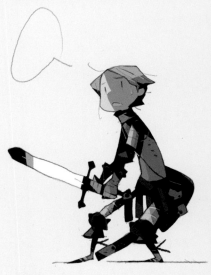

Scared Knight
怯えた騎士

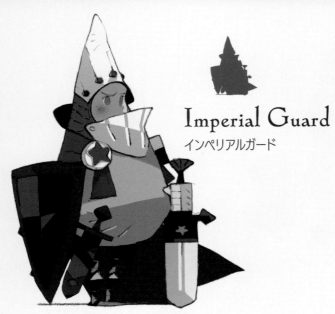

Imperial Guard
インペリアルガード

Wise Man
賢者

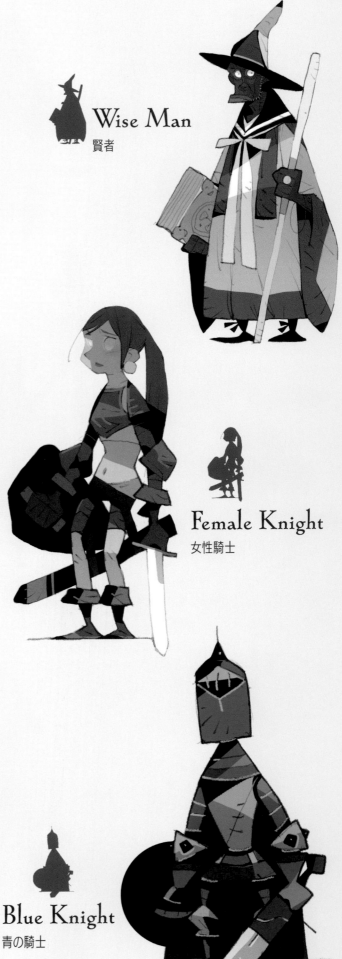

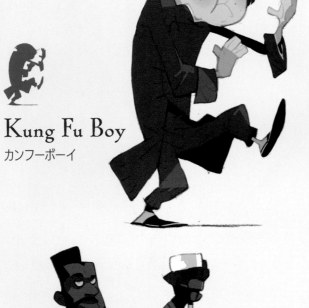

Kung Fu Boy
カンフーボーイ

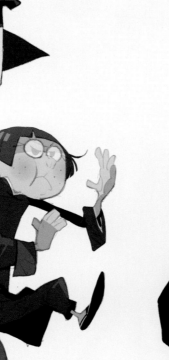

Female Knight
女性騎士

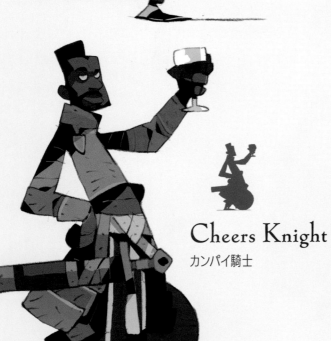

Cheers Knight
カンパイ騎士

Blue Knight
青の騎士

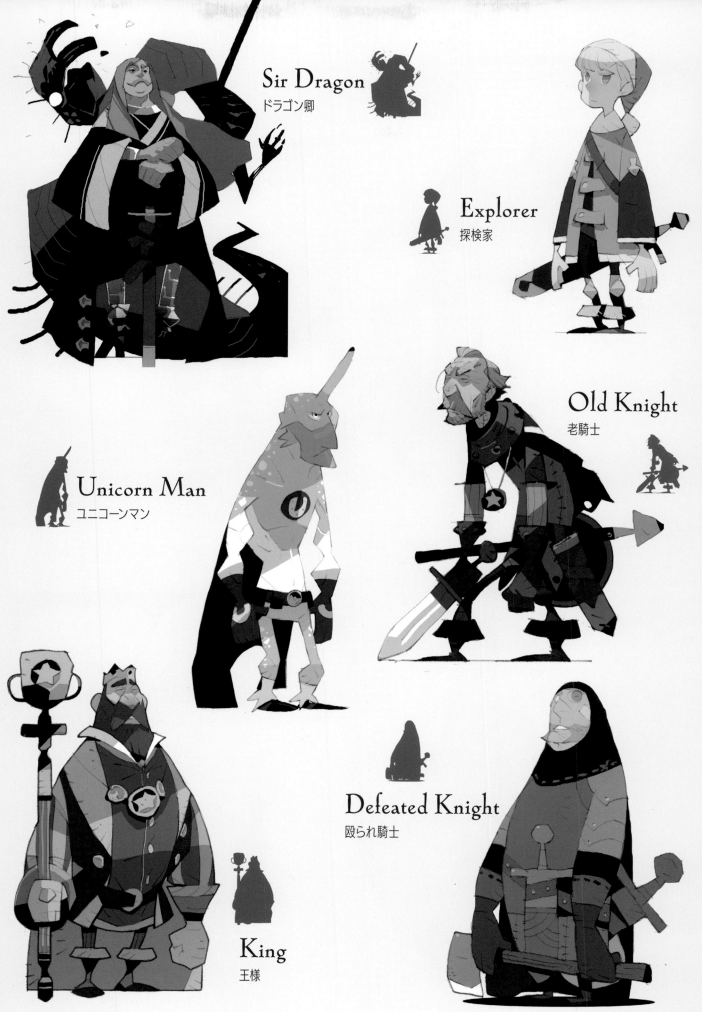

Sir Dragon
ドラゴン卿

Explorer
探検家

Old Knight
老騎士

Unicorn Man
ユニコーンマン

King
王様

Defeated Knight
殴られ騎士

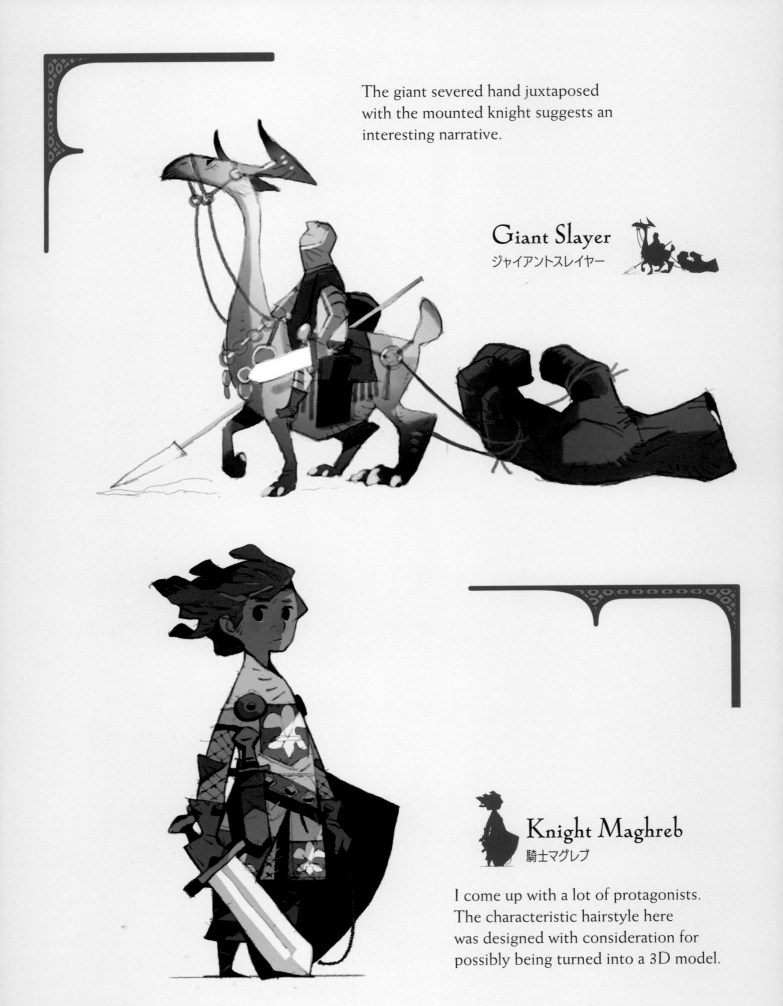

The giant severed hand juxtaposed with the mounted knight suggests an interesting narrative.

Giant Slayer
ジャイアントスレイヤー

Knight Maghreb
騎士マグレブ

I come up with a lot of protagonists. The characteristic hairstyle here was designed with consideration for possibly being turned into a 3D model.

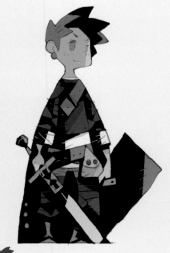

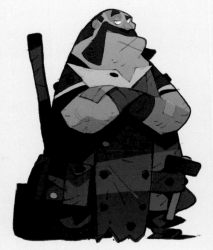

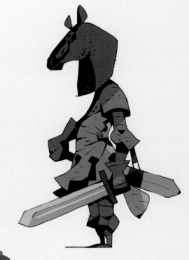

Knight Arlon
騎士アルロン

Blacksmith
鍛冶屋

Horse Head Knight
ウマアタマの騎士

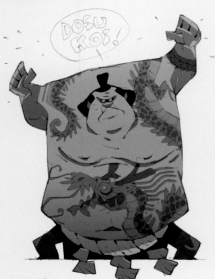

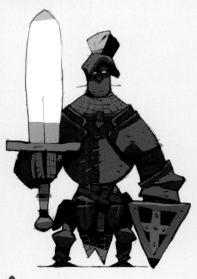

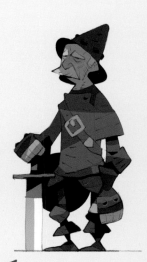

Sumo Wrestler
スモウレスラー

Fearsome Knight
騎士バルログ

Skilled Knight
熟練騎士

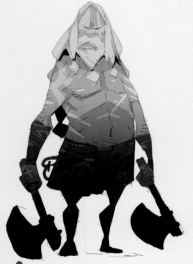

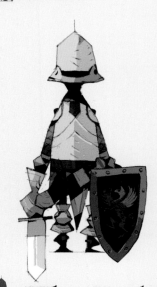

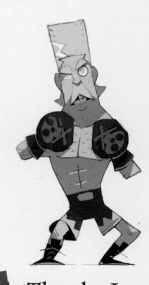

Tomahawk Viking
双斧のバイキング

White Knight
ホワイトナイト

Thunder Joe
サンダージョー

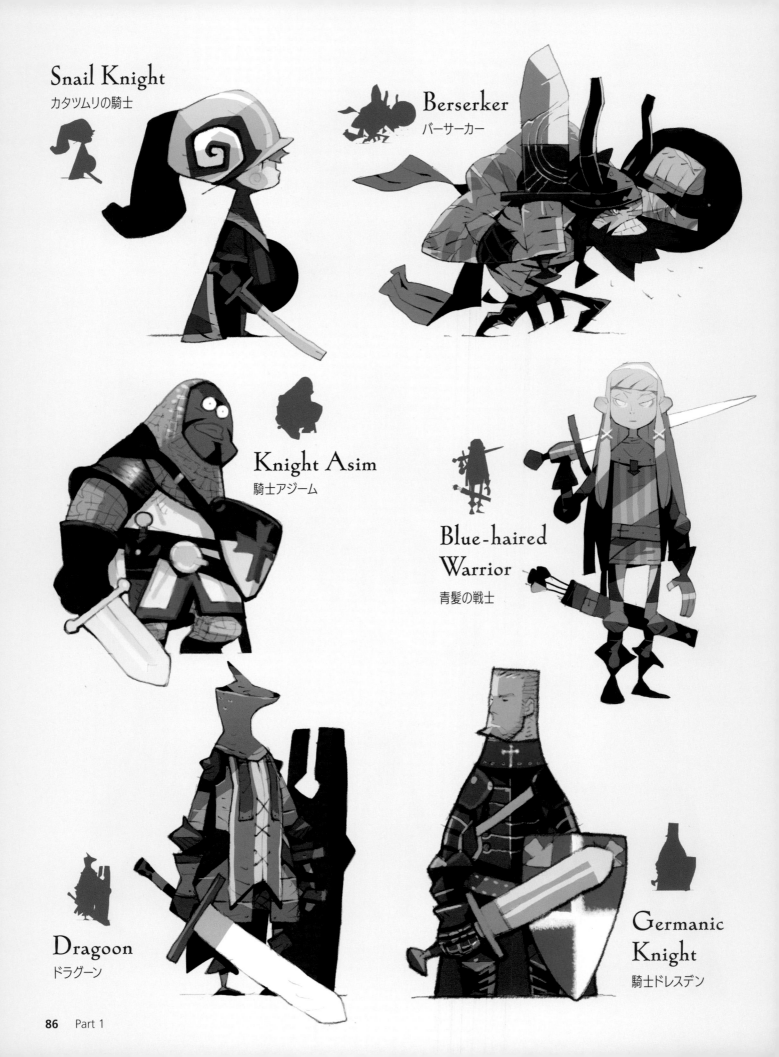

Snail Knight
カタツムリの騎士

Berserker
バーサーカー

Knight Asim
騎士アジーム

Blue-haired Warrior
青髪の戦士

Dragoon
ドラグーン

Germanic Knight
騎士ドレスデン

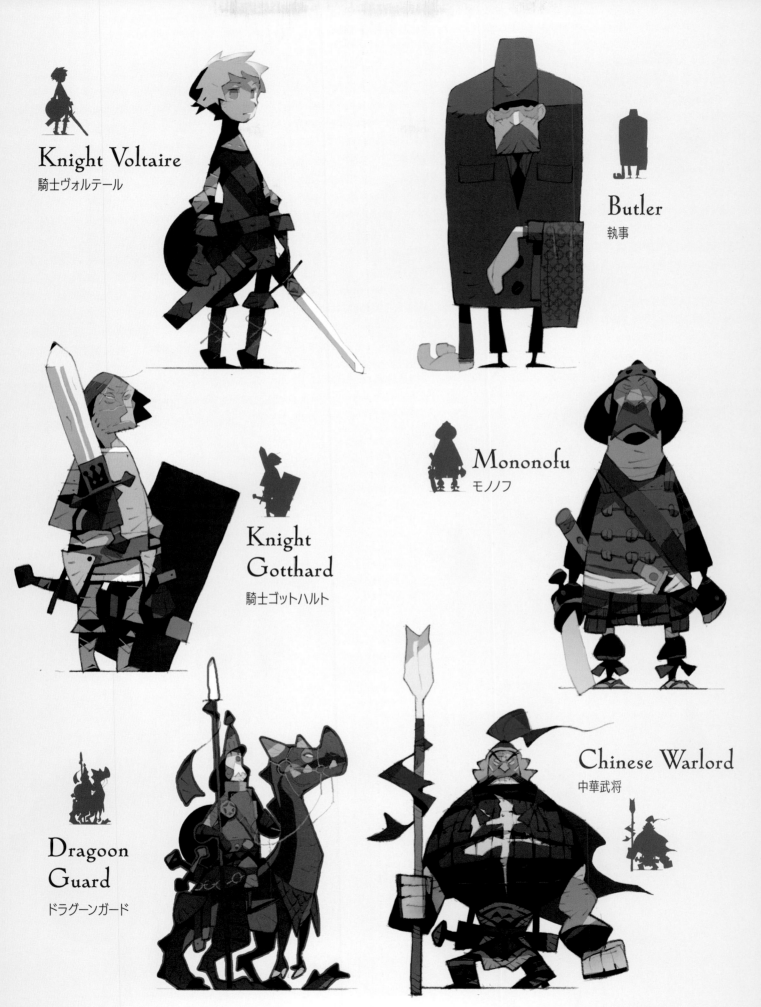

Knight Voltaire
騎士ヴォルテール

Butler
執事

Knight Gotthard
騎士ゴットハルト

Mononofu
モノノフ

Dragoon Guard
ドラグーンガード

Chinese Warlord
中華武将

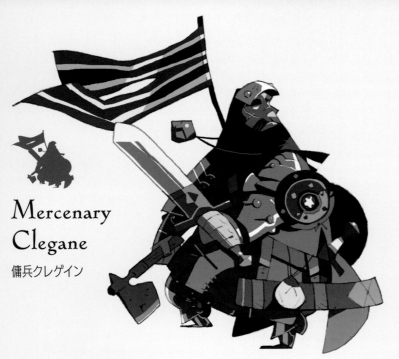

Mercenary Clegane

傭兵クレゲイン

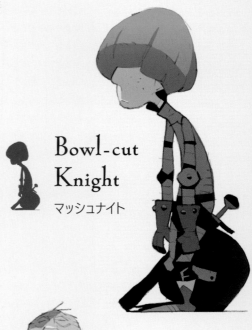

Bowl-cut Knight

マッシュナイト

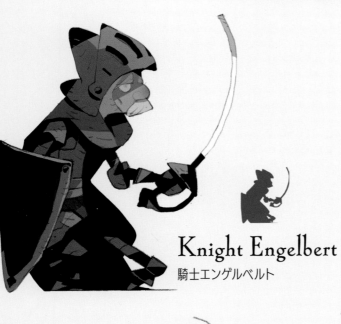

Knight Engelbert

騎士エンゲルベルト

Nordic Warrior

北欧の戦士

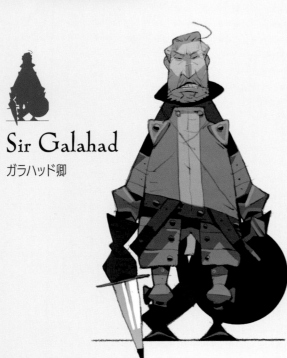

Sir Galahad

ガラハッド卿

Conical-helmeted Knight

三角帽の騎士

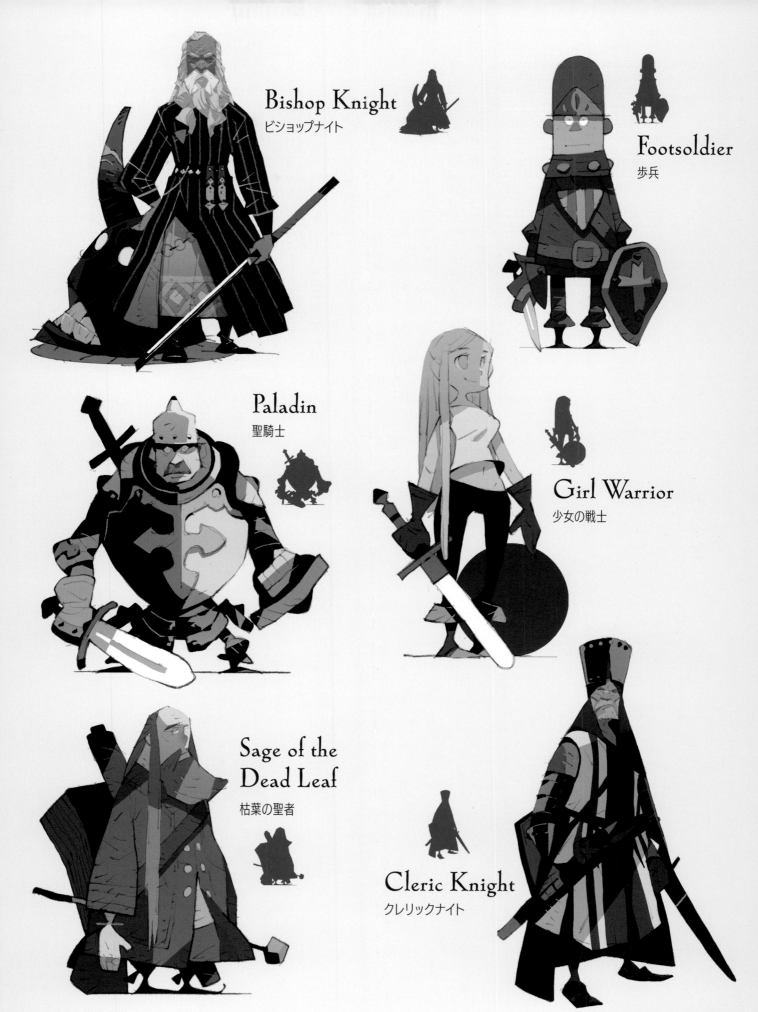

Bishop Knight
ビショップナイト

Footsoldier
歩兵

Paladin
聖騎士

Girl Warrior
少女の戦士

Sage of the Dead Leaf
枯葉の聖者

Cleric Knight
クレリックナイト

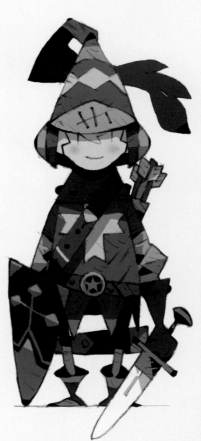

 # Orange Knight
オレンジナイト

I think red and orange are good colors for a flamboyant individual or a heroic character.

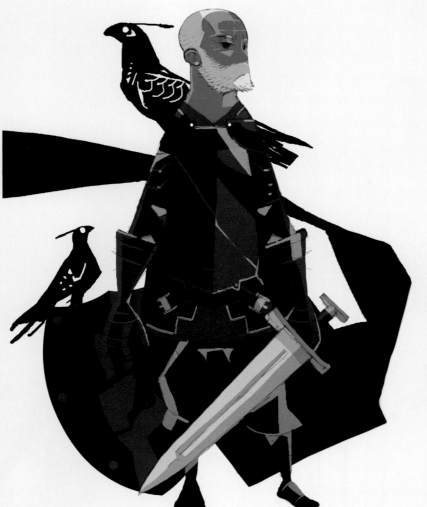

 # Eagle Knight
鷹飼騎士

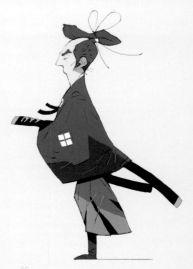

Ghost Gentleman
ゴースト紳士

Bobbed Knight
ボブヘアナイト

Topknot Samurai
ちょんまげ侍

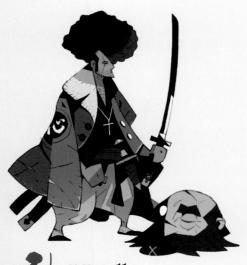

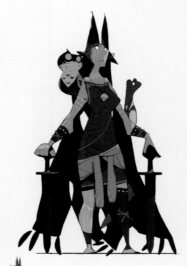

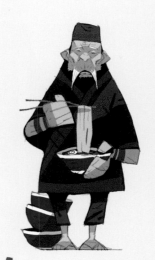

Headhunter
首斬りアフロ

Amazonian Queen
アマゾネスクイーン

Ramen Man
ラーメンマン

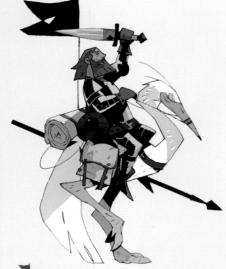

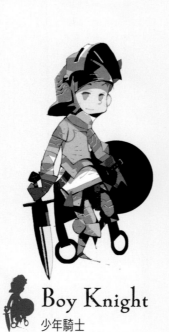

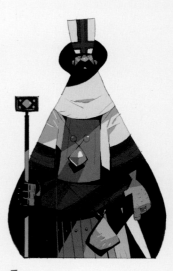

Heron Rider
ヘロンライダー

Boy Knight
少年騎士

Minister
大臣

Rogues, Assassins and Mercenaries

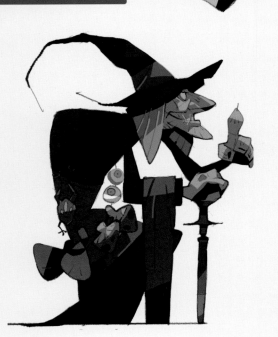

I probably draw characters like these with a grimace on my face, imagining, "This guy is going to do something bad." The face of a villain is all about personality. It's fun because I can be daring. Beards and scars are also appealing.

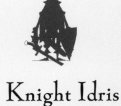

Knight Idris
騎士イドリス

Witch
魔女

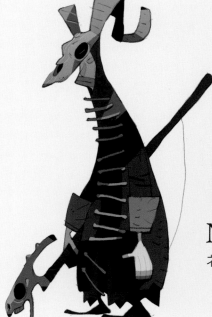

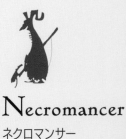

Necromancer
ネクロマンサー

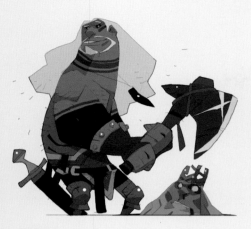

King Slayer
キングスレイヤー

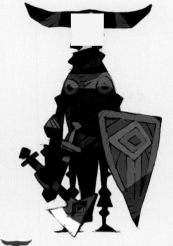

Cyclops Knight
サイクロプスナイト

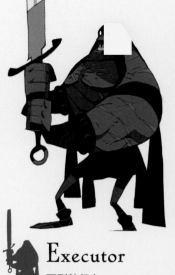

Executor
死刑執行人

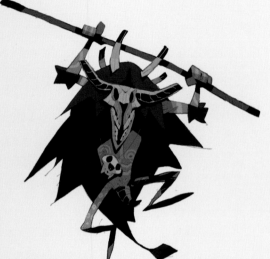

Bone Shaman
ボーンシャーマン

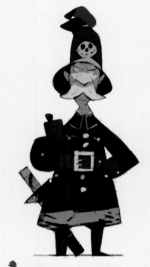

Baron Konstanty
コンスタンティ男爵

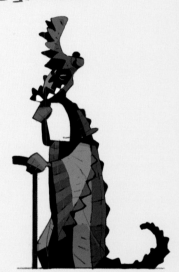

Sebek Priest
セベク司祭

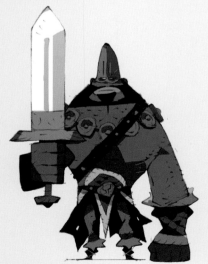

Golyat
ゴリアテ

Black Claw
ブラッククコー

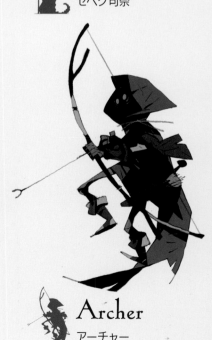

Archer
アーチャー

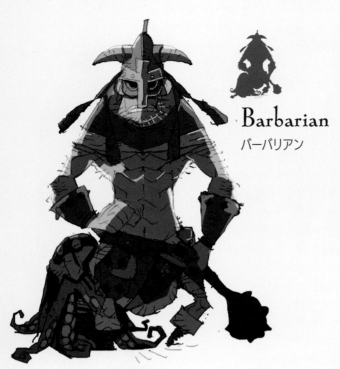

Barbarian
バーバリアン

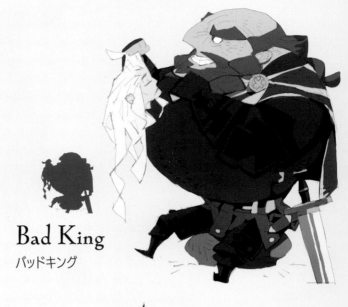

Bad King
バッドキング

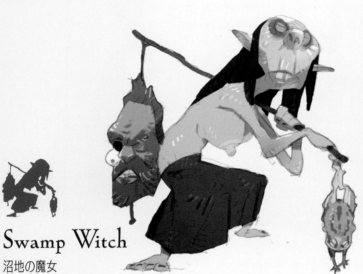

Swamp Witch
沼地の魔女

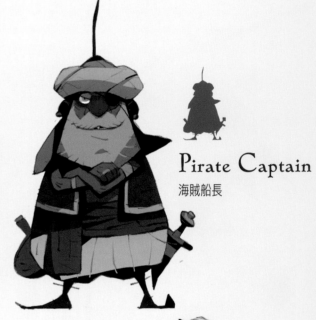

Pirate Captain
海賊船長

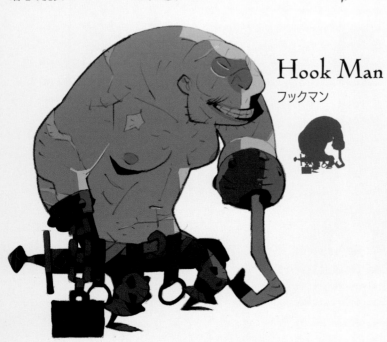

Hook Man
フックマン

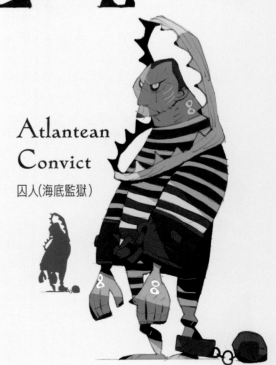

Atlantean Convict
囚人（海底監獄）

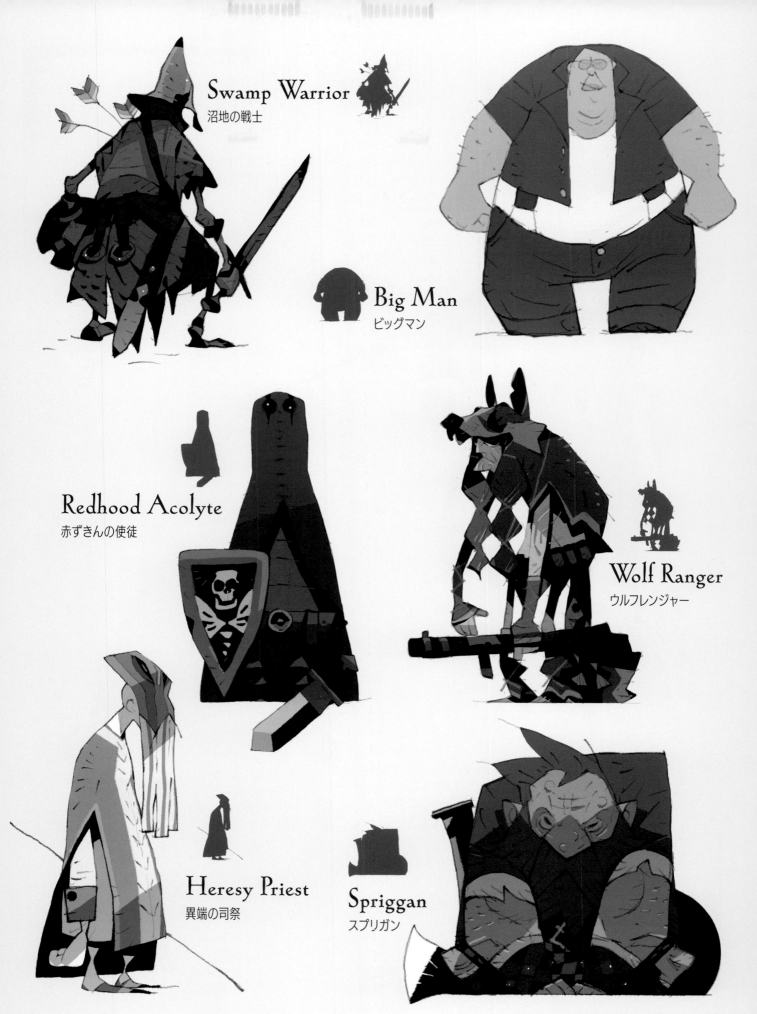

Swamp Warrior
沼地の戦士

Big Man
ビッグマン

Redhood Acolyte
赤ずきんの使徒

Wolf Ranger
ウルフレンジャー

Heresy Priest
異端の司祭

Spriggan
スプリガン

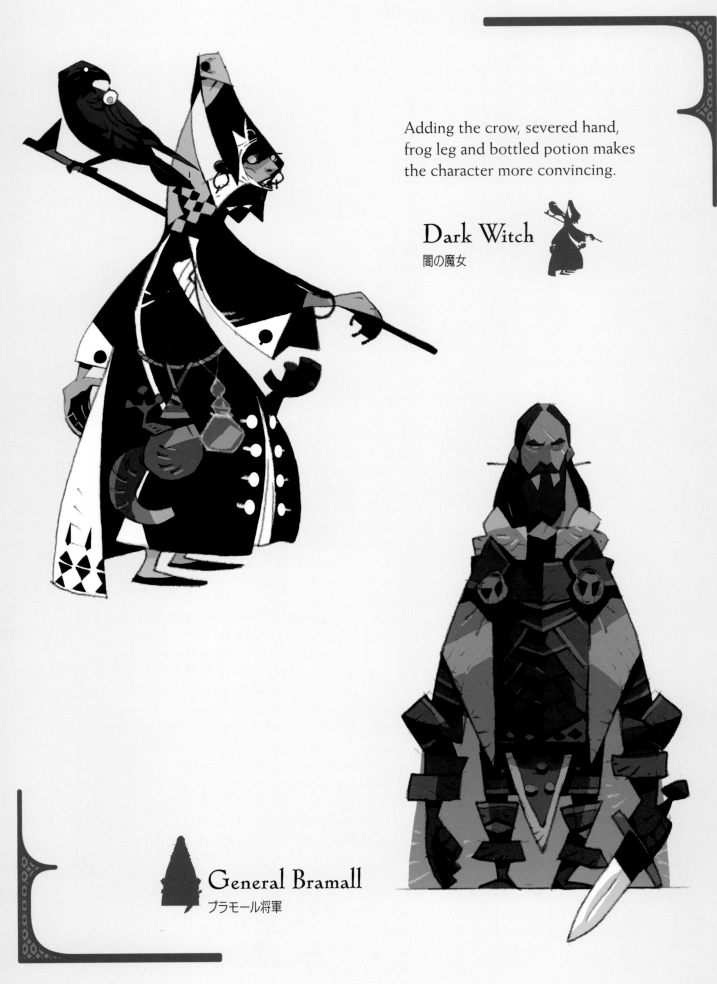

Adding the crow, severed hand, frog leg and bottled potion makes the character more convincing.

Dark Witch
闇の魔女

General Bramall
ブラモール将軍

Baron Penguin
ペンギン男爵

Catfish Warrior
ナマズタトゥーの戦士

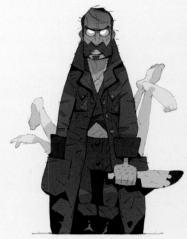

Jack the Ripper
切り裂きジャック

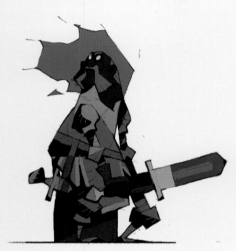

Torch Knight
トーチナイト

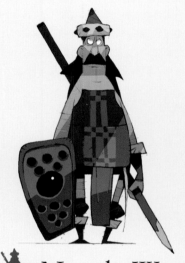

Nomadic Warrior
遊牧の戦士

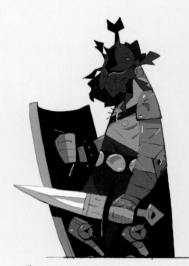

Beetle Gladiator
ビートルグラデュエーター

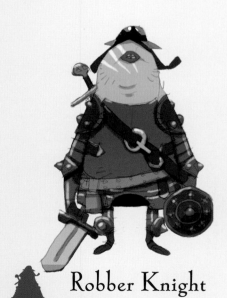

Robber Knight
盗賊騎士

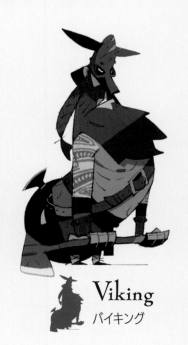

Viking
バイキング

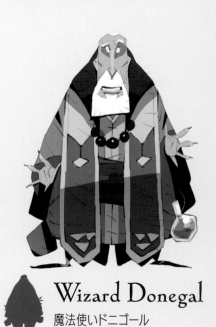

Wizard Donegal
魔法使いドニゴール

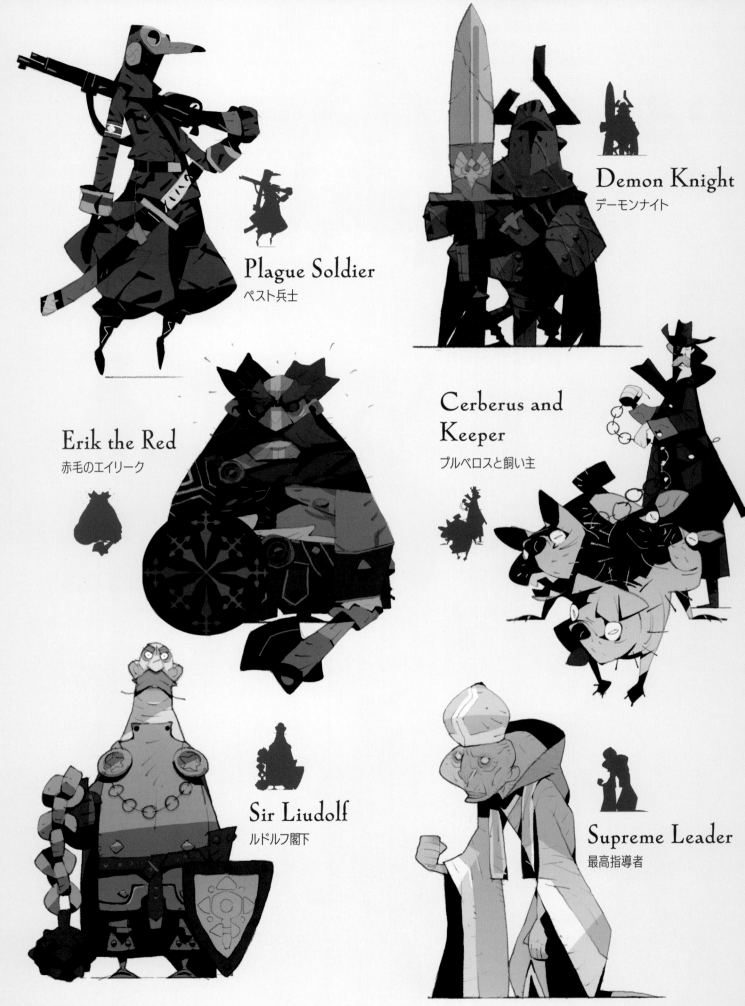

Plague Soldier
ペスト兵士

Demon Knight
デーモンナイト

Erik the Red
赤毛のエイリーク

Cerberus and
Keeper
ブルベロスと飼い主

Sir Liudolf
ルドルフ閣下

Supreme Leader
最高指導者

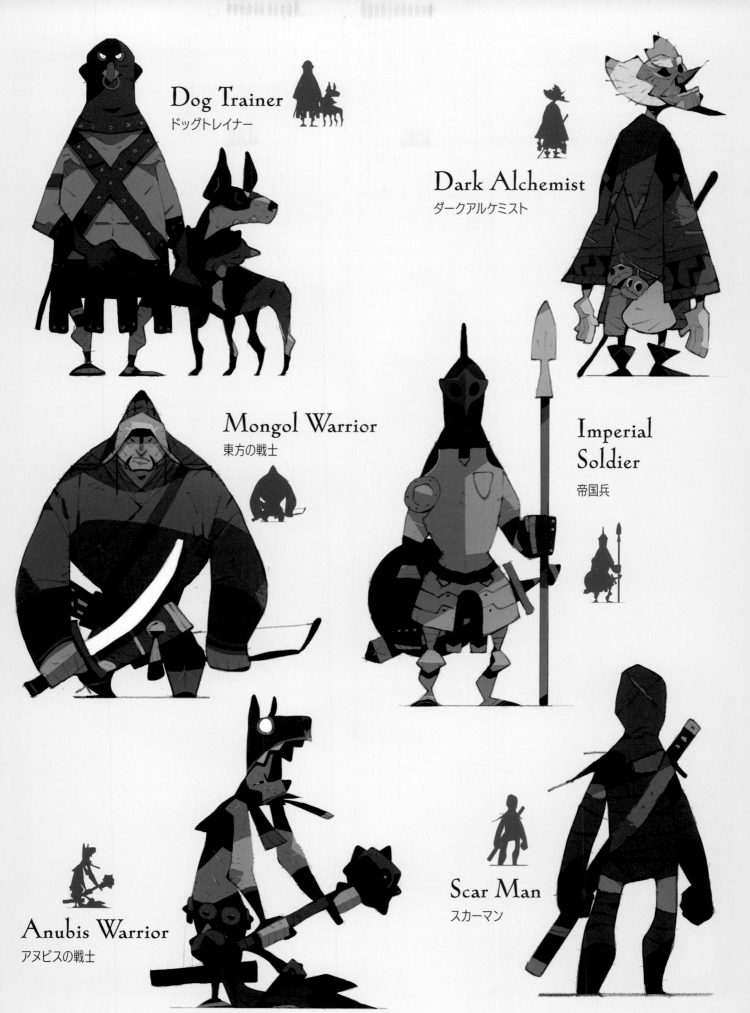

Dog Trainer
ドッグトレイナー

Dark Alchemist
ダークアルケミスト

Mongol Warrior
東方の戦士

Imperial Soldier
帝国兵

Anubis Warrior
アヌビスの戦士

Scar Man
スカーマン

Yōkai and Demons

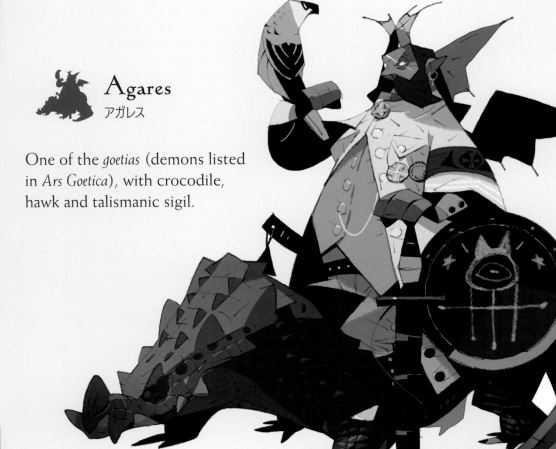

Agares
アガレス

One of the *goetias* (demons listed in *Ars Goetica*), with crocodile, hawk and talismanic sigil.

Unlike monsters and brutes, many of these designs seem to possess a cunning intellect, though I'm not always conscious of it. Common elements include horns, wings, tails and often purple or dark colors. Eventually, I want to draw all 72 demons from the *Lesser Key of Solomon* grimoire! Only 64 more to go!

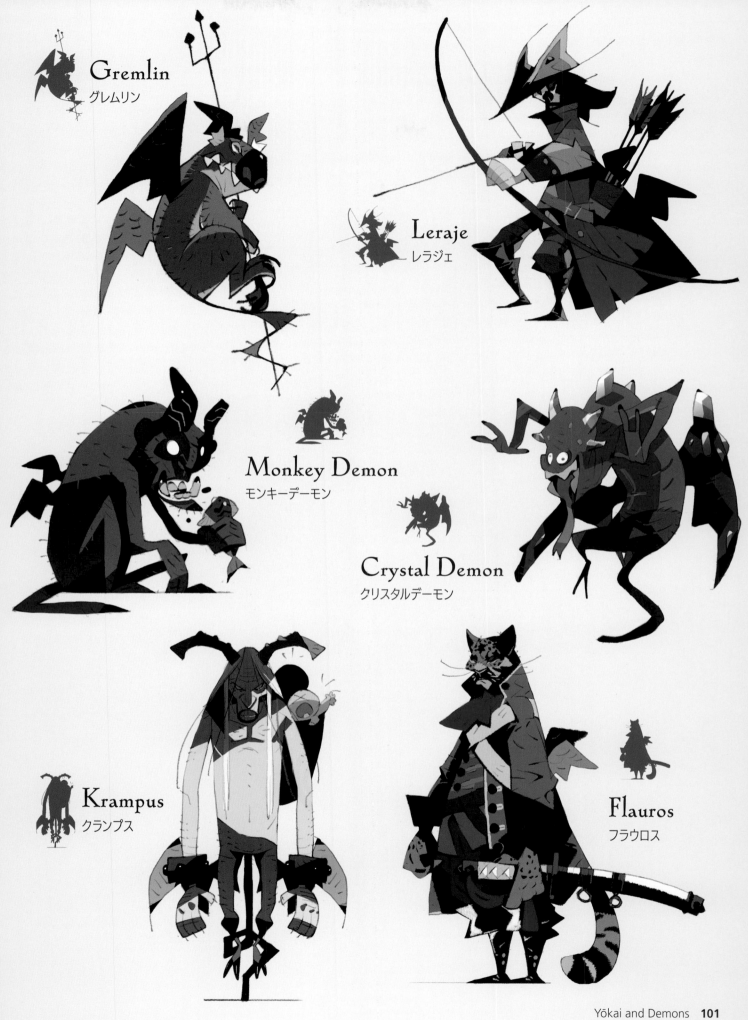

Gremlin
グレムリン

Leraje
レラジェ

Monkey Demon
モンキーデーモン

Crystal Demon
クリスタルデーモン

Krampus
クランプス

Flauros
フラウロス

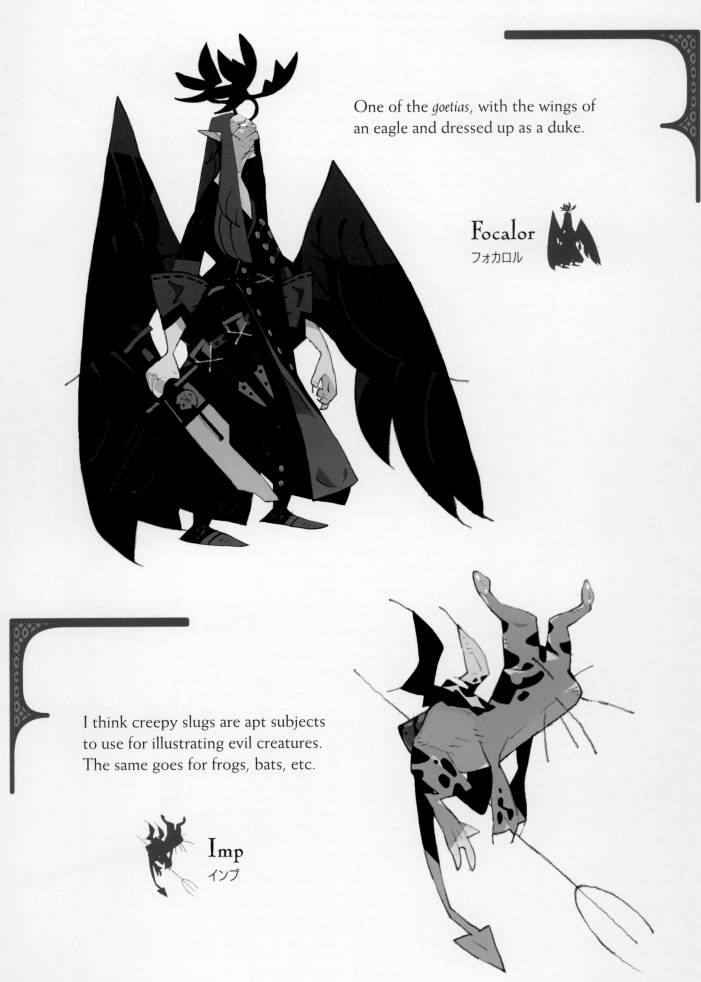

One of the *goetias*, with the wings of an eagle and dressed up as a duke.

Focalor
フォカロル

I think creepy slugs are apt subjects to use for illustrating evil creatures. The same goes for frogs, bats, etc.

Imp
インプ

Rubber Ghost
ラバーゴースト

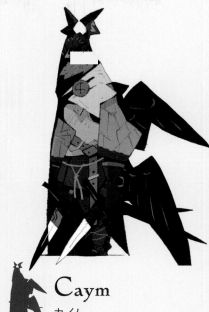

Caym
カイム

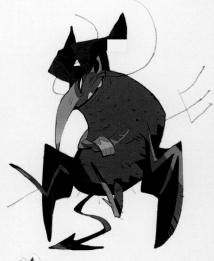

Hook-nosed Imp
鉤鼻の悪魔

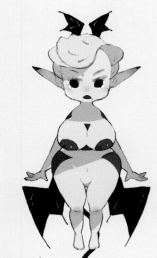

Succubus
サキュバス

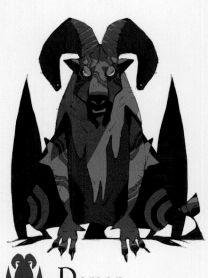

Demon
デーモン

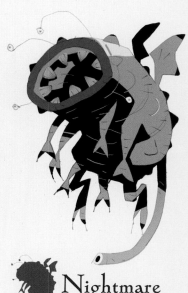

Nightmare
ナイトメア

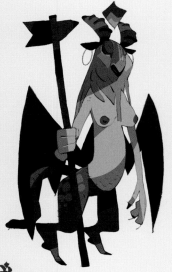

Baphomet
バフォメット

Elephant Imp
エレファントインプ

Black Goat Knight
ブラックゴートナイト

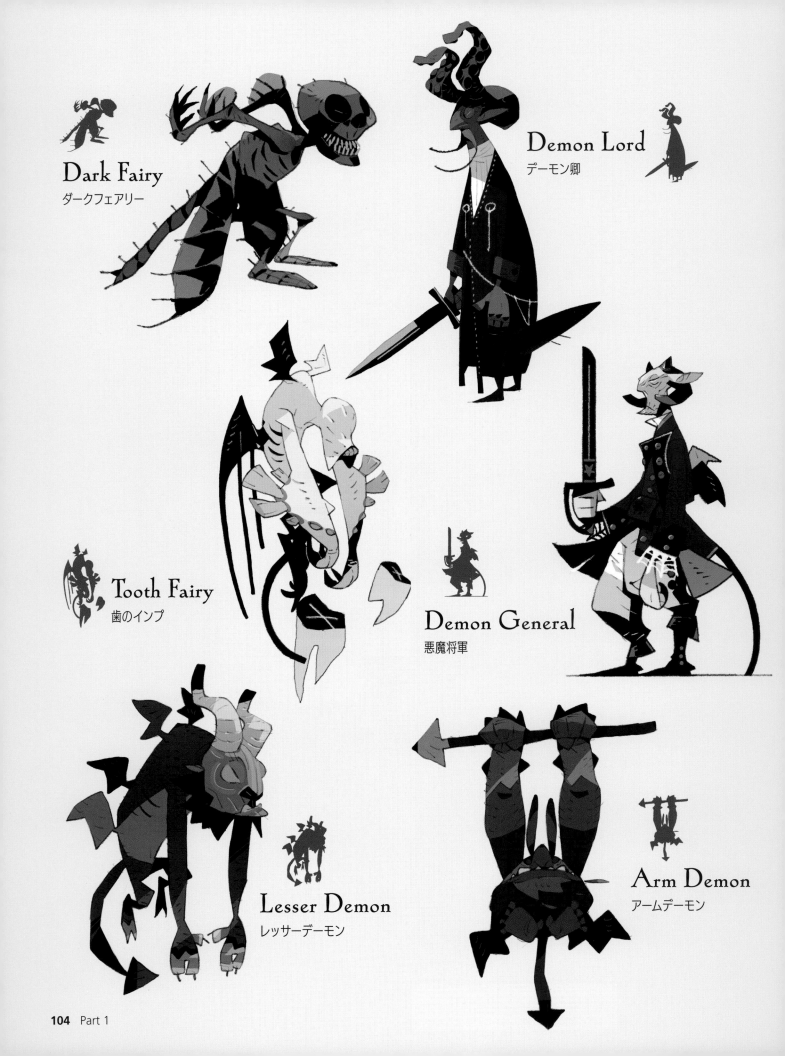

Dark Fairy
ダークフェアリー

Demon Lord
デーモン卿

Tooth Fairy
歯のインプ

Demon General
悪魔将軍

Lesser Demon
レッサーデーモン

Arm Demon
アームデーモン

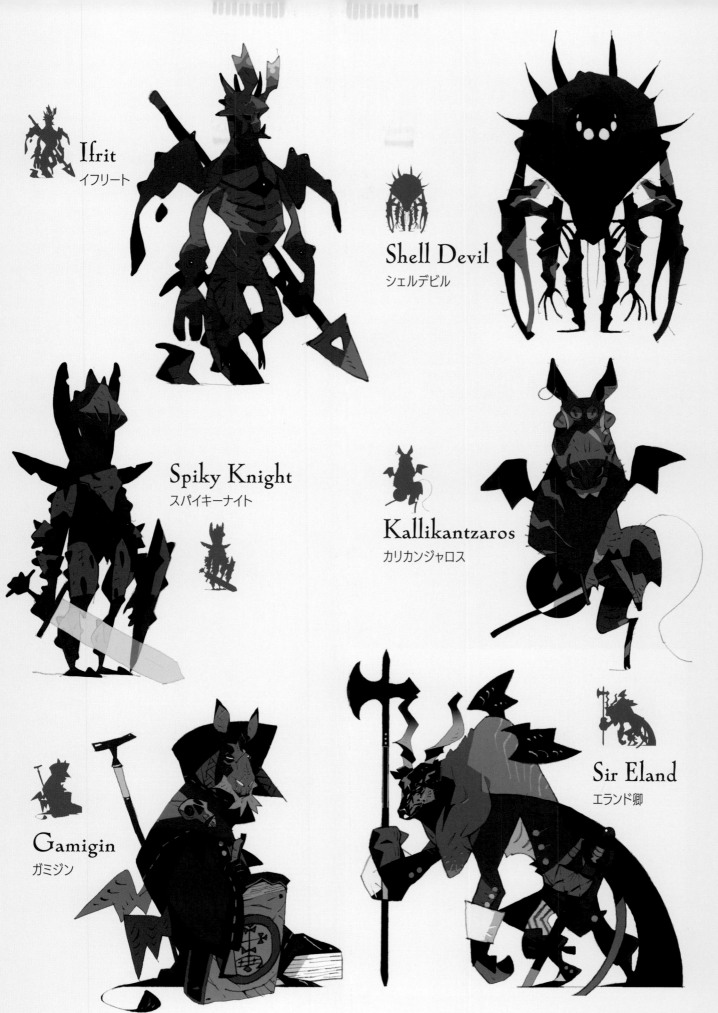

Ifrit
イフリート

Shell Devil
シェルデビル

Spiky Knight
スパイキーナイト

Kallikantzaros
カリカンジャロス

Gamigin
ガミジン

Sir Eland
エランド卿

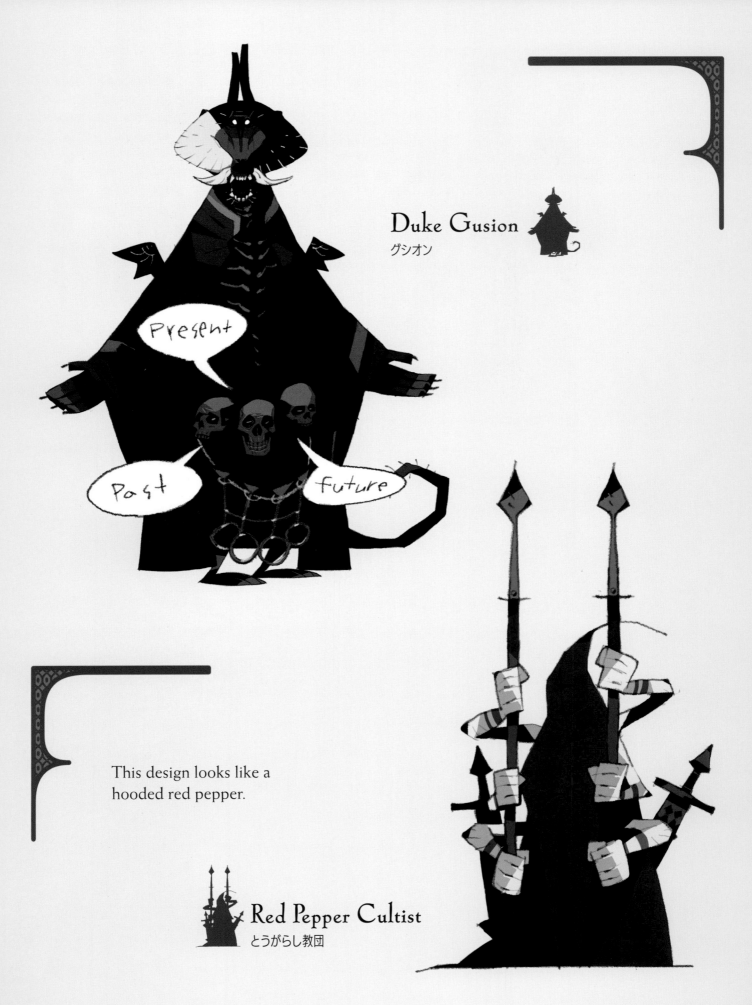

Duke Gusion
グシオン

This design looks like a
hooded red pepper.

Red Pepper Cultist
とうがらし教団

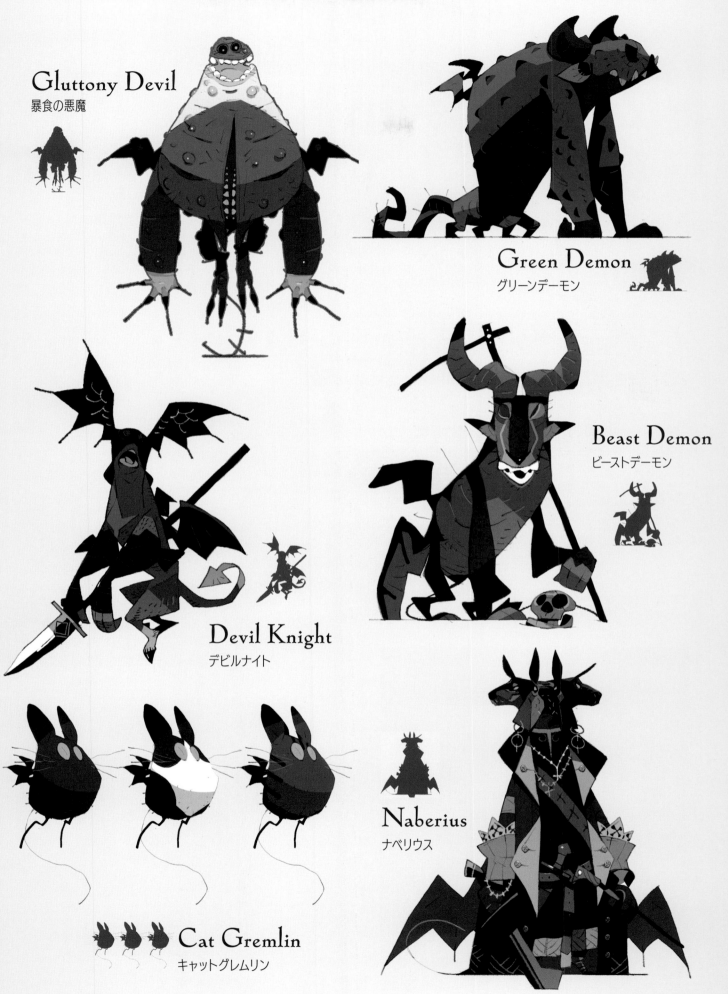

Gluttony Devil
暴食の悪魔

Green Demon
グリーンデーモン

Devil Knight
デビルナイト

Beast Demon
ビーストデーモン

Cat Gremlin
キャットグレムリン

Naberius
ナベリウス

Zombies and The Undead

I also enjoy drawing skeletons. I think about how much I can deform the bones, express various motifs with bones, turn them into zombies, etc. Also, the style of wrapping them like a mummy allows for fun variations.

Skeleton Soldier
スケルトンソルジャー

Undead Rider
アンデッドライダー

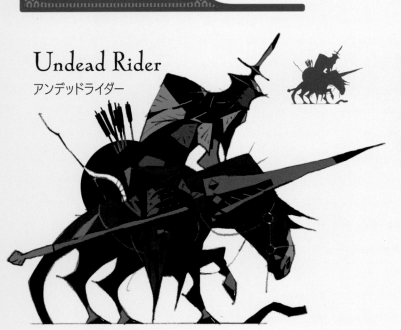

Zombie Girl
ゾンビガール

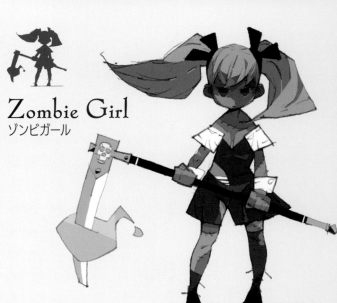

Lich

リッチ

Minotaur Zombie

ミノタウロスゾンビ

Undead Knight

アンデッドナイト

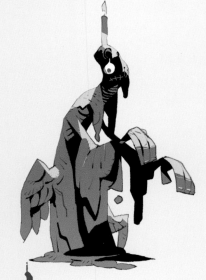

Candle Angel

ロウソクの天使

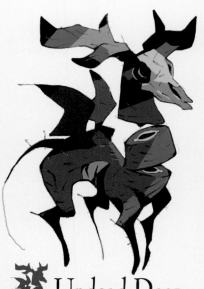

Undead Deer

アンデッドディア

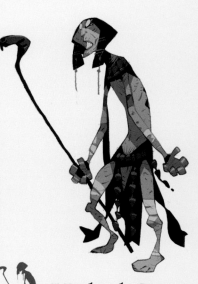

Undead Queen

アンデッドクイーン

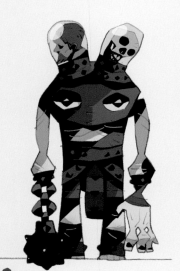

Conjoined Homunculi

ツインホムンクルス

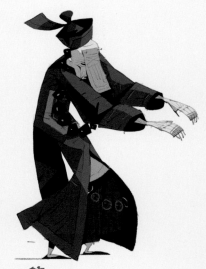

Jiang Shi

キョンシー

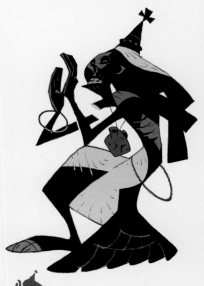

Skeleton Mage

スケルトンメイジ

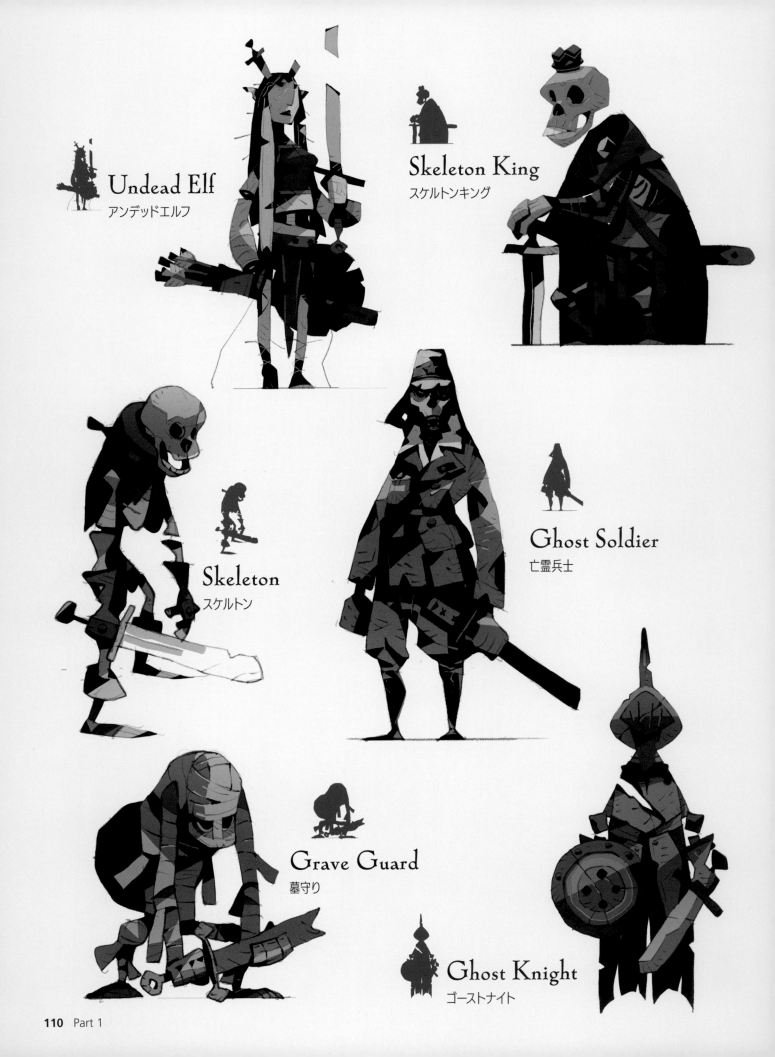

Undead Elf
アンデッドエルフ

Skeleton King
スケルトンキング

Skeleton
スケルトン

Ghost Soldier
亡霊兵士

Grave Guard
墓守り

Ghost Knight
ゴーストナイト

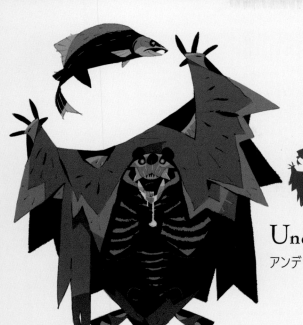

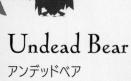

Undead Bear
アンデッドベア

Undead Angel Knight
死の天騎士

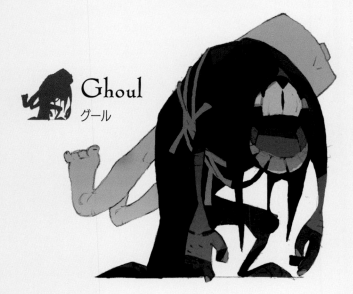

Ghoul
グール

Living Armor
リビングアーマー

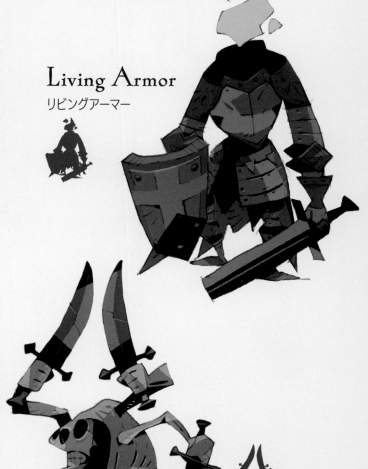

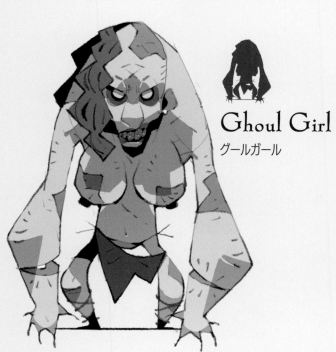

Ghoul Girl
グールガール

Four-armed Skeleton
四本腕のスケルトン

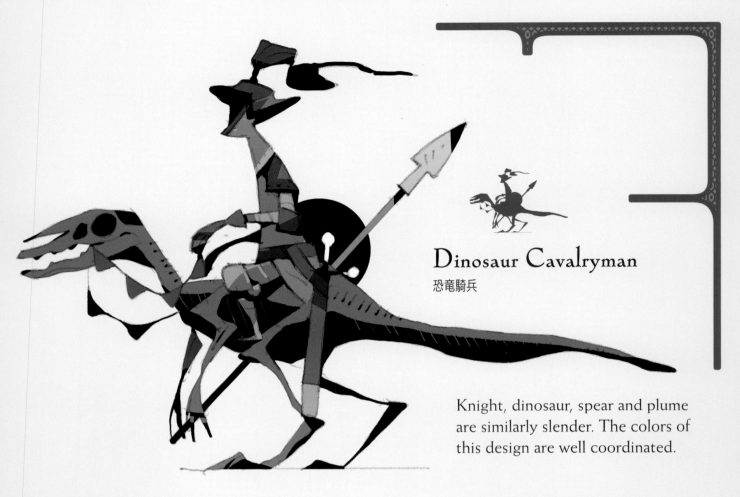

Dinosaur Cavalryman

恐竜騎兵

Knight, dinosaur, spear and plume are similarly slender. The colors of this design are well coordinated.

Headless Horseman

デュラハン

I drew this for Halloween. I think that making the ghostly horse's mane appear like a bluish-white flame lends an eerie impression.

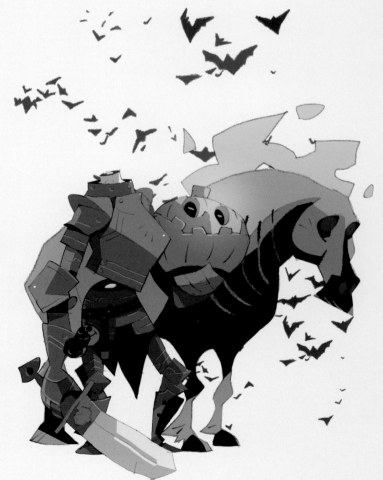

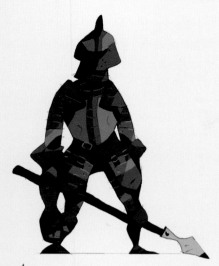

Immortal Knight
リビングナイト

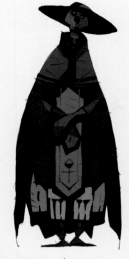

Death Priest
死の司祭

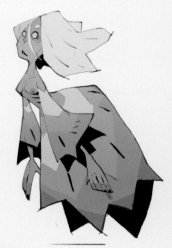

Banshee
バンシー

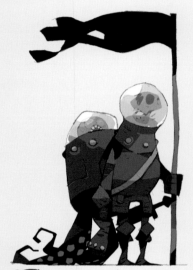

Hammal
荷運び人

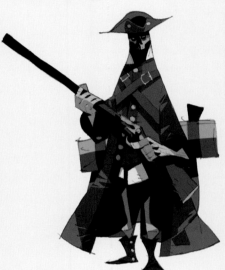

Skeleton Jaeger
ガイコツ猟兵

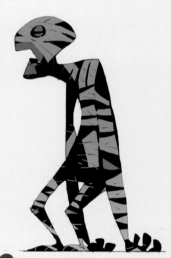

Mummy
マミー

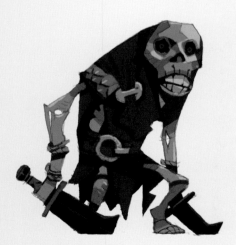

Dagger Skeleton
ダガースケルトン

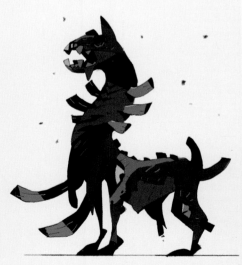

Zombie Hound
ゾンビハウンド

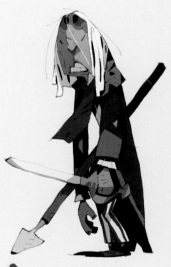

Sir Philip
フィリップ卿

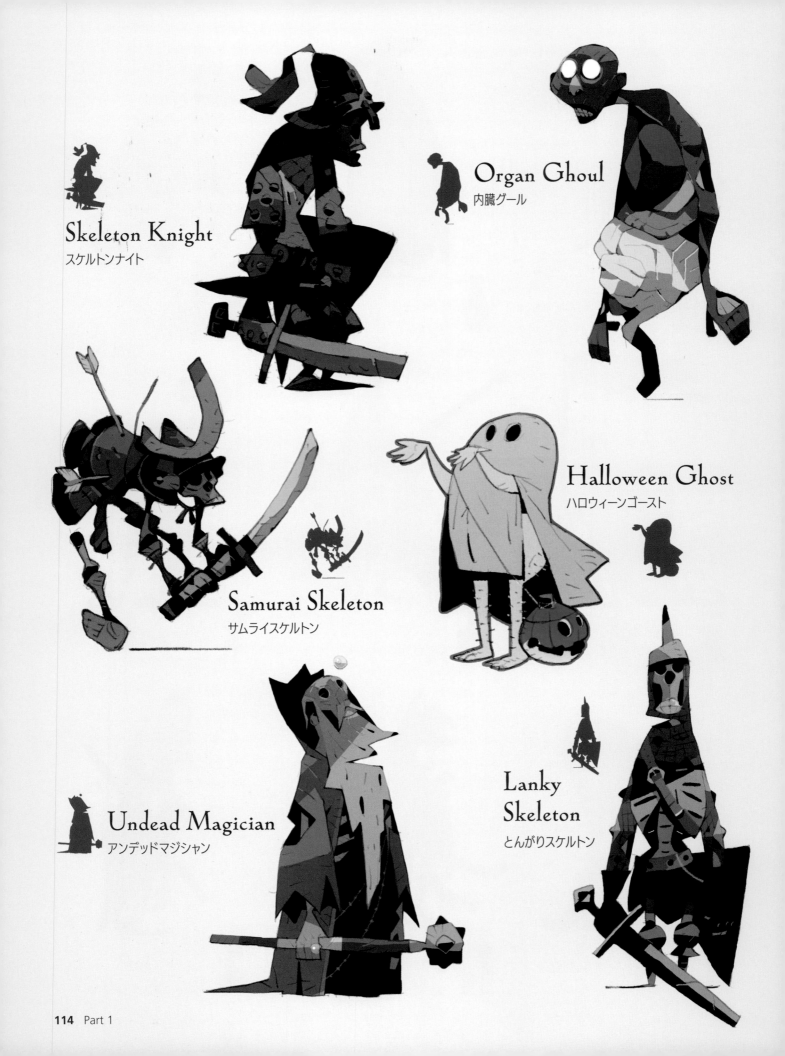

Skeleton Knight
スケルトンナイト

Organ Ghoul
内臓グール

Samurai Skeleton
サムライスケルトン

Halloween Ghost
ハロウィーンゴースト

Undead Magician
アンデッドマジシャン

Lanky
Skeleton
とんがりスケルトン

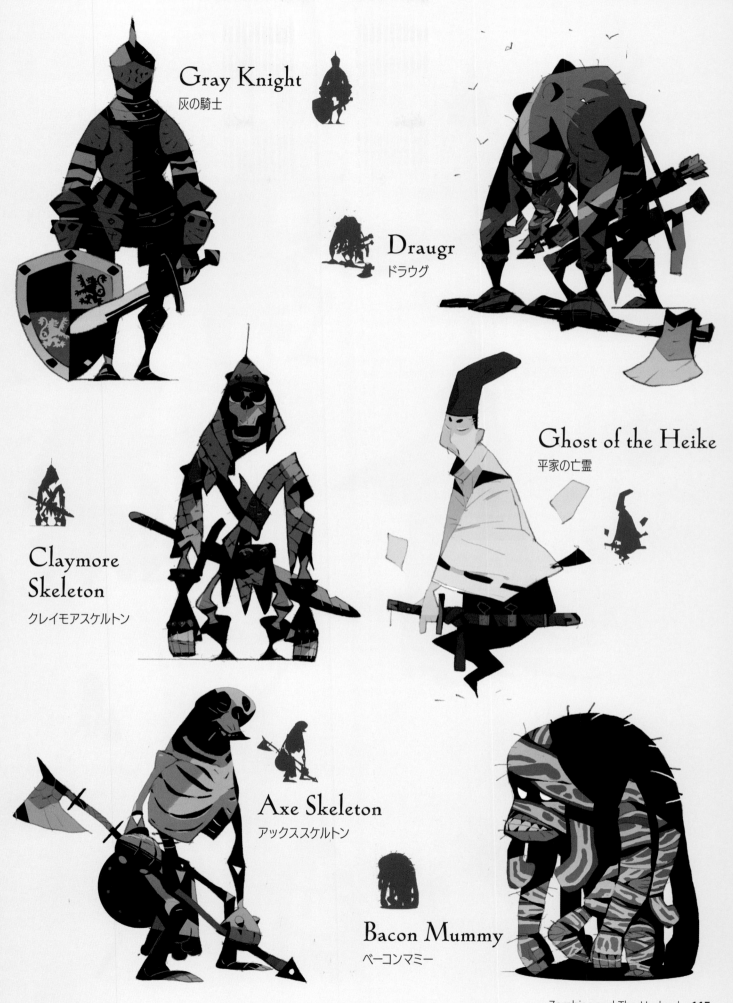

Gray Knight
灰の騎士

Draugr
ドラウグ

Claymore
Skeleton
クレイモアスケルトン

Ghost of the Heike
平家の亡霊

Axe Skeleton
アックススケルトン

Bacon Mummy
ベーコンマミー

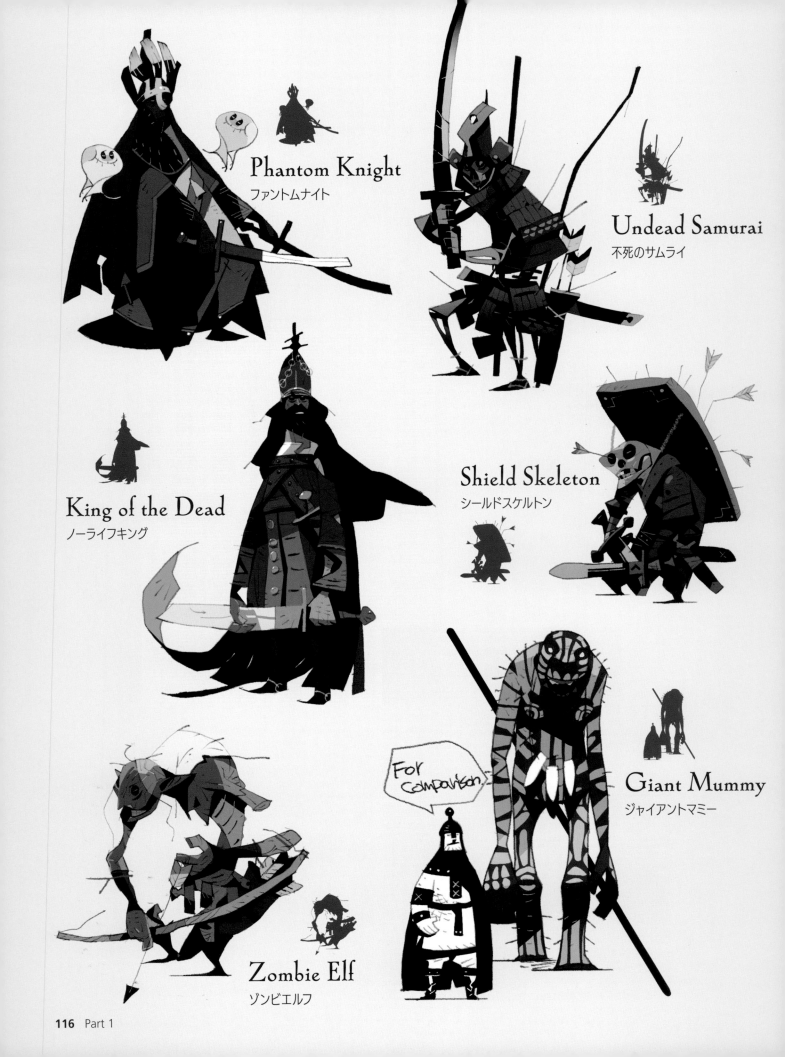

Phantom Knight
ファントムナイト

Undead Samurai
不死のサムライ

King of the Dead
ノーライフキング

Shield Skeleton
シールドスケルトン

For Comparison

Giant Mummy
ジャイアントマミー

Zombie Elf
ゾンビエルフ

Skeleton General
スケルトンジェネラル

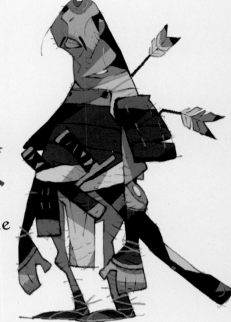

Samurai Zombie
サムライゾンビ

Undead Angel
アンデッドエンジェル

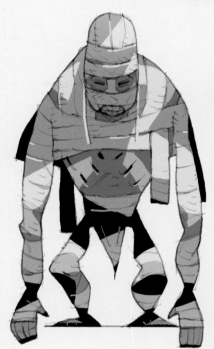

Carrion Mummy
腐肉ミイラ

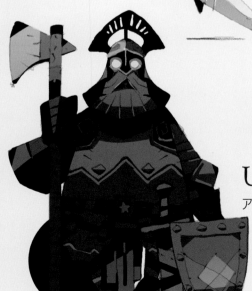

Undead Viking
アンテッドバイキング

Eyeball Mummy
目玉マミー

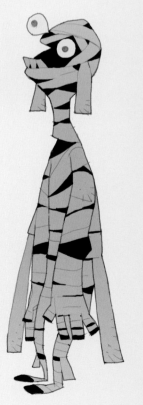

Anthropomorphic Plants and Food

When turning plants or food into monsters, what I consider is whether the motif is generally known or not. If it's something not well-known or something that cannot be easily imagined, it becomes a character that's difficult to recognize. I do like obscure motifs, but if the viewer doesn't "get it," there's no point to the drawing.

 ## Corn King
モロコシキング

This is a character redrawn in my own style from a child's doodle.

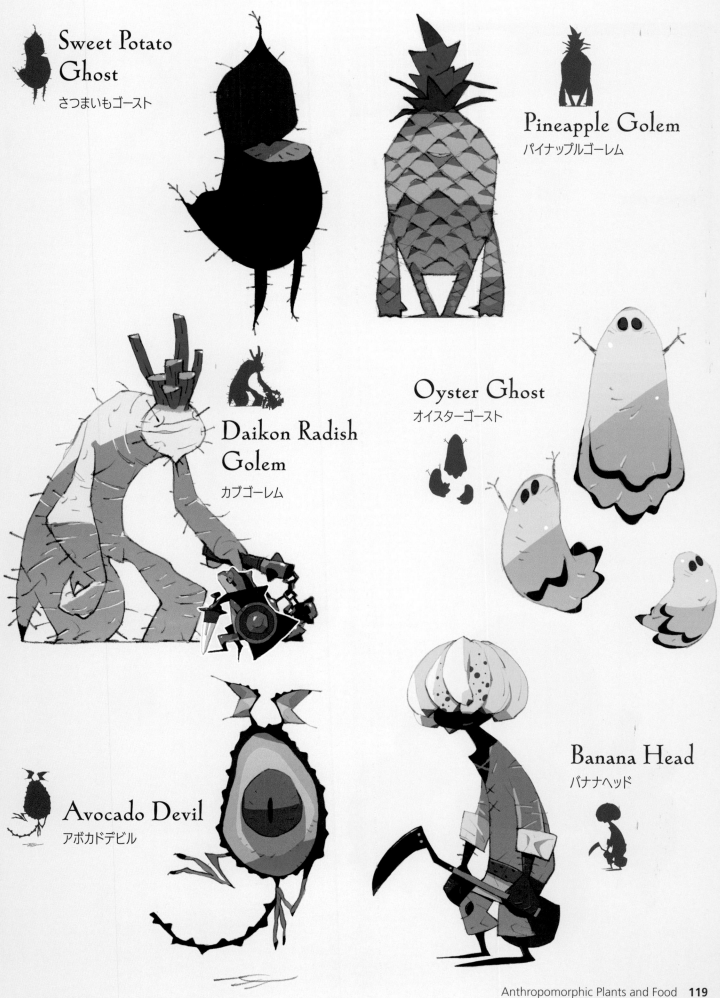

Sweet Potato Ghost
さつまいもゴースト

Pineapple Golem
パイナップルゴーレム

Daikon Radish Golem
カブゴーレム

Oyster Ghost
オイスターゴースト

Avocado Devil
アボカドデビル

Banana Head
バナナヘッド

Walking Plant
ウォーキングプラント

This funny character would be one of the weaker adversaries that appear at the beginning of a video game.

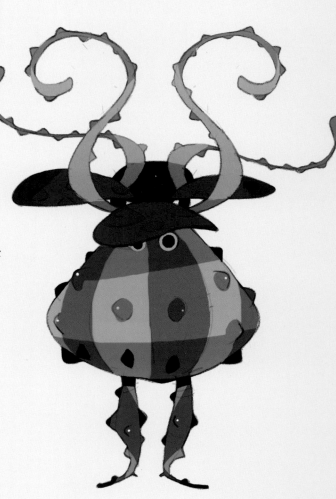

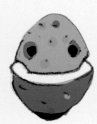

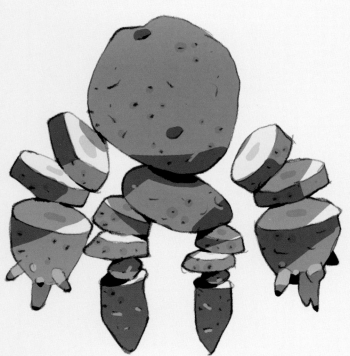

Potato Golem
ポテトゴーレム

Potatoes can be rather boring for anthropomorphism, but by slicing them into rounds and showing the interior color, the design becomes more interesting.

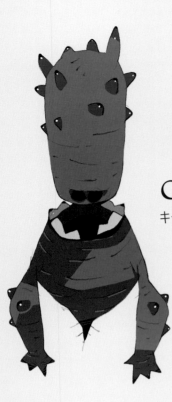

Carrot Devil
キャロットデビル

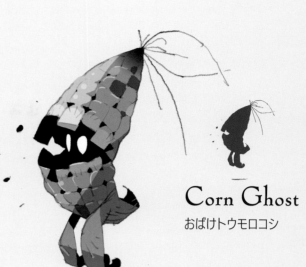

Corn Ghost
おばけトウモロコシ

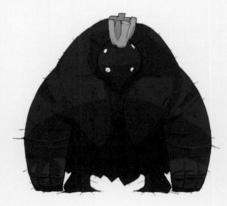

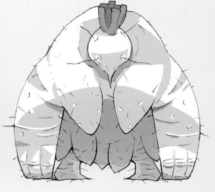

Radish Golem
ラディシュゴーレム

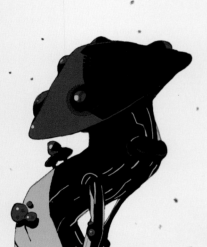

Mushroom Man
キノコマン

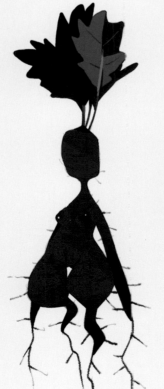

Mandragora
マンドラゴラ

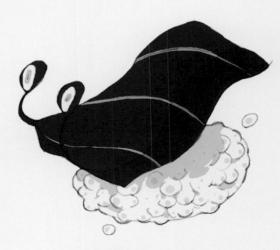

Sushi Monster
スシモンスター 赤身

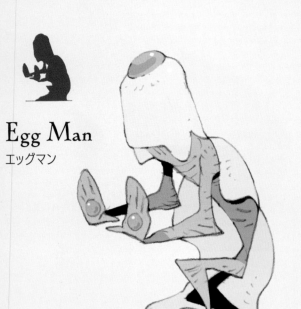

Egg Man
エッグマン

Sword Guardian
ソードガーディアン

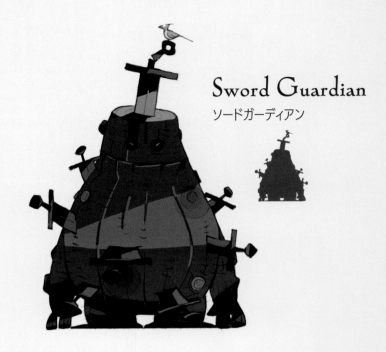

Mush Turtle
マッシュタートル

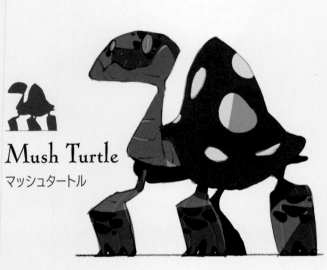

Cactus Lizard
サボテンリザード

Maneater
マンイーター

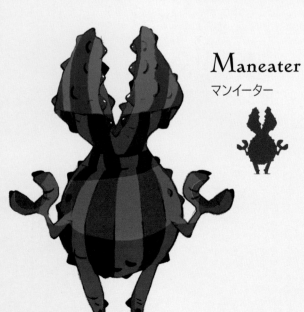

Mush Druid
マッシュドルイド

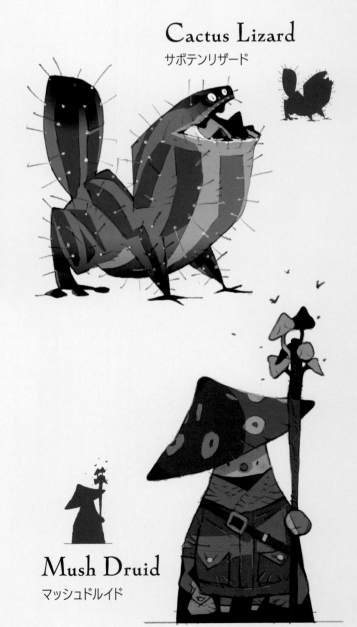

Pumpkin Knight
パンプキンナイト

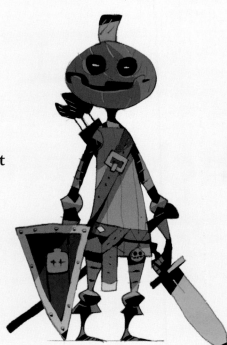

Chest Knight
イガグリナイト

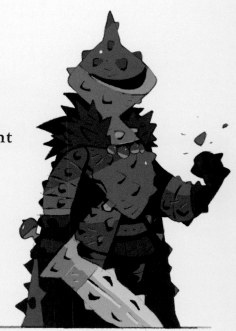

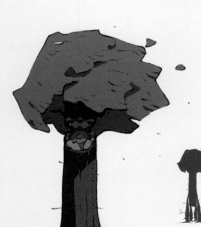

Young Treant
ヤングトレント

Treant
トレント（樹人）

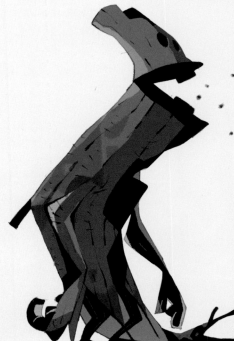

Mushroom Knight
マッシュルームナイト

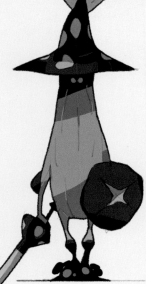

Seaweed Monster
おばけワカメ

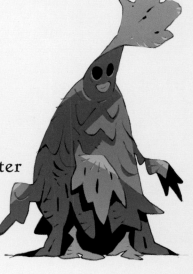

Enchanted and Exotic Creatures

There are many golems (artificial humans) in folklore. The designs gathered here are not of living creatures, but rather seem to be animated by someone. It's fun to draw hard materials like stone. Designs that are difficult to categorize are also included here.

Walking House
歩く家

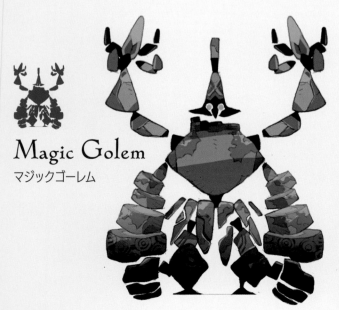

Magic Golem
マジックゴーレム

Golem Master and Red Golem
ゴーレムマスターと
レッドゴーレム

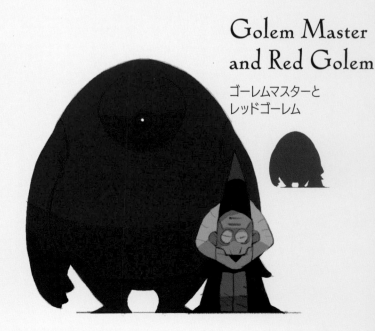

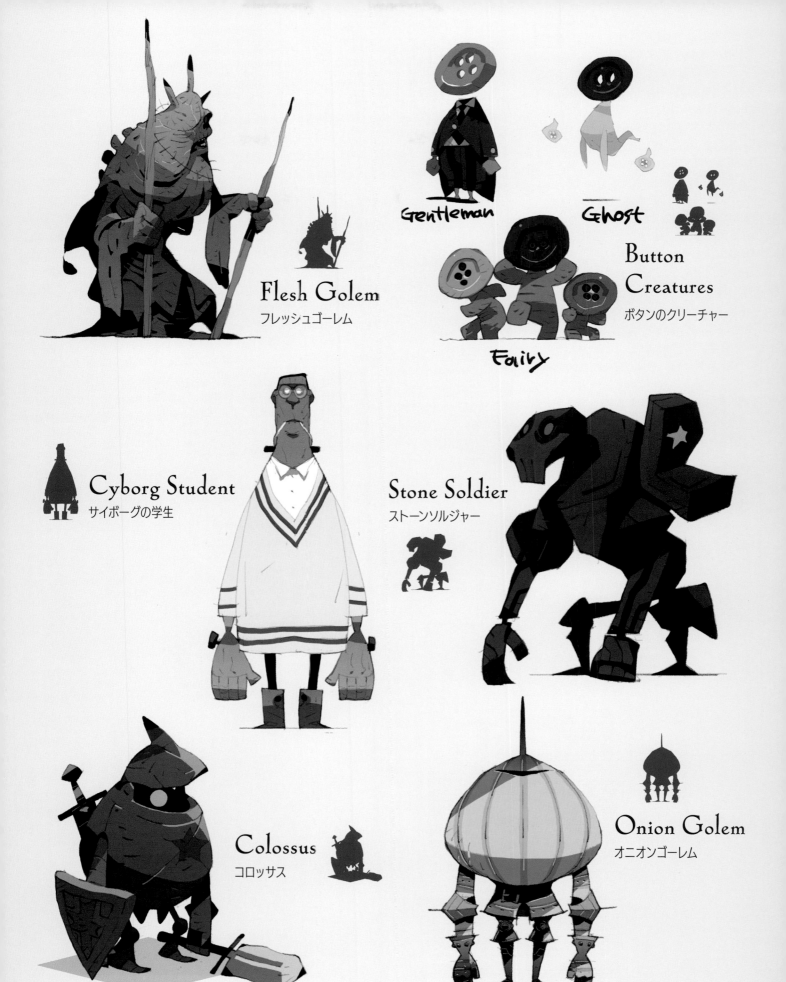

Flesh Golem
フレッシュゴーレム

Gentleman

Ghost

Button Creatures
ボタンのクリーチャー

Fairy

Cyborg Student
サイボーグの学生

Stone Soldier
ストーンソルジャー

Colossus
コロッサス

Onion Golem
オニオンゴーレム

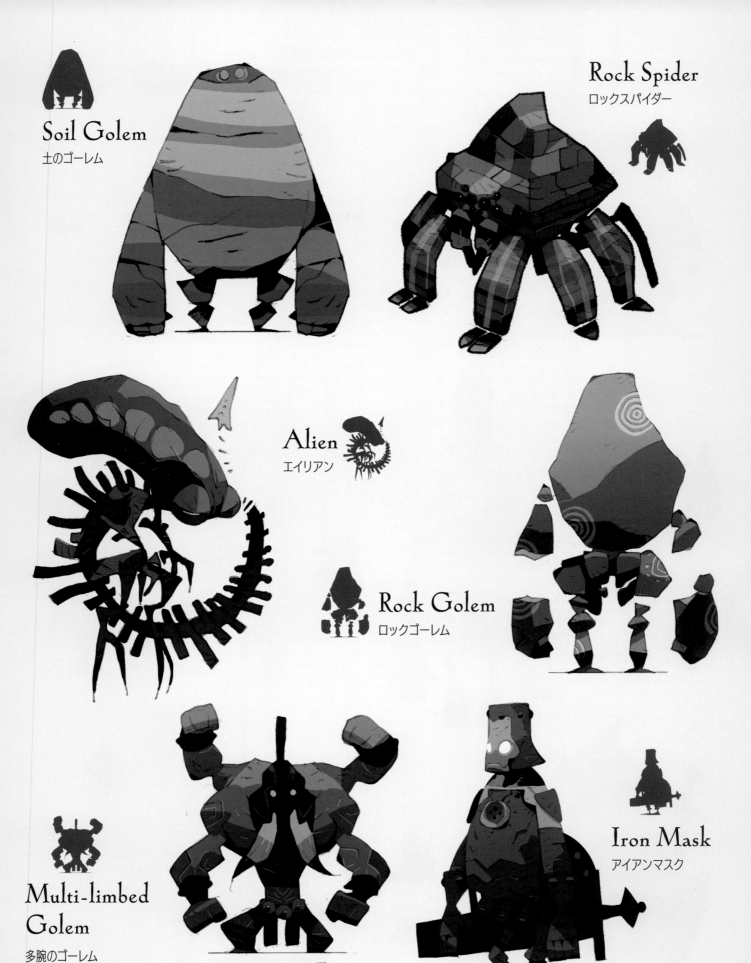

Soil Golem
土のゴーレム

Rock Spider
ロックスパイダー

Alien
エイリアン

Rock Golem
ロックゴーレム

Multi-limbed Golem
多腕のゴーレム

Iron Mask
アイアンマスク

Evil Puppet
邪悪な人形

Concrete Golem
コンクリートゴーレム

Mr. Brain
ミスターブレイン

Iron Golem
アイアンゴーレム

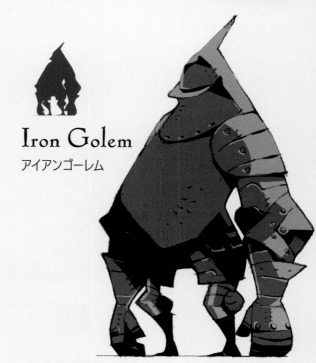

Crystal Warrior
クリスタルの戦士

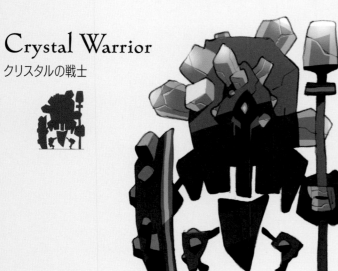

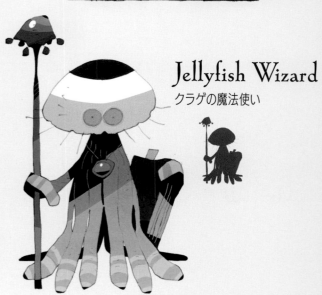

Jellyfish Wizard
クラゲの魔法使い

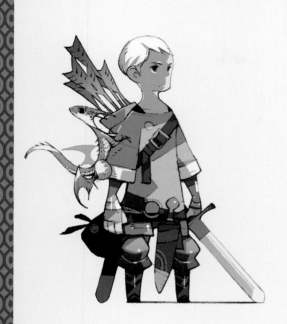

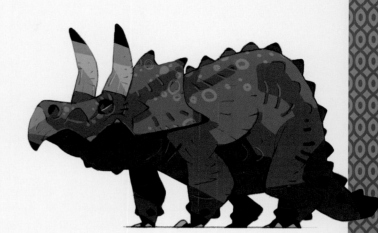

Part 2
My Character Design Process

Design New Characters by Combining Characteristics

Theme 1:
Anthropomorphize a Mouse

Visualize

The Attributes of a Rodent
- Agile
- Cunning
- Loathsome
- Dirty
- Swarming

Rodent Models
- Mouse
- Hamster
- Guinea Pig
- Gerbil
- Naked Mole Rat

Bandit + **Mouse**

That's it!
Make it a Mouse Thief!

▼

Bring out thief-like elements such as a knife, hood and cloak.

▼

Because it's a mouse, I'll make the front paws small and the back feet large to create interesting contrast in the silhouette.

It fits within the circle.

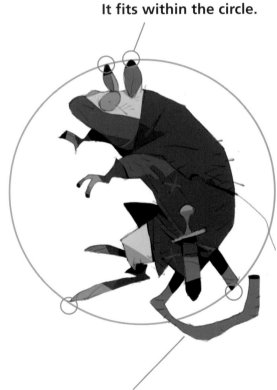

By having the tail protrude from the circle, I create irregularity in the silhouette, which makes the form more interesting to view.

When designing, my basic approach is to combine two different things. Generally, this could be "human" + "creature," "dragon" + "creature," and so on. Also, when drawing a fire attribute monster, I might base it on an animal with naturally reddish coloration, or if it's a mischievous character, I could use an animal with a notoriously impish disposition. I feel that this approach lends credibility to the design.

Theme 2:
Combine a Stag Beetle and a Tiger

Visualize

The Attributes of a Stag Beetle
- Large Mandibles
- Cool

The Attributes of a Tiger
- Striped
- Furry Muzzle
- Claws
- Cool
- Powerful

Let's Draw a Beetle Tiger!

▼

I added a beetle's jaw to the body of a tiger. By giving it six insect legs, it no longer has the body shape of a tiger, which adds a sense of wonder.

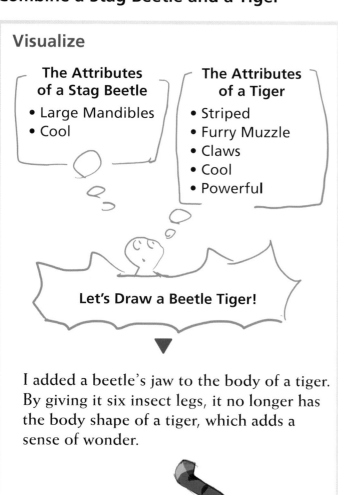

Theme 3:
Turn a Moth into a Fairy

Visualize

Female Fairy　**With Butterfly Wings**

↓

An original design that uses butterfly wings

↓　　　↳ **A Unique Motif**

Beetle? / **Cicada?** / **Moth?**

↓

Let's draw a Moth Fairy!

▼

The features of a moth are its fluffy antennae and wing patterns, which I transform into something unfamiliar.

▼

Make it original, or something familiar?

▼

What if I design it exactly like a swallowtail butterfly's wings?

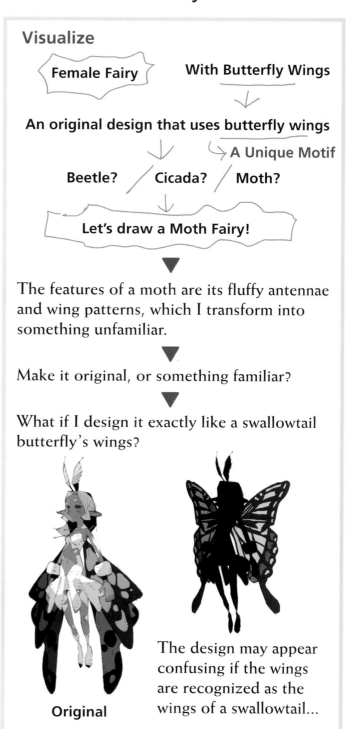

Original

The design may appear confusing if the wings are recognized as the wings of a swallowtail...

You Can Identify Characters by Their Silhouettes Alone

Forest Dragon

(Page 15)

This is a basic lower-level dragon. Because it's a weak dragon, I've used a limited color palette and haven't included any patterns or designs. I've made the wings small and created a large gap at the top left. If I made large wings that filled the square frame, I think it would become a boring design. By emphasizing the length of the neck, arms and legs, it creates an interesting silhouette.

Empty space

Breaking the plane

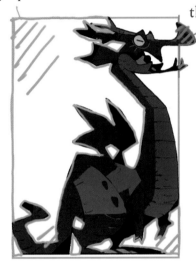

Atlantean Convict

(Page 94)

I thought a shark jaw specimen looked cool, so I wondered if I could use it in a character design. From there, I expanded the image and turned it into a prisoner's restraint. The setting is a deep-sea prison.

Leave some negative space

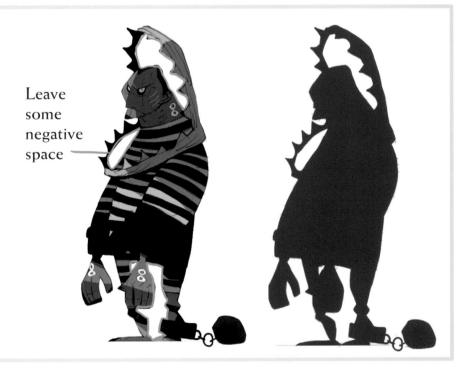

What I particularly value when thinking about character design is the ability to recognize the character from its silhouette alone. In the first part of this book, I included a silhouette for each character. Here, I discuss ways to create a unique silhouette.

Avocado Devil

(Page 119)

This is a demon modeled after an avocado. The large seed typical of an avocado is used as the eye, and the rough outer skin is exaggerated. Because the body silhouette is simple and cute, I made the legs slender for a creepy effect, and the long, skinny tail accents the roundness of the body. Also, by placing small wings on top, I created the impression of a large body being barely held aloft in wobbly flight.

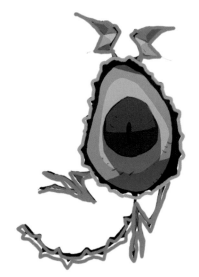

The simple shape is accented with thin, elongated legs and tail.

Create a silhouette using the color replacement tool.

Mush Turtle

(Page 122)

I initially thought it would be interesting to make a turtle's shell into a mushroom. The turtle motif is a tortoise. To emphasize the characteristic heaviness of the legs, the part where the legs join the body is made slender. Also, by making the legs long and leaving space under the turtle's body, I have made the silhouette distinctive. As a color accent, I have added the orange stripes often found on the skin of green turtles.

You Can Identify Characters by Their Silhouettes Alone, cont'd.

Blowfish Fighter

(Page 50)

I've tried to anthropomorphize a pufferfish. It has a round body with long, slender limbs for its silhouette. I've added orange accents to the tips of the fins. I'm also conscious of defining the shape through color division, and in the case of this character, that would be the beige parts around the belly and eyes.

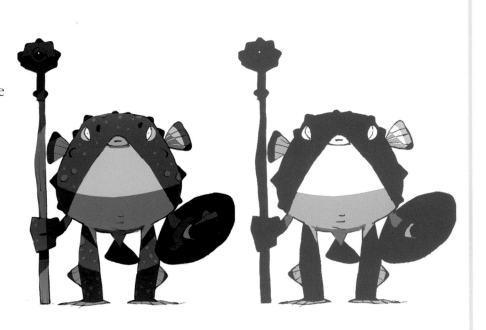

Mosasaurus

(Page 21)

I started by looking at reference material on Mosasaurus, a real dinosaur, and once I had a decent image in my head, I began to draw. From that point on, I don't look at other materials. I draw Mosasaurus somewhat loosely, with parts freely expressed. I designed the back to look like a crocodile's, the fins like a whale's, and the fangs in clusters. This is the Mosasaurus I think is cool.

Crocodile Tail

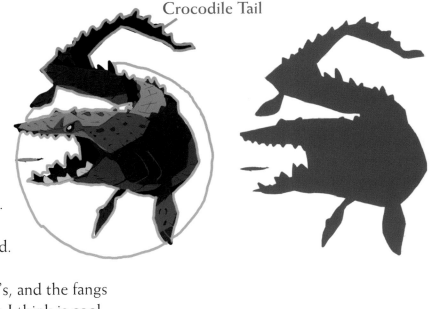

King

(Page 83)

This is a benevolent king. I've
made the upper body large to
give it a sense of gravitas, while
the lower body is somewhat weak
in contrast. In terms of color,
I used gold jewelry to express
nobility, and blue to convey
fidelity and sincerity. I gave him a
staff, inspired by the Holy Grail,
because the silhouette became too
regular when I added the cape.

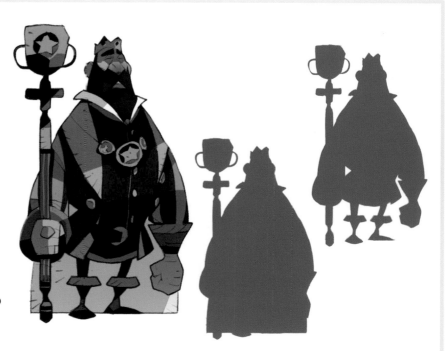

Blue-haired Warrior

(Page 86)

I used blue as the main color to
create a cool character. Design
cohesion is expressed through the
vertical lines in the hair, slender
limbs and the striped clothing. By
arranging the sword and quiver
to be roughly perpendicular to
the hair and limbs, I broke up the
vertical emphasis of the silhouette.

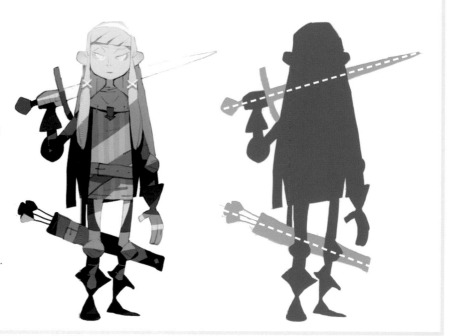

From Inspiration to Final Art: My Process

Drawing a Character that is a Combination of a Dragon and a Samurai

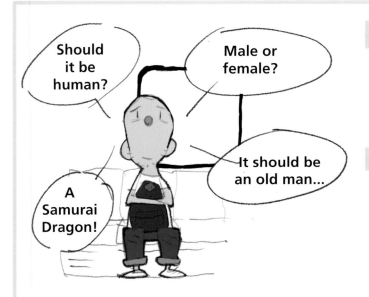

Should it be human?

Male or female?

It should be an old man...

A Samurai Dragon!

Visualize what you want to draw

Humanoid → Gender: Male? Female? → Let's go with an old man!
Add elements of a dragon → Let's make it an Asian dragon!

A samurai wearing dragon armor!

Think about the common features of a samurai, armor and a dragon:

- I want to represent the old man's beard and the dragon's beard well
- Using strong red as the base
- Making the armor scale-like?
→ Rejected because it will obscure the armor

❶ Sketch
A helmet inspired by a dragon. I've made the neck guard large so that the silhouette becomes interesting. Instead of a sword for a weapon, I've given him a *naginata* (polearm), to convey the image of being "as long as a dragon."

A bit of a dragon-like addition.

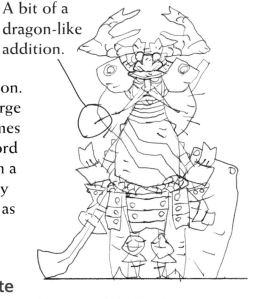

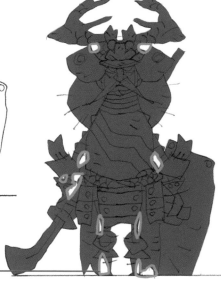

❷ Analyze the silhouette
I consider the overall silhouette. I'm mindful of making the shape interesting, and also aware of the negative space so that it doesn't appear too dense.

Here, I introduce the entire process, from generating ideas, to drawing a rough sketch, creating a silhouette, and coloring. A key point is to boldly incorporate shadows.

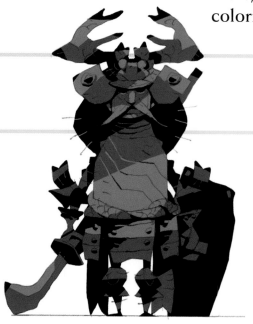

❸ Add shading

Add shading in two stages: 100% black and 25% black (or 15%). Apply it boldly and firmly.

❹ Add color

I colored it using red as the base color. I added accents of bluish-green as contrasting colors, and I tried adding a vibrant red to the small areas like the cords of the helmet.

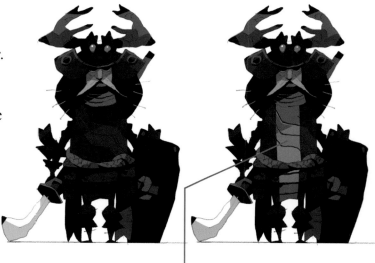

The design was too plain, so I added a vertical stripe.

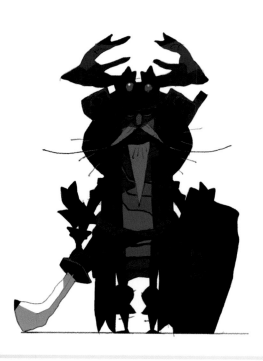

❺ Color adjustment

To create a sense of cohesion, I added an adjustment layer and finished the process. I adjusted it using the color balance tool to achieve the desired result.

From Inspiration to Final Art: My Process, cont'd.

Drawing a Monster that is a Combination of a Dinosaur and a Toxic Cloud

Visualize What You Want to Draw

A poison-themed monster...
A Poison Dragon? A Poison Lizard?

A Poison Dinosaur!

Design characteristics of the poison dinosaur:
- Purple color: Give it a distinctive purple hue.
- Warning colors: Incorporate vibrant and attention-grabbing patterns reminiscent of hazardous wildlife like poison frogs, and venomous snakes and insects.

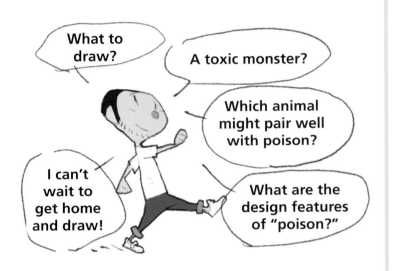

What to draw?

A toxic monster?

Which animal might pair well with poison?

I can't wait to get home and draw!

What are the design features of "poison?"

❶ Sketch

Draw what you envision in your mind. Don't dwell on it—just draw quickly.

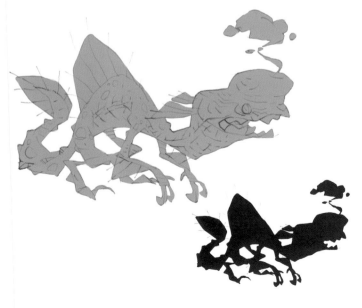

❷ Analyze the Silhouette

Start by filling in the base colors and consider the overall silhouette. Make the shape interesting and be mindful of preserving the negative spaces to avoid flattening the image. Using gray for this stage makes it easier to visualize.

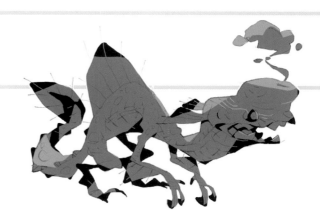

❸ Add Shading

Add shading in two stages: 100% black and 25% black (or 15%). Apply it boldly and generously to create strong shadows.

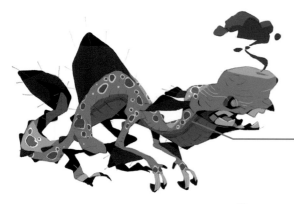

❹ Add Color

Color it with vibrant patterns and colors. In this step, I'm working based on what I have in mind without referring to any references or sources.

Note

Color separation in the silhouette: I added accents such as red stripes running from the throat to the belly.

❺ Add variation in the outline to create areas of emphasis and contrast

Darken the areas where the outline casts shadows to create more depth.

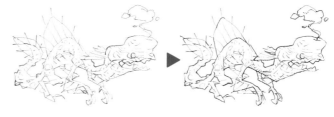

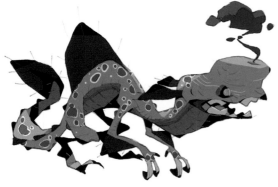

❻ Color Adjustment

To achieve an overall sense of unity, I will add an adjustment layer and make final adjustments. I use the color balance tool to achieve the desired effect. I also adjust the saturation and tone curve to create the desired look.

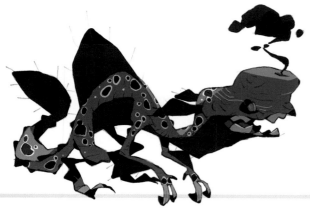

Fixing Designs That You Don't Like

Hippo Dragon
(Page 12)

Before

✕ Unattractive silhouette
(minimal negative space)

✕ Uninteresting characteristics
(few weaknesses, attack methods
or standout features)

Ambiguous

▼

After

✓ New negative spaces added

✓ Large tusks added.
It seems like this monster
will attack with these fangs!

New negative space

More formidable claws!

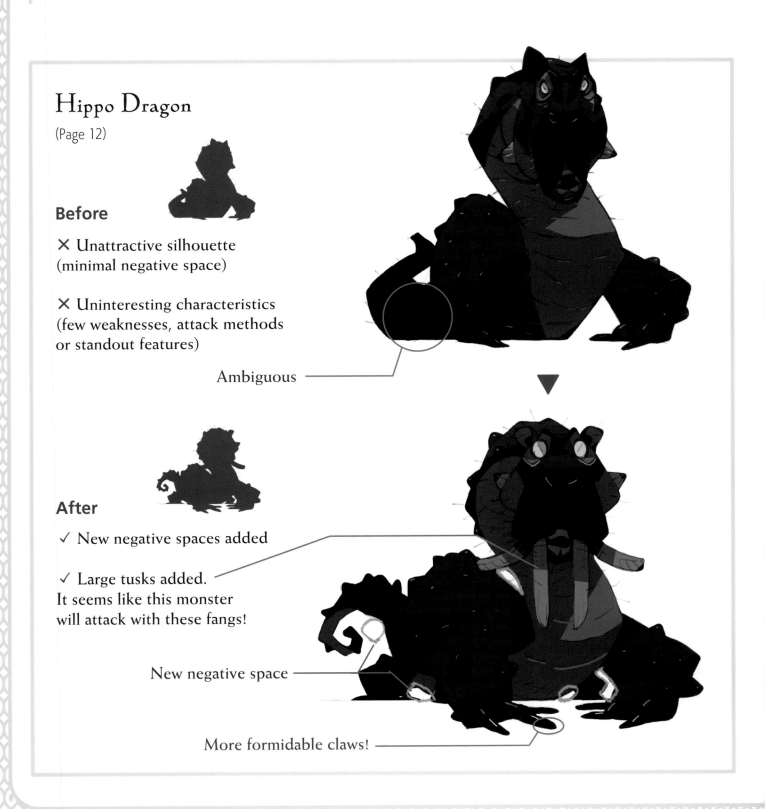

If you're not satisfied with the design you've drawn or find it lacking, it's a good idea to make changes. Often, the silhouette is the main issue. Here, I will provide examples of how to make corrections.

Heavy Dragonewt

(Page 48)

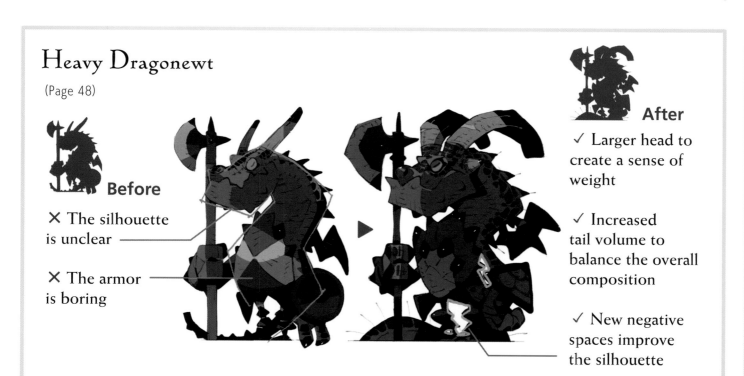

Before

✗ The silhouette is unclear

✗ The armor is boring

After

✓ Larger head to create a sense of weight

✓ Increased tail volume to balance the overall composition

✓ New negative spaces improve the silhouette

Snail Knight (Page 86)

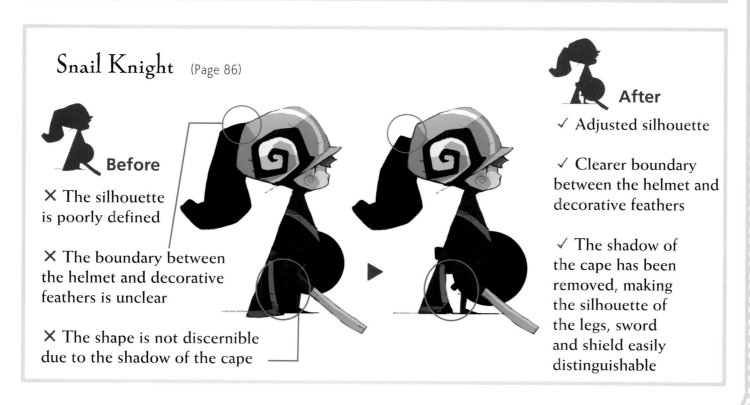

Before

✗ The silhouette is poorly defined

✗ The boundary between the helmet and decorative feathers is unclear

✗ The shape is not discernible due to the shadow of the cape

After

✓ Adjusted silhouette

✓ Clearer boundary between the helmet and decorative feathers

✓ The shadow of the cape has been removed, making the silhouette of the legs, sword and shield easily distinguishable

Author Notes

80% completeness → The viewer completes the design.
I strive for designs that aren't perfectly completed or designed from head to toe, but rather have gaps that allow the viewer to imagine and mentally fill in. I would be happy if, instead of being saddled with an overdesigned picture, viewers could freely imagine things like the character's method of attack or personality from the design.

I only physically draw for 1–2 hours → But I'm always thinking about the design.
Character design is my main job. I'm physically drawing for about 1–2 hours (in the case of a single character—it's different for illustrations). Because I'm a chronic procrastinator, I'm always looking for ways to draw efficiently in a short amount of time. Before I start drawing, I picture the design in my head to a certain extent. Once I have a good enough image, all that's left is to draw it!

I aim to create designs that excite. I'm particularly pleased when children feel that way about my work.
When I was in elementary and middle school, new monster illustrations from *Dragon Quest* were featured in *Weekly Shonen Jump*. I looked forward to it and read each issue with excitement.

Given that, I want to draw creatures that excite today's elementary and middle school students just like I felt back then. Also, for those of my generation, I aspire to create designs that evoke the nostalgic Famicom and Super Famicom console era.

I don't design while looking at references → I input information daily.
When you draw while looking at references, it tends to result in a design that is too faithful to the reference (which isn't interesting). Whether it's animals, fish, birds or insects, I think I could draw almost any living creature without looking at references (accuracy aside). In my case, if I draw while looking at a reference, I get caught up in it, which results in a design lacking interest. It's best to simply observe various things on a daily basis. There are plenty of things that can populate your mental database, such as architectural features seen during commuting or walking, or food in restaurants and grocery stores. One of my habits is to peek at the fresh fish for sale at local supermarkets when I travel, to study the exotic specimens there.

Hybrid creature designs are easy as long as you get the primary details right.
For instance, when drawing a tiger monster, all you need to do is capture the unique features of a tiger, like its orange color, striped pattern and fur on its cheeks. After that, whether it's a fish or a bird hybrid, you'll have a tiger-type monster.

It all started from pixel art—drawing pictures that I enjoy.

My first job in the game industry was creating pixel art. I joined a company hoping I could do design work, but I didn't get many opportunities to draw what I liked. Even though I wanted to draw characters, I ended up doing background, effects and clerical tasks.

As a solution, I started drawing pictures that I liked in my free time. I was able to draw my favorite images unabashedly, without feeling concerned about critiques from my superiors or colleagues. Despite having work from the company and being quite busy, I always found time to draw. Nowadays, with social media, there are also opportunities to easily have your work seen by others. If you keep drawing, you might even receive job offers to draw pictures you love. Wouldn't it be a joy to be able to draw pictures you like and get paid to do so?

When you can't draw, or don't want to draw, don't! Wait until the urge strikes.

When I graduated from high school and entered a vocational school for design, my teacher at the time told me, "If you don't want to draw, you don't have to. You'll eventually want to." There was a period when I just played games without doing any assignments!

When you're not in the mood to draw, I recommend taking a break from drawing and changing your mood rather than forcing yourself to remain at the desk. If you draw reluctantly, it will show in your art. By watching movies or playing games, you input ideas—effectively using your time even when not drawing.

Drawing imaginary creatures and monsters is fun!

The primary reason for this is that I can design freely. There are various design restrictions that arise when designing human characters, but drawing creatures is truly enjoyable.

I try not to worry about the skeletal structure or other anatomical details too much. If you're so concerned about those aspects that you can't complete a drawing, it's better to just draw a lot in any way you can. This is particularly true for monsters—they don't exist in reality, so anything goes! I'm always designing while thinking, "This doesn't exist, but it would be interesting if it did."

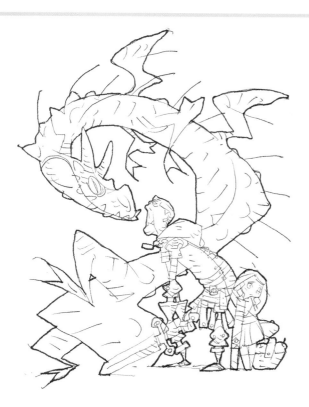

The Author

SATOSHI MATSUURA is a video game character designer who specializes in creature design. He has worked on game titles such as *Legend of Mana* (Square Enix), *Monster Guardians* (Konami), *Magical Vacation* (Nintendo), *Denpa Ningen no RPG* (Genius Sonority), *Bravely Default* (Square Enix), *Monster Takt* (Silicon Studio), *Little Noah: Scion of Paradise* (Cygames) among others. In the anime *Deca-Dence* (2020), he was in charge of Gadoll species creature design. He has also contributed illustrations to the book *The Prince's Medicine Illustration Book* series (Jihou). @hiziri_pro

"Books to Span the East and West"

Tuttle Publishing was founded in 1832 in the small New England town of Rutland, Vermont [USA]. Our core values remain as strong today as they were then—to publish best-in-class books which bring people together one page at a time. In 1948, we established a publishing outpost in Japan—and Tuttle is now a leader in publishing English-language books about the arts, languages and cultures of Asia. The world has become a much smaller place today and Asia's economic and cultural influence has grown. Yet the need for meaningful dialogue and information about this diverse region has never been greater. Over the past seven decades, Tuttle has published thousands of books on subjects ranging from martial arts and paper crafts to language learning and literature—and our talented authors, illustrators, designers and photographers have won many prestigious awards. We welcome you to explore the wealth of information available on Asia at www.tuttlepublishing.com.

Published by Tuttle Publishing, an imprint of Periplus Editions (HK) Ltd.

www.tuttlepublishing.com

ISBN: 978-4-8053-1794-5

KUSO SEKAI NO JUNIN TACHI – MATSUURA SATOSHI CHARACTER DESIGN
Monster & Human, Imaginary Creatures – by Satoshi Matsuura
Copyright © 2021 Satoshi Matsuura English translation rights arranged with GIJUTSU-HYORON CO., LTD. through Japan UNI Agency, Inc., Tokyo

English translation © 2023 Periplus Editions (HK) Ltd

27 26 25 24 23 10 9 8 7 6 5 4 3 2 1
Printed in China 2310EP

Distributed by:

North America, Latin America & Europe
Tuttle Publishing
364 Innovation Drive
North Clarendon
VT 05759-9436 U.S.A.
Tel: (802) 773-8930 | Fax: (802) 773-6993
info@tuttlepublishing.com | www.tuttlepublishing.com

Japan
Tuttle Publishing
Yaekari Building 3rd Floor
5-4-12 Osaki Shinagawa-ku
Tokyo 141 0032
Tel: (81) 3 5437-0171 | Fax: (81) 3 5437-0755
sales@tuttle.co.jp | www.tuttle.co.jp

Asia Pacific
Berkeley Books Pte. Ltd.
3 Kallang Sector, #04-01
Singapore 349278
Tel: (65) 6741-2178 | Fax: (65) 6741-2179
inquiries@periplus.com.sg | www.tuttlepublishing.com